Mary Ellen Mi

was born in Skaneateles, New York, in 1952,
and educated at the universities of Princeton and Yale.
From Yale she received an M.A. in 1978, and a Ph.D. in
History of Art in 1981. At the same university she now
holds the post of Associate Professor of History of Art.
Professor Miller has worked extensively in Central
America, particularly Mexico, Guatemala, Belize and
Honduras, where she has carried out research in Maya
art, architecture and culture. She is the author of many
articles on Mesoamerican art in learned journals, and her
book, *The Murals of Bonampak* (1985), was hailed by
Michael Coe as 'the best analysis of a body of Maya art
that I have ever read . . . a classic in the
literature on Mesoamerica.'

WORLD OF ART

This famous series
provides the widest available
range of illustrated books on art in all its aspects.
If you would like to receive a complete list
of titles in print please write to:
THAMES AND HUDSON
30 Bloomsbury Street, London WC1B 3QP
In the United States please write to:
THAMES AND HUDSON INC.
500 Fifth Avenue, New York, New York 10110

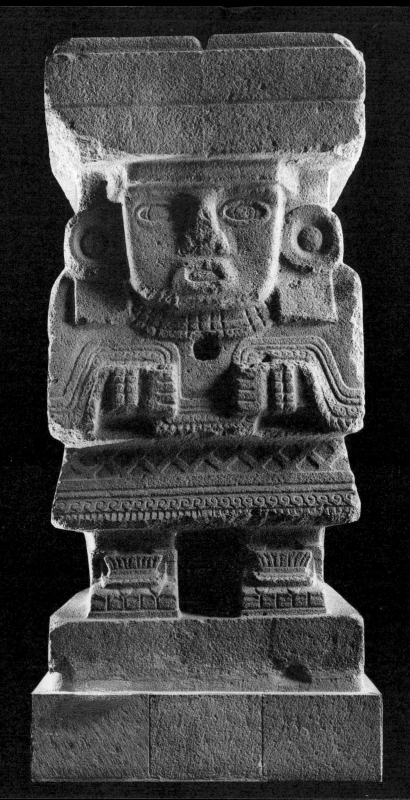

THE ART OF MESOAMERICA
from Olmec
to Aztec

Mary Ellen Miller

186 illustrations, 20 in color

THAMES AND HUDSON

Frontispiece: Once set near the Pyramid of the Moon at Teotihuacan, this great basalt water goddess seemingly wrings moisture from her very garments. Early Classic.

First published in the United States in 1986 by Thames and Hudson Inc., 500 Fifth Avenue, New York, New York 10110

Library of Congress Catalog Card Number 85-51916

Printed and bound in Spain by Artes Graficas Toledo S.A. D.L. TO–1664–1985

Contents

Chronological table

		CENTRAL MEXICO	OAXACA	GULF COAST	WEST MEXICO	MAYA HIGHLANDS/ PACIFIC COAST	LOWLAND MAYA — South	LOWLAND MAYA — North
1519	LATE POSTCLASSIC	Aztecs / Toltecs — *Tenochtitlan* *Tlaxcala*	Mixtec independent kingdom	Aztecs	Tarascans	Maya independent city-states *Mixco Viejo, Iximché, Utatlán*	*Tayasal* (Itzá)	*Tulum* *Sta Rita*
1200		*Tula*						*Mayapán*
	EARLY POSTCLASSIC		*Mitla* *Yagul*	Huastecs				*Chichen Itzá* (Toltec Maya)
900	TERMINAL CLASSIC	*Xochicalco*						
	LATE CLASSIC	*Cacaxtla*	Monte Albán IIIb	Classic Veracruz			Tepeu Late Classic Maya	Puuc and Central Yucatán
600		Teotihuacan Phases I–IV		El Tajín — *Remojadas*		*Cotzumalhuapa*		
	EARLY CLASSIC		Monte Albán IIIa	*Cerro de las Mesas*	*Ixtlán del Rio*	*Kaminaljuyú* *Escuintla*	Tzakol: Early Classic Maya	
300								*Dzibilchaltún*
	PROTO CLASSIC		Monte Albán II					
AD	LATE FORMATIVE				*Chupícuaro*	*Izapa, Kaminaljuyú,*	Cerros	
BC		*Cuicuilco*		*Tres Zapotes*	Colima	*Abaj Takalik*		
300								
			Dainzu	*La Venta*				
600	MIDDLE FORMATIVE	*Tlatilco*	Monte Albán I	Olmecs				
900	EARLY FORMATIVE			*San Lorenzo*	*Xochipala*			
1500					Capacha	Ocos		
	ARCHAIC							

This book is intended as a general introduction to the history of Mesoamerican art and architecture for the student or traveler. I have made no attempt to write a complete archaeological study of the region, but I have drawn extensively on the researches of explorers and archaeologists. I have given special attention to recent discoveries. In the vast field of Mesoamerican art, many objects – even places – have been overlooked in favor of a careful consideration of what I hope is a representative selection of the finest pieces and sites.

Let me here point out some special aspects of pronunciation. In the sixteenth century, the letter *x* in the Spanish alphabet was pronounced like the phoneme *sh* in English today. In general, names in native Mesoamerican languages with this consonant require the *sh* sound – as in Yaxchilán, for example. Most *c*'s, regardless of the following vowel, are hard. When *u* precedes another vowel, the resulting sound is similar to a *w*, as in Náhuatl. The *l* of the *tl* in many Náhuatl words is very soft, and in many modern Spanish words taken from ancient Mexico, the *l* has been dropped. *Tómatl*, for example (the source of the English word for this fruit), has become *tomate*. Spanish words ordinarily have a stress on the final syllable unless they end in a vowel, *n*, or *s* (when preceded by an *n* or a vowel) – in which case the penultimate syllable is stressed. Hence, in this text, Uxmal has no accent, since the stress falls as it would in Spanish on the last syllable. To indicate stresses that differ from normal Spanish usage, accents have been added – for example, as in Dainzú or Ahuítzotl. The spelling of Teotihuacan (without accent) follows current usage. In general, vowels are pronounced as they are in Spanish. Throughout, the last Aztec ruler's name is correctly spelled Motecuhzoma, rather than the more popular Montezuma or Moctezuma.

My ideas about Mesoamerican art have been developed in the classrooms of Street Hall and with the useful insights of my students at Yale. I am also grateful to those who first taught me the history of Mesoamerica: Gillett Griffin, George Kubler and Michael Coe. From

them I have learned to see the great achievements of Precolumbian civilization from many points of view. My generous colleagues and friends in Mesoamerican archaeology and art history have shared ideas and speculations about their work through the years, and most recently, they have helped me to assemble the illustrations for this book. Most of all, I am indebted to Ed Kamens, who thoughtfully commented on this manuscript as I wrote it.

1 Gold repoussé disks were dredged from the Sacred Cenote, Chichen Itzá, at the turn of the century, and, like the paintings in ill. 153, they show Toltec warriors gaining domination of Mayas. The graceful human proportions suggest lingering Classic traditions.

Introduction

At the time of the Spanish Conquest, the Aztec ruler Motecuhzoma II kept tax rolls that show tribute paid from regions far to the north and south, from the limits of the barbarian ('Chichimec') north to the rich, cacao-producing coast of modern Guatemala. If we extend these limits across their respective lines of latitude, 14 to 21 degrees north, we define Mesoamerica, a cultural region united by use of the ritual 260-day calendar and a locus of New World high civilizations for over 3,000 years, from 1500 BC until the arrival of the Spanish. Although the Caribbean, lower Central America, northern Mexico, and the United States Southwest all had contact with Mesoamerica, they remained separate from it, with independent traditions stronger than those they shared with Mesoamerica. Among the high civilizations that flourished in Mesoamerica are the Olmec, Maya, and Aztec.

Despite its narrow latitudinal range, Mesoamerica is a place of great climatic and topographic diversity, depending on both altitude and rainfall. The tribute paid to Motecuhzoma II ranged from jaguars to eagles, from exotic bird feathers to gold and jade treasure, materials and resources found in greatly varying ecological zones. The high, cool valleys provide a sharp contrast to the steamy lowland jungles, and then as now the valleys attracted dense populations. Certain critical resources, such as obsidian, the 'steel' of the New World, were found only in the highlands, while cacao and cotton grew in moist, tropical regions. Trade in these goods brought highland and lowland Mesoamerica into constant contact.

Most civilizations of ancient Mesoamerica were located either in the highlands or lowlands, although the Maya inhabited both. The earliest civilization, that of the Olmecs, rose along the rivers of the tropical Gulf Coast. Most Maya development also took place in the lowlands, under tropical conditions ranging from rainforest to scrub jungle in Yucatán, Chiapas, Guatemala, and Belize. The ancient cities of Tula and Teotihuacan, as well as Tenochtitlan, Motecuhzoma's city, were located at high altitudes, and the center of highland life was the Valley

of Mexico. Modern Mexico City is built on top of the Aztec capital, and so the Valley of Mexico still dominates Mesoamerica as it did in antiquity.

According to some archaeologists, man first entered the New World 20,000 or 30,000 years ago, when he began periodically to cross what was then a land passage at times of low sea level from Asia to Alaska. At least some peoples had probably arrived within the boundaries of Mesoamerica 10,000 years later. Waves of migration continued to bring newcomers from the north into Mesoamerica, however, and this process ceased only with the Spanish Conquest. These waves affected the political geography of Mesoamerica, for each succeeding movement of peoples required re-adjustment on the part of the others. For instance, some think that Nahua speakers were late arrivals, entering the Valley of Mexico at the fall of Teotihuacan in the seventh century AD and perhaps in part responsible for that city's decline. These Nahua speakers soon dominated the highlands, developing first as Toltecs and later as what we know as Aztecs. Now lost in the shuffle are the people of Teotihuacan, whose ethnic identity remains unknown.

Little that is of interest to the history of art remains of the earliest colonizers of the New World. Fine projectile points, such as the Folsom, were crafted almost 10,000 years ago, and village life thrived throughout Mesoamerica by the second millennium BC. Only with the rise of Olmec civilization around 1500 BC, however, did art and architecture appear which combined ideological complexity, craft, and permanence.

Compared with the Old World, the Mesoamerican high civilizations seem to have lagged behind technologically: the wheel was never used for anything other than miniatures, and obsidian tools and weapons served in place of wrought metal ones. Lack of a draft animal may explain the absence of the wheel; obsidian, though easily chipped, in fact makes such a sharp instrument that it has been returned to modern use by ophthalmic surgeons! New World technology did in any case develop slowly. Metallurgy, for example, was first used in the ancient Andes about 3000 BC, and metalworking techniques were gradually passed north, traveling up through Central America and arriving in Mesoamerica about AD 800. Even then, however, metals did not replace stone and obsidian functional objects, and precious metals were worked instead into luxury goods: jewelry,

masks, and headdress elements – although gold never completely replaced jade as the most precious material. Hernando Cortés's men quickly learned that the people of Mesoamerica valued greenstones more than any other material, and gold was willingly traded for green glass beads. Throughout Mesoamerican history, the finest objects were worked from jade and other green materials, such as feathers. What has come to be called 'Motecuhzoma's headdress,' for example, *176* was made of long, green quetzal feathers, jade discs, and tiny hollow gold beads.

Long before the emergence of high civilization in Mesoamerica, man had domesticated corn, beans, squash, tomatoes, and chili peppers. Later he created innovative methods of high-yield agriculture that allowed human energy to be devoted to the arts. Poetry was written and recited. The movements of the heavens were charted. By Classic Maya times a calendar of interlocking cycles was in use that is as accurate as any known today, and far more accurate than the Julian calendar used by Cortés and his men. Monumental architecture, characterized by pyramidal constructions, fine jade and gold treasures, and intricate stone carvings all testify to the value placed on the arts in ancient Mesoamerica.

Because of its realistic system of human proportions and complex hieroglyphic writing, Maya art has long been preferred by modern students to the art of any other era in Mesoamerica, and its florescence has accordingly been labeled the Classic, c.AD 300–800. Preclassic and Postclassic were the terminology then assigned to the predecessors and successors of the Classic Maya. Despite the suggestion of value that these terms bear and repeated efforts to replace them with such conventions as those used in the Andes (e.g. 'Late Intermediate Period'), these terms survive, although the Preclassic is generally referred to today as the Formative. Formative, Classic, and Postclassic should now be considered chronological markers, not descriptive terms. The Olmecs flourished during Formative times, approximately 1500 BC to 100 BC. Some Classic civilizations, such as that of Teotihuacan, rose before the Classic Maya, and others, such as the Classic Veracruz florescence at El Tajín, persisted after the eclipse of most Maya cities in AD 800. By the tenth and eleventh centuries, many Postclassic traits had developed, but the most important of Postclassic peoples, the Aztecs, did not found their capital city of Tenochtitlan until AD 1325. By 1531, ten years after the Conquest, the Precolumbian

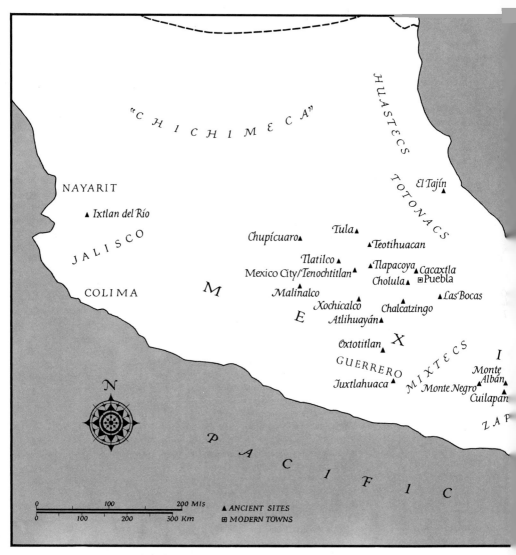

"CHICHIMECA"

HUASTECS

TOTONACS

NAYARIT

▲ Ixtlan del Río

El Tajín ▲

JALISCO

Chupícuaro ▲ Tula ▲

▲ Teotihuacan

COLIMA

Tlatilco ▲ ▲ Tlapacoya ▲ Cacaxtla

Mexico City/Tenochtitlan ▲ Cholula ▲ ⊡ Puebla

M

Malinalco ▲ ▲ Las Bocas

E Xochicalco ▲ Chalcatzingo ▲

Atlihuayán ▲

Oxtotitlan ▲ X

MIXTECS I

GUERRERO Monte

Juxtlahuaca ▲ Albán ▲

Monte Negro ▲ Cuilapan ▲

N ZAP

P

A C

I

F I C

| 0 | 100 | 200 Mls |
| 0 | 100 | 200 | 300 Km |

▲ ANCIENT SITES
⊡ MODERN TOWNS

2 Mesoamerica, showing sites mentioned in the text.

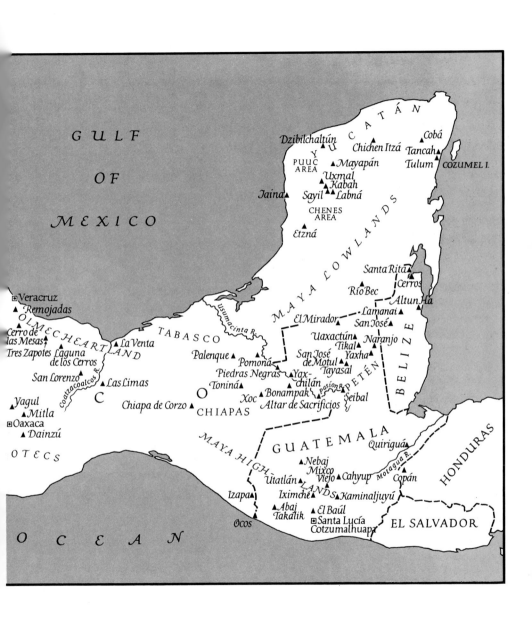

GULF

OF

MEXICO

YUCATÁN

Dzibilchaltún ▲ Cobá

Chichen Itzá ▲ Tancah

PUUC
AREA ▲ Mayapán Tulum

COZUMEL I.

Uxmal
▲ Kabah

Jaina ▲ Sayil ▲ Labná

CHENES
AREA

▲ Etzná

MAYA LOWLANDS

Santa Rita ▲
Cerros
Río Bec
Altun Ha

El Mirador ▲ Lamanai
San José ▲

BELIZE

Uaxactún Naranjo
Tikal ▲
San José Yaxha
de Motul ▲
Tayasal

▲ Veracruz
▲ Remojadas

OLMEC HEARTLAND

Cerro de
las Mesas ▲
Tres Zapotes ▲
Laguna
de los Cerros

San Lorenzo ▲

Coatzacoalcos

Yagul ▲
▲ Mitla
Oaxaca
▲ Dainzú

OTECS

TABASCO

Usumacinta R.

La Venta ▲

Palenque ▲
Pomoná ▲
Piedras Negras ▲
Toniná ▲

Las Limas ▲

C O

Chiapa de Corzo ▲

CHIAPAS

Xoc ▲

Yax-
chilán ▲

Bonampak ▲
Altar de Sacrificios

Pasión R.

Seibal ▲

PETÉN

GUATEMALA

Quiriguá ▲

MAYA HIGHLANDS

Nebaj ▲
Mixco
Utatlán ▲ Viejo ▲ Cahyup ▲

Motagua R.

Copán ▲

HONDURAS

Izapa ▲

Iximché ▲ Kaminaljuyú ▲

Abaj
Takalik ▲ El Baúl ▲
Santa Lucía
Cotzumalhuapa

EL SALVADOR

Ocos ▲

OCEAN

artist, architect, and patron produced little that could be identified with the Precolumbian, Mesoamerican tradition.

Not all the art and architecture of ancient Mesoamerica was lost from view as culture succeeded culture. Teotihuacan in the Valley of Mexico was visited regularly by Motecuhzoma II as a place of pilgrimage, and Western visitors have traveled there since the Conquest. Indeed the question of the recovery and understanding of the past preoccupied the Aztecs as much as it does archaeologists today (even if in a different way) – as recent excavations in the sacred precinct of Tenochtitlan have shown. Objects and treasures were uncovered by the Aztecs and brought to Tenochtitlan from throughout the realm, probably with little appreciation of their original significance. These objects were then deposited in caches, leaving yet greater archaeological and chronological puzzles for the twentieth century.

Sources record that Motecuhzoma II's grandfather, Motecuhzoma I, sent out wise men to seek the origins of the Aztecs, but no answers were found. The Spanish wondered whether these new people were truly human at all. Did they, so it was asked, derive from the same creation in the Garden of Eden as they themselves did? Explanations were sought for the isolation of a New World race: were the Amerindians a Lost Tribe of Israel or refugees from Atlantis? Did they, as Father José de Acosta suggested in the late sixteenth century, enter the New World by a land bridge from Asia?

Even after it was accepted that Mesoamerica was populated by the means Father Acosta had suggested, Mesoamerica continued to be identified as the recipient of culture from the Old World. Egypt, Phoenicia, China, and Africa have all been cited at one time or another as probable sources, usually on the basis of nothing more than vague resemblances. For example, the distinctive scrollwork of El Tajín has often been associated with the scroll designs made in China in the late Chou dynasty. In Mesoamerica, the origin and use of the double scrolls is linked to the game played with a rubber ball. Rubber (as well as the game it gave rise to) is native to the New World. The Chou dynasty ended in 256 BC, long before the advent of the Classic era in Mesoamerica. It seems more likely therefore that the scrolls were independently invented, as such conventions have been throughout the history of the world. It is worth noting that useful technologies – just what one would imagine would be most likely to be exchanged –

were generally not shared between Old and New Worlds. Recently, outer space has joined the list of improbable sources of high civilization in Mesoamerica. Many such claims are made by those unwilling to accept the modern Mesoamerican peasant as the descendant of creators of high culture. Although the question of contact remains unanswered in all its details, by and large it will be assumed here that ideas, inventions and civilizations arose independently in the New World.

The systematic recovery of ancient Mesoamerica by modern man did not begin until almost 300 years after the Conquest. Starting at the end of the eighteenth century and continuing up to the present, explorers have searched for the ruins of ancient Mesoamerica. With the progress of time, archaeologists have unearthed civilizations increasingly remote in age. It is as if for each century logged in the modern era an earlier stratum of antiquity has been revealed. Nineteenth-century explorers, particularly John Lloyd Stephens and Frederick Catherwood, came upon Maya cities in the jungle, as well as evidence of other Classic cultures. Twentieth-century research has revealed a much earlier high civilization, the Olmec. It now scarcely seems possible that the frontiers of early Mesoamerican civilization can be pushed back any further in time, although new work – such as in Oaxaca – will continue to fill in details of the picture.

The process of discovery often shapes what we know about the history of Mesoamerican art. New finds are just as often made accidentally as intentionally. In 1971, for instance, workers installing Sound and Light equipment under the Pyramid of the Sun at Teotihuacan stumbled upon a remarkable cave within the structure; this chance discovery has done as much for our understanding of the pyramid as any systematic study. Archaeology has its own fashions too: the isolation of new sites may be the prime goal in one decade, the excavation of pyramids the focus in the next; in a third decade, outlying structures rather than principal buildings may absorb archaeologists' energies. Nor should one forget that excavators are vulnerable to local interests. At one point, reconstruction of pyramids to attract tourism may be desired; at another, archaeologists may be precluded from working at what has already become a tourist attraction. Modern construction often determines which ancient sites can be excavated. In Mexico City, for example, the building of the subway initiated the excavations there and renewed interest in the old Aztec capital.

The study of Mesoamerican art is not based exclusively on archaeology. Much useful information about the native populations was written down in the sixteenth century, particularly in Central Mexico, and it can help us unravel the Precolumbian past. Although there are many sources, the single most important one to the art historian is Bernardino de Sahagún's *General History of the Things of New Spain*. A Franciscan friar, Sahagún recorded for posterity many aspects of prehispanic life in his encyclopedia of twelve books, including history, ideology, and cosmogony, as well as detailed information on the materials and methods of the skilled native craftsmen.

During the past thirty years, scholars have also made great progress in the decipherment and interpretation of ancient Mesoamerican writing systems, a breakthrough that has transformed our under-standing of the Precolumbian mind. Classic Maya inscriptions, for example – long thought to record only calendrical information and astrological incantations – can now be read, and we find that most glorify family and ancestry by displaying the right of individual sovereigns to rule. The carvings can thus be seen as portraits, public records of dynastic power. Mesoamerican artists did not sign their works, but master painters have now been identified among them, particularly on Maya vases. Knowledge of the minor arts has also come in large part through an active art market. Thousands more small-scale objects are known now than thirty years ago, although often at great cost to the ancient ruins from which the majority have been plundered.

The modern student of ancient Mesoamerica can still view the art and architecture of these civilizations with something of the awe of the first Spaniards to enter Tenochtitlan in 1519. The pyramids, palaces, bright colors, and customs, are unlike anything known before, especially from Europe, and dazzle us across the centuries. On present evidence, and in a very general sense, they all have their origins in the enigmatic Olmec civilization of the Gulf Coast.

The Olmecs

By 1500 BC or so, dense populations and successful agricultural techniques gave rise along the Gulf Coast to the civilization now known as the Olmec. The name 'Olmec' is derived from that of the historical people living in the same region at the time of the Spanish Conquest, and the ethnic identity of Olmec civilization itself remains unknown.

These early Olmecs established major centers along the rich riverine lowlands of the modern Mexican states of Veracruz and Tabasco, particularly at the sites of San Lorenzo, La Venta, Laguna de los Cerros, and Tres Zapotes. The area is often called the Olmec heartland, indicating that it was the source of Olmec culture. But, as we shall see, the Olmecs had an advanced social and economic system, with networks for commerce extending far to the west and south. The fertile Gulf plain probably allowed for an agricultural surplus, controlled by only a handful of individuals. From the art and architecture of their ceremonial centers (we know too little about Olmec domestic life to call their sites 'cities'), it is clear that social stratification was sufficiently advanced for a major emphasis to fall upon the monumental record of specific individuals, particularly in the form of colossal heads.

Long before radiocarbon dating could testify in mid-century to the antiquity of this culture, archaeologists and art historians had become aware of the powerful physiognomy of Olmec art through individual objects. Some identified this Olmec culture as the oldest of Mesoamerican civilizations, perhaps a 'mother culture,' as Miguel Covarrubias called it, from which all others derived. Eventually, much to the chagrin of Mayanists, the antiquity of Olmec culture was confirmed, and today many important elements of Mesoamerican art and architecture can be seen to have had a probable Olmec origin: pyramid building, portraiture, the making of mirrors. Some later deities probably derive from Olmec gods, and even the 'Maya' calendrical system was in use by peoples in the Olmec area during the Late Formative.

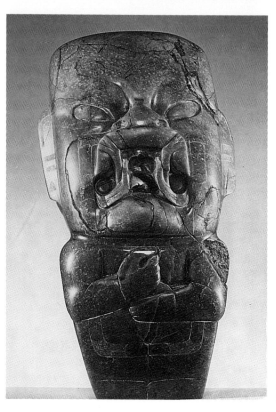

3 The Kunz Axe is a jadeite effigy 'were-jaguar' which grasps a miniature axe in its hands. Pieces of the precious greenstone have been cut away from the back of the figure. Middle Formative.

One of the first important Olmec objects to come to modern attention was the Kunz Axe, acquired in the 1860s in Oaxaca and then brought to New York City for display. It puzzled and intrigued investigators for years. It was clearly neither Aztec nor Maya: in fact, it had no features that could be linked with known Mesoamerican cultures, yet it had surely been made in Mesoamerica in antiquity. The axe exhibits many qualities of the style we now call Olmec: precious blue-green translucent jade, worked to reveal a figure in both two and three dimensions. The large-scale face was drilled to facilitate carving of the hard jade surface. More than half the celt is devoted to the creature's face – the open, toothless mouth, and closely set, slanting eyes which have often been likened to the face of a howling human infant. The viewer's attention first focuses on the open mouth, and then the more subtle qualities of the rest of the creature's body become evident. His hands are worked in lower relief, and in them he grasps a

18

miniature version of himself. Feet and toes are indicated only by incision, and incision also marks the face, ears, and upper body, perhaps to suggest tattooing, ear ornaments, and a tunic. For over two millennia the large, precious Kunz Axe was presumably kept as a treasure or heirloom. Sections were periodically cut from its rear, each slice perhaps carrying something of the power and magic of the whole. It was not until 1955, after several seasons of excavation at La Venta had produced many fine objects and a convincing series of radiocarbon dates in the first millennium BC, that objects such as the Kunz Axe were at last understood by scholars to embody the principles of the first great art style of Mesoamerica.

Early students of the Olmec style noticed a repeated pattern of imagery on the carved stone objects. Many 'howling baby' faces were found, and other faces seemed to combine human and jaguar features in a sort of 'were-jaguar.' Today, while the presence of jaguar imagery is still acknowledged, scholars have discovered that aspects of many other tropical rainforest fauna can be identified in the carvings. The caiman (a kind of alligator), harpy eagle, toad, jaguar, and snake all appear in the Olmec supernatural repertory. The sharp cleft in the forehead of many Olmec supernatural beings may be associated with the naturally indented heads of jaguars or toads, or it may simply indicate the human fontanele. David Joralemon has suggested that most of the motifs and images can be allocated to a few Olmec deities. The 'paw-wing' motif, for example, can be shown to be an element of the winged dragon, itself perhaps derived from the harpy eagle and caiman. This whole intricate symbolic code appears to have been in use from the first appearance of the Olmecs, and to have been employed consistently for a thousand years.

SAN LORENZO

The earliest Olmec center was probably the great earthen platform at San Lorenzo Tenochtitlan, where careful testing by Michael Coe and Richard Diehl in the late 1960s revealed that the entire complex was completely manmade, honeycombed with drainage systems, and perhaps planned in a zoomorphic shape. Freestanding architectural forms were limited to lowlying mounds, possibly including an early ballcourt of two parallel structures. At about 900 BC, 300 years or so after the founding of San Lorenzo, monumental sculptures at the site

4

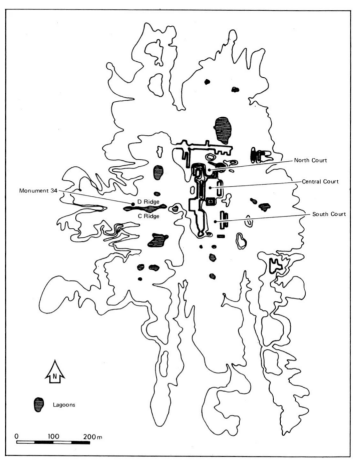

4 Plan of San Lorenzo. The ridged, man-made outline of the site might have been intended to resemble a great birdlike monster.

were systematically interred along the ridged outline of the earth-works, and many fine works were ritually 'killed.' Stone monuments were brutally defaced: great pits were bored into colossal heads, recognizable features were ground down on altars, and human 6 sculptures such as Monument 34 were decapitated. In some cases the work of destruction must have been as laborious as that of the original creation. The ritual interment was equally thorough: Monument 34, for example, was placed on a red gravel floor and covered with a specially prepared limestone fill.

20

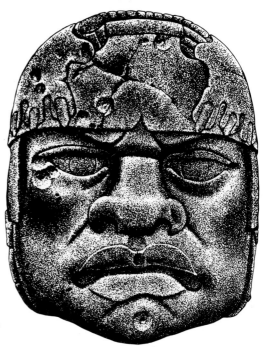

5 Colossal Head 5, San Lorenzo. Jaguar paws, perhaps emblematic of family lineage, drape across head and brow of this early Olmec ruler. Early Formative.

Among the early Olmec sculptures dealt with in this manner are masterful works representing humans and deities. Colossal Head 5, a freestanding basalt boulder, probably depicts a ruler of the region. Like small-scale works such as the Kunz Axe, the features of the colossal head were drilled, giving emphasis to the deep-set eyes, nostrils, and strong, slightly asymmetrical mouth. Eight round dimpled pits were bored into the head (one on the chin, giving this head a resemblance to Kirk Douglas!). Jaguar paws are shown draped over the figure's forehead, and perhaps the individual wore the feline pelt as a lineage title or symbol of office. (Much later, in Mixtec manuscripts and Maya inscriptions, many lords are named with a jaguar title.)

Ten colossal heads have now been found at San Lorenzo. The most recent discovery (Number 10) is much smaller in scale than Colossal Head 5. In fact both physiognomy and insignia vary from one head to another, reinforcing their individual identities. The raw basalt of Colossal Head 5 weighs about eighteen tons, and was brought from the Tuxtla Mountains, some sixty miles away, probably floated in on

5

rafts. The very process by which these sculptures were obtained and created informs us of the power held by these early kings.

6 Monument 34 from San Lorenzo also reveals the strong three-dimensional qualities of early Olmec art. Perishable and movable arms were no doubt once attached to the torso, and it is easy to imagine the torsion of the figure, from the tense, compact, lower body to the moving arms. The tucked right foot is like a coiled spring, about to be released. Special attention has been given to costume detail, and knots in particular are carefully drawn. The figure wears a concave disk as a pectoral decoration, which probably represents a concave mirror of the sort often recovered from Olmec contexts. Magnetic materials appealed to the Olmecs, and they worked ilmenite and magnetite into dark, shiny disks. Indeed, such objects were highly prized throughout Mesoamerican history. The polished surface not only showed one's reflection, but it also cast light; in addition it could be used by a diviner to foretell the future.

7 The so-called Wrestler, acquired in the nineteenth century near Minatitlan, Veracruz, has three-dimensional qualities similar to those of Monument 34, and may very well belong like it to the first phase of Olmec art. The human figure is completely released from the solid block in contrast to so much Mesoamerican sculpture. The artist must originally have intended it to be viewed from all sides. The long diagonal line of the figure's back and shoulders is as beautiful and commanding as the frontal view. The bearded face suggests a portrait,

6 Monument 34, San Lorenzo. Like many other monumental stones from the same site, this sculpture was first damaged – the head was lopped off – and then ritually interred. Early Formative.

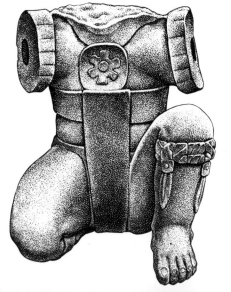
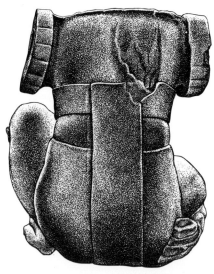

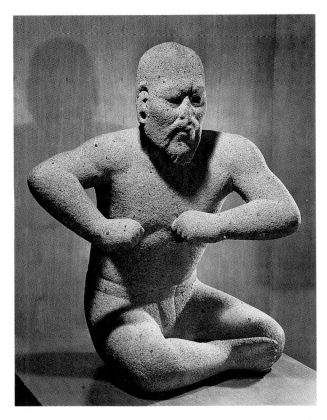

7 In both Monument 34, San Lorenzo (ill. 6), and in the Wrestler, as the sculpture here is known, the artists have captured the torsion of the human form. Early Formative.

and the Wrestler may once have been attired in perishable Olmec garb, further distinguishing him. These early Olmec monuments, of which this sculpture is typical, are among the most powerful three-dimensional portraits of the ancient New World. The Aztecs may have sought such antiquities when creating the vocabulary for their own art style, for it is only among their works that we find Mesoamerican stone freed to three dimensions in a comparable way.

Some interesting aspects of Olmec art found elsewhere are not seen at San Lorenzo. Two-dimensional workmanship played little part in its sculpture. Jade and serpentine are not in evidence either, and perhaps the rise and fall of San Lorenzo occurred before the Olmecs had gained access to greenstone sources, far to the south and west. What *is* clear is that a systematic destruction of San Lorenzo took place about 900 BC, and a new center of Olmec civilization was established at La Venta.

La Venta occupied a small, swampy island in the Tonala River, where oil derricks now mark the landscape. During the 400- or 500-year occupation of the site, both monumental architecture and earthworks of colored clays and imported stones were completed. The most important structure is a large pyramid toward the end of the northern

8 axis, in the form of what has been called a 'fluted cupcake.' This impressive mound may have been intended to echo the shape of a Central Mexican volcano, or it may simply be the eroded remains of a pyramidal platform – the first of a long series in Mesoamerican history – designed to raise a perishable shrine above the plaza level. The excavators discovered fine burials in the 1950s under other structures at La Venta, but they failed to penetrate this main mound, which may yet hold the tomb of an individual whose portrait appears as one of the four colossal La Venta heads. Parallel mounds lead north from the pyramid to a sunken courtyard flanked by massive basalt columns. Great basalt sarcophagi were found buried in the court. A smaller stepped pyramid with a single staircase then ends the axis to the north.

Following a bilaterally symmetrical pattern, great deposits of serpentine, granite, and jade celts were laid out and buried at the entrance to the sunken northern court. Some of the slabs formed

9 mosaic masks, such as the one illustrated here, a cleft-headed monster. Few of these constructions were meant to be seen, and most were buried immediately after they had been created. Such works show the relation of art to architecture for the Olmecs, and the interest in

8 Reconstruction of the major mound cluster at La Venta. The ceremonial center extends north from the 'fluted cupcake.' Ancient Olmecs placed structures in bilateral symmetry either side of the north–south axis.

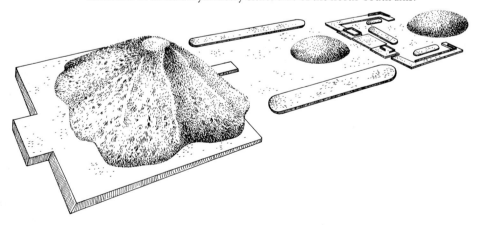

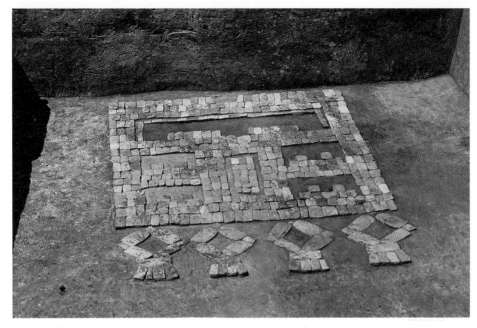

9 Made of large serpentine blocks, this abstract mosaic mask was systematically buried under colored clays and adobe bricks at La Venta. Tassels decorate the chin, and a cleft marks the top of the head. Middle Formative.

process over product. We can think of these works as a sort of 'hidden' architecture.

The whole of La Venta was laid out on a specific axis, eight degrees west of north. The Olmecs may have used a simple compass to achieve this orientation: at San Lorenzo the archaeologists recovered an object that they identified as just such a compass, made out of lodestone. Thus at La Venta we see established some principles of architectural planning that were repeated many times in the history of Mesoamerica: ceremonial cores laid out along astronomically determined axes; concern for natural topography – a sort of geomancy – which may have inspired the erection or overall orientation of individual structures (as for instance the 'fluted cupcake'). The plaza, a 'negative space' seen in the sunken court of La Venta, was as significant as the structure or 'mass' that defined it. The process of interring works of art may also have been as important as their execution. But above all the visual emphasis fell on the pyramid.

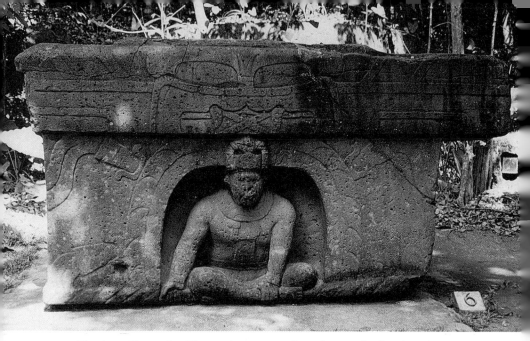

10 Altar 4, La Venta. An Olmec ruler emerges from the mouth of a schematic cave at the front of the stone. Such 'altars' may also have been thrones from which the reigning lord would have presided. Middle Formative.

The four colossal heads at La Venta were set as if to guard or protect the ceremonial core of the site, three to the south and one to the north. If erected during the reign of a ruler, such heads would have been effective images of royal power; if erected posthumously, fearsome memorials. The La Venta heads are somewhat broader and squatter in general than those of San Lorenzo, but like the latter they suggest a series of powerful men who held absolute sway over the populace.

Other sculptural types are known from La Venta, including so-called 'altars' (also present at San Lorenzo but all badly damaged) and stelae. Through time, the monuments of La Venta became increasingly two-dimensional and specific in terms of setting, costume, and ritual paraphernalia. These developments suggest a growing preoccupation with the status of the ruler. Altar 4 shows a ruler carved in rich three-dimensional form seated within a niche or cave, holding a rope wrapped round the circumference of the stone which binds two-dimensional captives in profile to the lord on the front. The lord's power is emphasized by his action, the holding of the rope, and by the technique, which subordinates the two-dimensional figures. Such

26

'altars' may well in fact have served primarily as thrones; the painted figure at Oxtotitlan (below), for instance, is represented sitting on a throne similar to Altar 4, and Altar 4 may once have been decorated in the brilliant colors of the painting. The surface of the monument is carved with a jaguar pelt, a royal cushion on the seat of power. *19*

Altar 5 may emphasize a different aspect of Olmec rulership. As on Altar 4, a highly three-dimensional figure, about life-size, emerges from a niche on the front of the monument, while two-dimensional figures are shown on the sides. The central figure in this instance, however, holds out an infant, who lies limp in his lap. The Las Limas figure (see below) is also of an adult and infant, although there the child is clearly supernatural. The representation on Altar 5 may reflect a concern with legitimate descent, and perhaps the ruler is displaying an heir, as in some Maya paintings and carvings. The subsidiary figures on the sides of Altar 5 are also adults and infants, humans who hold rambunctious Olmec supernatural children.

On Stela 3, two men face one another while small figures, perhaps *11* deities or ancestors, hover above. The man at left carries a baton, and

11 Stela 3, La Venta. Against a schematic background, two Olmec lords meet. The beard and towering headdress of the figure at right has earned this monument the nickname of 'Uncle Sam.' Middle Formative.

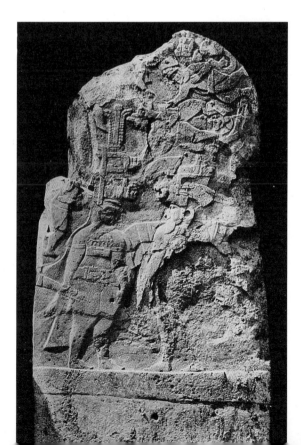

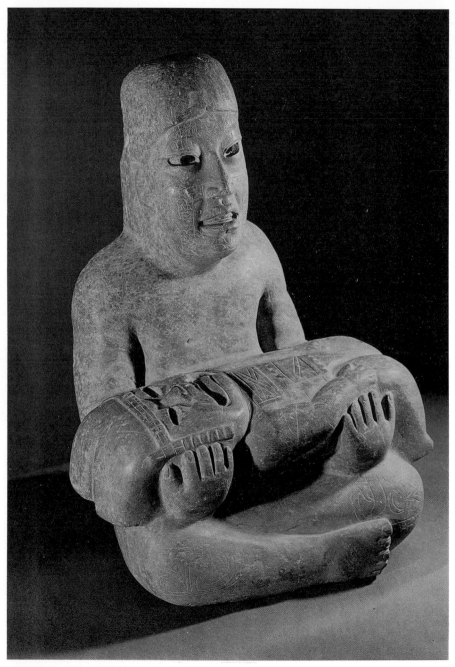

12 Mexican peasants who found this large greenstone sculpture near Las Limas, Veracruz, believed it to be a madonna and child. In fact, it represents a youth holding an Olmec rain deity in his lap. Middle Formative.

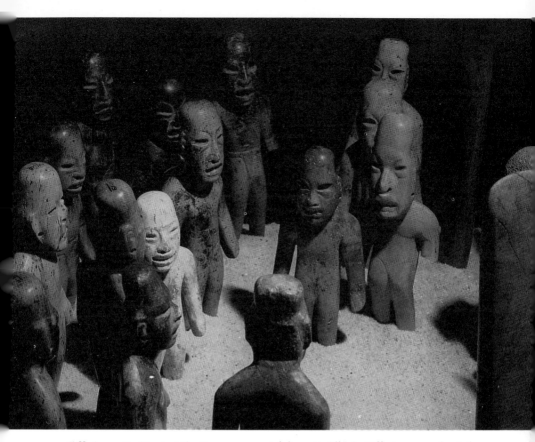

13 Offering 4, La Venta. Like the monumental deposits (ill. 9), Offering 4 was buried after being laid out in just this configuration. The single figure of granite (foreground) appears to be regarded in a hostile fashion by those made of precious greenstone. Middle Formative.

the one at right wears what appears to be a beard, winning for this monument the nickname 'Uncle Sam.' Indeterminate shapes, perhaps architecture or landscape, appear behind the two men, thus suggesting that an historical event is being recorded, not just historical figures. This is a new preoccupation at La Venta, one not emphasized at San Lorenzo, and it may be a precursor of historical records written in a script. Even the notion of carving an upright finished stone slab is new, introduced here for the first time.

Offering 4 at La Venta records history in a different fashion, as well *13* as in a different medium: jade. Jade was missing from the excavations

at San Lorenzo, and its use here may date the Olmec expansion to the areas where the raw material is found. Six celts and fifteen jade and serpentine figurines were specifically set out in Offering 4 so that the one figure made from a base stone – granite – faced the group made from precious stones. The celts placed behind recall the columns of the La Venta sunken court where this offering was laid, and it is entirely possible that the scene recreates a judgment against the lone figure that once occurred within inches of its small-scale, tableau-like memorial. About a century after its interment, this offering was uncovered and then reburied, as if an important event needed to be reconfirmed. The later exhumation was made with precision, and perhaps records were kept. Other individual, sinewy jades – warm, plastic, and almost feline in their posture – have been found, and were among the objects that attracted the attention of collectors early in this century. It is likely that they came from similar groupings elsewhere.

12
Of all Olmec greenstone sculptures, the largest and most beautiful is the Las Limas figure. When it was discovered in 1965, villagers considered it a miraculous madonna, and it was brought to the church of Las Limas. The sculpture, however, is no Christian mother and child. A youth, neither specifically male nor female, holds an infant in his lap, a reference, perhaps, to legitimate descent. The infant has the monstrous face of the Olmec rain deity, and the knees, shoulders, and face of the larger individual are incised with the faces of other supernatural images from the Olmec canon.

THE OLMEC FRONTIER

By the time of La Venta's apogee, about 600 BC, Olmec links had been forged with Central Mexico, west to the modern state of Guerrero, and far to the south, perhaps in search of blue-green Costa Rican jade. In their expansion, the Olmecs came in contact with established regional cultures. Strong indigenous traditions of terracotta figurine-
14 making had already taken firm root, for example, at Xochipala, Guerrero, where solid, life-like figurines were in the repertoire as early as 1500 BC. Expressive gestures, naturalistic forms of hair, breasts, and plastic arms and legs, make the early Xochipala figures among the finest ceramic works of the ancient New World. Many of the figurines, both male and female, are naked, and they may once have been dressed with perishable garments.

15 A vessel in the shape of a fish from Tlatilco. Ceramics recovered from this brickyard on the edge of Mexico City first revealed the spectrum of terracotta works of the highlands. Animal effigies, particularly of ducks and fish, are common. Other vessels show the schematic symbols of Olmec art. Middle Formative.

14 *(above)* A ceramic female figure from Xochipala. The surface of this extraordinary portrait is flecked with hematite. Perishable garments probably once adorned her. Early Formative.

16 A hollow 'baby' ceramic figure from Las Bocas. A rocker-stamp motif associated with an Olmec deity runs down its spine. Early/Middle Formative.

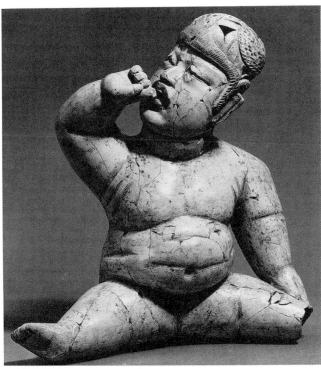

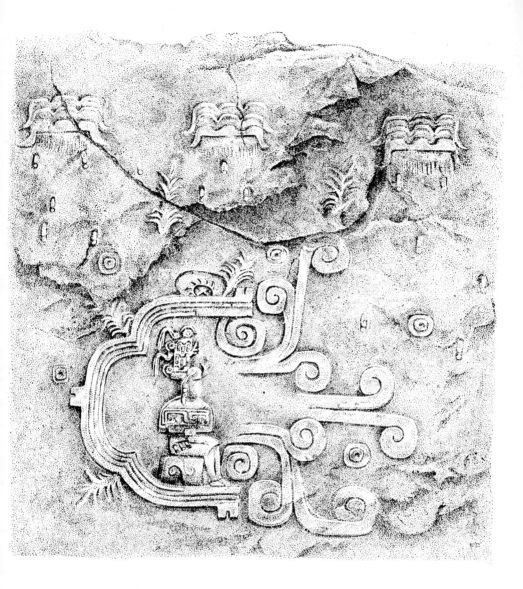

17 Petroglyph 1, Chalcatzingo. Set within a cave mouth in a schematic landscape where maize flourishes, an Olmec ruler sits on a throne. Middle Formative.

18 Petroglyph 4, Chalcatzingo. Supernatural jaguars maul fallen men. The foreshortened human forms may have been sketched in charcoal from cast human shadows. Middle Formative.

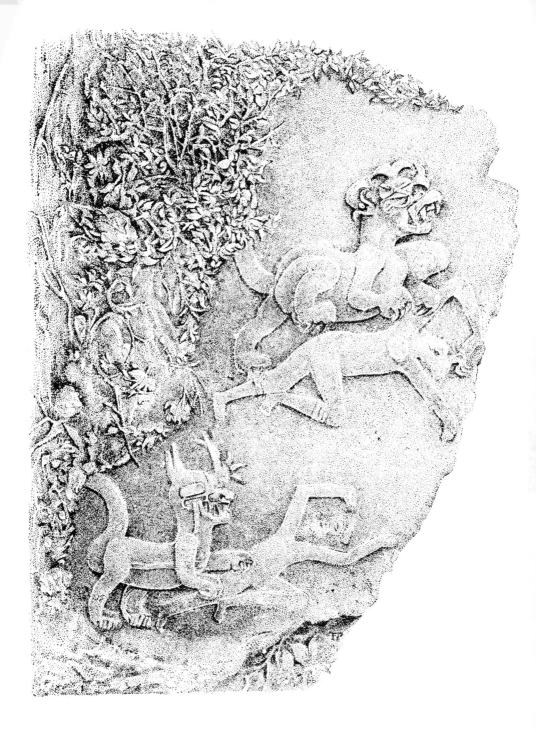

At Tlatilco, on the outskirts of modern Mexico City, a rich cemetery revealed a figurine cult perhaps dedicated to fertility at this time. Swelling breasts and thighs were emphasized, as well as narrow waists. The hair and face received great attention, and these figurines are often known as 'pretty ladies.' Others are grotesques, and their split 'Janus'-like faces appealed to artists of the early twentieth century.

The Tlatilco 'pretty ladies' were found in association with large Olmec-style ceramic figures, known also from Las Bocas, Atlihuayán, Tlapacoya, and other places in Central Mexico – incomplete ones have been discovered at coastal sites too. The fine-grained, plastic white kaolin of Las Bocas may have freed its artists to produce the finest of these figures. Although many of the sculptures seem to be babies, the loose, hanging flesh also suggests age, perhaps not unlike late medieval representations of the Christ child, where both age and infancy are portrayed. The hollow figure from the Metropolitan
16 Museum sucks his thumb; his hair is groomed in the shape of a helmet. A red cross-bands-and-wing motif runs down this baby's back, perhaps made by a rocker stamp. Similar motifs carved on ceramic vessels, such as the hand-paw-wing, are repetitions of the constant Olmec symbolic system, and are suggestive of writing.
15 Other pots were worked as three-dimensional effigies, such as the fish illustrated here.

Another important class of Olmec works of art was identified in the 1930s at Chalcatzingo, Morelos. Here strange figures and fantastic creatures were carved in three distinct groups on the surface of a great natural rock formation, an igneous plug that marks a pass through the eastern end of the modern state of Morelos and the access to the rich Valley of Puebla. The most striking of these carvings is known locally
17 as 'El Rey,' a representation of an enthroned ruler (perhaps female, given the skirt the figure wears). This may be an Olmec overlord or governor, who could well reflect the extent to which power was imposed by the Olmecs in this frontier region, far from the Gulf Coast and the heartland of their civilization. The lord sits within a section of a cave or niche, like that depicted three-dimensionally on Altar 4, La
10 Venta. In the petroglyph, the cave lies within a schematic landscape where phallic raindrops fall on young maize plants.
18 Petroglyph 4, on the other hand, shows large felines attacking human figures with supernatural characteristics. The foreshortened human

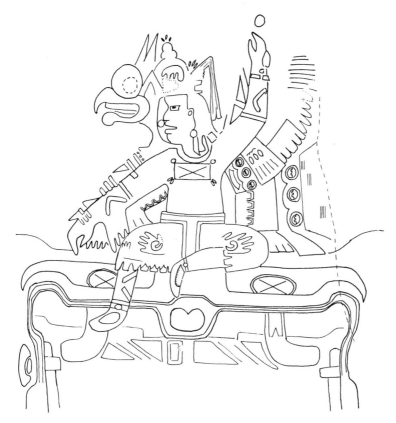

19 A cave painting at Oxtotitlan. The ruler's face can be seen in X-ray fashion, within a great bird suit. Drawing by David Joralemon. Middle Formative.

forms suggest that their outlines might first have been traced from cast human shadows. The petroglyphs at Chalcatzingo are remarkably varied: some portray warring Olmecs, others simple natural motifs, such as squash plants.

The earliest Mesoamerican paintings survive only in caves, their condition and presentation not unlike Palaeolithic cave art in France, although not on the same magnificent scale. Fine examples have been found at Oxtotitlan and Juxtlahuaca caves in Guerrero. One from Juxtlahuaca shows what may be the mating of a human male with a female jaguar, perhaps the source of the race of 'were-jaguars' so

35

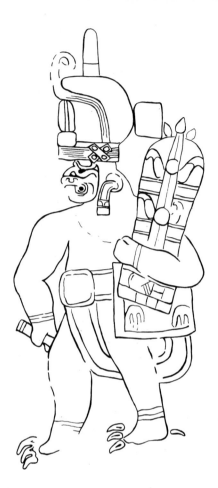

20 This rock carving of an Olmec lord bearing a bundle was discovered far from the Olmec heartland at Xoc, Chiapas. Reconstruction drawing. Middle Formative.

common in Olmec imagery. A badly battered sculpture from the Olmec heartland also shows such mating, but in that instance a human female and a male jaguar are represented.

19 A large painting at Oxtotitlan, 3.8 × 2.5 meters, set 10 meters over the entrance to the cave, depicts an Olmec lord wearing a great green bird suit, cut away in X-ray fashion so that we see his face and limbs. The bird's eye was probably inlaid with a precious material, and the lord sports a jade noseplug. His throne resembles Altar 4 at La Venta. The palette of these early Olmec paintings was broad, including bright greens and reds, although simpler black-on-white paintings have also been found.

Far to the south, at Copán, Honduras, kings of this period, whether Maya or Olmec, were buried with Olmec pomp: their paraphernalia consisted of jade celts, jade necklaces, and vessels worked with Olmec symbols. Also distant from the heartland, at Xoc, Chiapas, an Olmec petroglyph was discovered depicting a male Olmec carrying a great burden. One wonders what this lord bore in his bundle: could it have held cult objects, perhaps even a sculpture like the Kunz Axe? Whatever the content of the bundle, the very presence of Olmecs so far from their coastal origins raises the possibility of widespread dissemination of Olmec culture. In establishing contact from Honduras to Guerrero, the Olmecs came close to defining the geographic boundaries of Mesoamerica.

During the Late Formative, and certainly before 100 BC, the once successful Olmec culture weakened and collapsed for reasons that are still unknown. The first of the great Mesoamerican civilizations to rise, flourish, and fall, it influenced all the civilizations that were to follow.

The Late Formative

The Olmecs continued to hold sway in some areas into the Late Formative, but the great centers of La Venta and San Lorenzo were already in eclipse by the end of the Middle Formative. Monuments were destroyed and earthworks abandoned. Olmec contacts with distant regions apparently broke down; the ceramics of Central Mexico, for example, were no longer infused with the symbolism of elite Olmec culture. Of the major Olmec sites known today, only Tres Zapotes enjoyed sustained occupation and development during Late Formative times (that is, 400 BC–100 BC and continuing on here for perhaps 200 years more). Yet there was a minor florescence of Olmec culture in highland Guatemala at this time, and several smaller but still colossal heads were made. Even more surprisingly, perhaps, it was at just this point that early Mesoamericans made their most lasting contribution to New World high civilization: the creation of sophisticated writing and calendrical systems. The very disorder of the period may have fostered the development of a uniform symbolic system.

The disintegration of Olmec long-distance trade routes probably made it possible for strong regional and ethnic styles of art and architecture to develop under independent local elites. It was in this era that the Zapotecs first flourished at Monte Albán, Oaxaca, subsequently their capital for 1500 years. In West Mexico, the shaft tombs of local elites were filled with fine ceramics. Among the Maya, the first cities of the Petén were built. But the most interesting art and architecture of the Late Formative appeared along the Belize coast and in the highlands of Guatemala and Chiapas.

WRITING AND CALENDRICAL SYSTEMS

The roots of all Mesoamerican calendrical systems – highly varied though they subsequently became – lie in the Late Formative era. Two such means of recording time, the 260-day calendar and the 365-day calendar, evolved at the very beginning of the period and were

generally used simultaneously. In terms of intellectual achievement, however, the most important system was a slightly later development, the continuous record called the Long Count, used in conjunction with the 260- and 365-day calendars. An appreciation of the intricacies of all three systems as they appear in ancient inscriptions is necessary, not only to help us date monuments, but also to understand the concepts of time and thought expressed in Mesoamerican art and architecture.

The 260-day cycle is the oldest and most important calendar in Mesoamerica. Stone monuments in Oaxaca seem to indicate its use perhaps as early as the sixth century BC (although the inscriptions have yet to be deciphered in detail), and it is still employed in Guatemala today for ritual divining. Indeed, use of the 260-day calendar effectively defined the limits of high civilization in ancient Mesoamerica and provided an aspect of cultural unity. Yet its origins remain obscure. Some have noted that 260 days is the period of time that elapses between solar zenith passages (when the sun lies directly overhead at noon) at a latitude of 15 degrees north – the latitude along which the important sites of Izapa and Copán lie. Zenith passage is a relatively easy phenomenon to observe in the tropics, but it seems an unlikely basis for a calendar first recorded to the north of the 15-degree latitude. A much more fundamental unit of 260 days in the human life cycle is the length of gestation, from first missed menstrual flow to birth. Mesoamerican peoples were named for the day of their birth in this calendar and were perceived as having completed a 260-day round at birth, so this seems a considerably more likely origin for the 260-day cycle.

The 260-day calendar was not subdivided into weeks or months as our year is, but into a round of 20 different day names. Counting systems around the world on the whole use a base of either 10 or 20, depending upon whether fingers or fingers and toes are used, and throughout Mesoamerica the base was vigesimal rather than decimal. But the 20 day names were also associated with a cycle of 13 day numbers, which ran at the same time. Each day, therefore, had one of 20 day names and one of 13 day numbers, so the cycle would take 260 days to complete.

This cycle always had its own name in various Mesoamerican languages: the Aztecs, for example, called it the *tonalpohualli*, and the written version of the cycle – the fundamental tool of the diviner – was

called the *tonalamatl* (*amatl*, or *amate* in modern Spanish, refers to the fig paper on which such a manuscript was often written). The 260-day system is the 'almanac' of Mesoamerican calendrical cycles.

A child was named for the day on which he was born in this cycle – 13 Monkey, for example, in the *tonalpohualli* – and the diviner or calendar priest was consulted to study the augury both for that day and for the period of 13 days within which it fell. According to the Aztecs, some entire such periods were afflicted by either certain shortcomings or gifts. Those born under the period of 1 Death, for example, would suffer drunkenness. To try to alter the prediction, a naming ceremony was often held on a more auspicious day.

In conjunction with the almanac a 365-day calendar was used. This corresponded roughly with the true solar year, and was divided into 18 'months' of 20 days each, plus 5 'nameless' days at the end of the year. Each group of 20 days had its own month name, and was linked with a number from 1 to 20 or 0 to 19, depending on the region. Names were also given to each year – usually one of the 4 possible day names (along with its number) of the almanac that occurred on the last day of the eighteenth month. For example, in Aztec times, Quetzalcóatl was awaited in each year named 2 Reed. There is no evidence that the approximate solar year was ever corrected to allow for the extra days in the true tropical year. Without the addition of leap days, the 365-day calendar wandered, eventually passing from one season to the next, and requiring movable agricultural feasts.

When the 260-day calendar and 365-day calendar were set in motion, it took exactly 52 years of 365 days for a given day to recur. This period of 52 years is called a calendar round, and we may liken it to a century in our own system. The end of this 52-year cycle was widely celebrated, particularly by the Aztecs, who held a New Fire ceremony at its completion. The 5 nameless days which preceded the end of the cycle were especially dangerous: the gods might choose that moment to end life on earth. Certain behavior was required: all pots had to be smashed, pregnant women kept indoors, and fires doused. At midnight before the first day of the new year, a sacrificial victim had his heart ripped out, and there, in his open chest, a flame was started with a fire drill. The burst of light assured the light of the morning sun and the opening of a new 52-year cycle.

The calendrical systems described so far were based on relatively short periods of time that could be easily related to human experience.

21

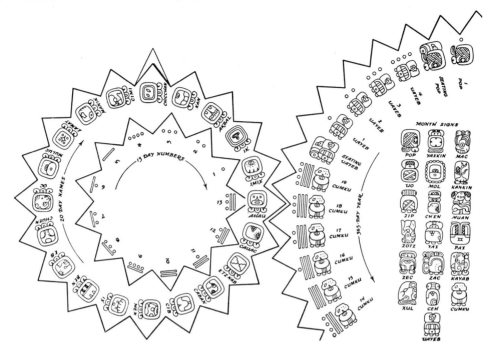

MONTH SIGNS

21 All Mesoamerica observed the 52-year cycle, created by the intermeshing of the 260-day calendar (left) and the 365-day calendar (right). It is drawn here as a system of interlocking cog wheels and follows standard Maya notation, although the days and months had different names and symbols in each culture.

The 260-day calendar was perhaps the most basic to Mesoamericans. It is the first one for which written records survive, and it is the one still in use today among some Highland Mayas. It is composed of 20 day names (outer wheel) and 13 day numbers (inner wheel), both of which rotate endlessly. It takes 260 days for all the combinations to occur.

The 365-day calendar is composed of 18 months, each of which has only 20 days, numbered 0–19 or 1–20, depending on the region, and the 5 unlucky days (known as Uayeb among the Maya). In this larger wheel, the end of the month of Cumku and the 5 unlucky days (the Aztec called them *nemontemi*, or 'nameless' days) are shown – other month glyphs are at right.

Here, 13 Ahau (left) and 18 Cumku interlock. It will take 52 × 365 days (in other words, 52 years) before the cycles will all reach this point again. This is the calendar round.

It is true that the completion of an entire round of 52 years by any individual would have meant a very long life in Mesoamerican terms, but it was possible to survive to this age, barring death in infancy, war, or first pregnancy.

Over longer periods of time, dates in the calendar round may have been difficult to order chronologically, since any given year name

recurred once every 52 years. The use of the last two digits of our year calendar produces a similar effect: is '49 a reference to the California Gold Rush or the beheading of Charles I? At some point during the Late Formative, perhaps to eliminate just such ambiguity in historical records, another calendrical system, the Long Count, was introduced, and it was perfected by the Maya in Classic times.

Long Count dates record the complete number of days elapsed since a mythological starting point corresponding to 3114 BC in our calendar – hence the alternative modern name, Initial Series dates. The Maya later held that the 'zero' date fell within an era of divine activity, as does the zero date of our calendrical system. In the Long Count, time was normally recorded in periods of 400 years, 20 years, years (in this count all years have 360 days), 20 days, and days – i.e. to five places running from largest to smallest. Most dates of the Late Classic period, for example, begin with 9 periods of 400 years, and the date 9.10.0.0.0 can be correlated with the year AD 633. The achievement of this calendar was the ability to pinpoint events in time without ambiguity. Particularly for the Maya, this very record was a focus of artistic achievement, and Maya artists transformed what could have been simple notations into beautiful works of calligraphy. Although other cultures must have known of the Long Count, its use was limited to the Olmecs and Maya.

Long Count dates can be easily read. They were always placed at the beginning of inscriptions and recorded in a system of bar-and-dot numeration, in which the bar equals 5 dots. The development of the null cipher, a placeholder similar to our zero, was a crucial step forward intellectually. In the history of mankind, it was achieved only in the Indo-Arabic and Mesoamerican numerical systems. The Maya generally represented this symbol as a maltese cross, perhaps derived from the human body with all four limbs outstretched, indicating the 20 digits. In Postclassic manuscripts a shell is used for the null cipher, and in Classic Maya inscriptions a head or full-figure variant could also be substituted.

The earliest known Long Count date is 36 BC, recorded on Stela 2 at Chiapa de Corzo. The cessation of the system in the tenth century (AD 909 at Toniná is the last date known) generally marks the close of the Classic era. The *katun* (the period of 20 years) count persisted up to the sixteenth century, thus allowing a correlation to be established between the Mesoamerican and European systems.

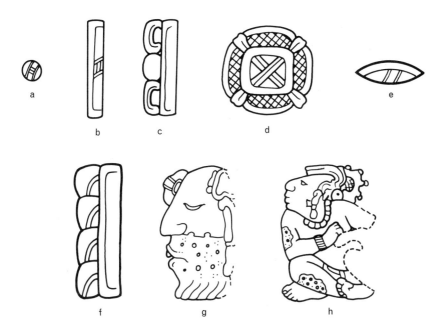

22 The Maya used three basic symbols in their numbering system: a dot for
one (a), a bar for five (b), and to represent the null cipher similar to our zero a
maltese cross (d) during the Classic (which became a stylized shell (e) in the
Postclassic). The number six, for example, was made up of a dot and a bar
combined (c)–the space either side of the dot being filled by so-called
'spaceholders' which are not counted.
 As well as this standard numeration, the Classic Maya sometimes
introduced a head or full figure as variant: the number nine, for instance, in its
common form (f) (four dots and a bar) also appeared as the head in (g) or the
full figure in (h).

The importance of this accurate calendar to the art historian and
archaeologist should not be underestimated: when inscriptions are
present, the calendrics precisely document Classic Maya chronology
in a way not known elsewhere in the New World. A subtle difference
of style between monuments, for instance, can be shown to reflect a
ten-year difference in their erection, and this knowledge can be used
subsequently to date monuments and ceramics without such calendri-
cal inscriptions.

The Maya recorded hundreds of dates, generally of the Classic
period, but on occasion they reckoned mythological dates deep into

the past and future. In some inscriptions, calendrical information can occupy a third to a half of the glyphs. For years, scholars made progress in deciphering only the calendrical content of Maya writing. This led some of them, particularly Sir Eric Thompson, to posit that the writings were purely calendrical, glorifications of the passage of time itself. The same thinking prompted the notion that the human figures carved on Maya monuments must have been anonymous calendar priests. But, as we shall see, Thompson's hypothesis and its corollary that the Maya were a pacific people, their lives overseen by astronomer priests, have been abandoned as recent scholars have determined the meaning of non-calendrical inscriptions.

During Late Formative times, non-calendrical writing also ap-peared, both in association with and independent of calendrical *27* statements. Glyphs occur with human figures, perhaps as names or events, and in long passages. Little progress has so far been made in reading these non-calendrical Late Formative glyphs. Some of the earliest Maya inscriptions, however, are recarved Olmec objects, as if an Olmec heirloom were later worked with a new owner's name. A fine Olmec greenstone pectoral now at Dumbarton Oaks, for example, was incised with a long Maya text, perhaps at the end of the Late Formative.

When John Lloyd Stephens visited the Maya area in 1839, he found many inscriptions that he believed represented a single system used from Copán in the south to Chichen Itzá in the north. One day, he felt sure, a new Champollion would rise to the challenge of translating the names and places of the ancient kings of the New World. About 120 years later, and 80 years after Long Count dates were first cracked, two breakthroughs began to fulfill his prophecy. They also began to explain just why the Maya (and probably the Olmecs and Zapotecs before them) were so absorbed in chronological reckonings: they needed a means to fix historical information firmly in time. Heinrich Berlin first noticed in 1958 that a particular glyphic compound closed many Maya texts, yet the main element of this cluster varied from site to site. It quickly became evident that these glyphic compounds must refer either to place or family, if not both. (Similarly the name York, for example, refers to both a lineage and a place in England.) These *23* glyphs have now been identified for most Maya sites with inscrip-tions. The text of Naranjo Stela 24, for example, includes two different 'emblems,' as Berlin called them. One might suspect trade,

44

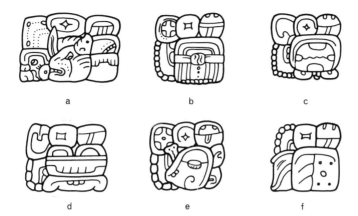

23 Maya emblem glyphs indicate lineage or place. Here is a sampling: (a) Copán (an Early Classic form); (b) Tikal; (c) Palenque; (d) Yaxchilán; (e) Bonampak; (f) Piedras Negras.

warfare, alliance, or marriage as the motivation for such an inscription, and in fact the hefty woman depicted on the monument was a foreigner who married into the Naranjo dynasty. Both the emblem of Naranjo and that of her place of origin appear in the text.

At about the same time that Berlin was working on emblems, Tatiana Proskouriakoff explained how the pattern of dates at Piedras Negras implied their historical nature. She hypothesized verbs – to do with birth, accession, capture, and death, among other things – and names – 'Bird Jaguar' and 'Shield Jaguar' at Yaxchilán, for example. She also showed the importance of royal women, and documented a 'female indicator' glyph.

A look at Yaxchilán Lintel 8 shows why she began to suspect that *24* such inscriptions had historical content. A skull within a beaded cartouche is inscribed on the thigh of the captive at right: this same glyph appears as the fourth glyph in the text above, left. The first two glyphs yield a date in AD 755; given modern Maya syntax and the frequency of the third glyph in passages associated with armed men and captives, Proskouriakoff then hypothesized that the third glyph was a verb, probably meaning 'to capture,' since that activity is depicted. To the right, the text continues. The last glyph could already be identified as a Yaxchilán emblem; the glyph preceding it is a

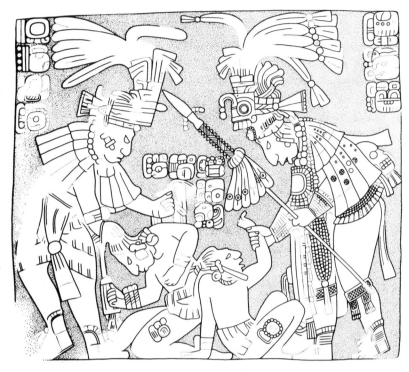

24 Lintel 8, Yaxchilán. Bird Jaguar, at right, captures 'Jeweled Skull,' whose name is emblazoned on his thigh and at the bottom of the column of glyphs at left. Bird Jaguar's name is the second in the column of glyphs at far right, and it is followed by the Yaxchilán emblem glyph. Late Classic.

jaguar head with a small bird superfixed. Based on its frequency in texts dating from about AD 750 to 770, Proskouriakoff proposed this glyph to be the ruler's name in that era, and she called him 'Bird Jaguar.' Thus, if we ignore the caption material that appears in the middle of the scene, the text might be paraphrased: 'On 7 Imix 14 Tzec [in AD 755] was captured Jeweled Skull by Lord Bird Jaguar, of the Yaxchilán lineage.'

By this time studies had also been completed by Yuri Knorosov in Leningrad, who was able to show the phonetic values of many glyphic elements. Unlike Proskouriakoff or Berlin, who worked with Classic inscriptions, Knorosov took the sixteenth-century manuscript of

Diego de Landa, bishop of Mérida, and the three Postclassic Maya manuscripts as his focus of study. Landa had asked an educated Maya source to write Maya characters beside the letters of the Spanish alphabet. In this way, some thirty-odd Maya glyphs had been written down. Knorosov used these to begin to determine the phonetic value of the texts.

The capture glyph in the passage decoded by Proskouriakoff was one to which Knorosov had already turned his attention. He read the three elements of the glyph at A3 as *chu-ca-ah*, or *chucah*, literally the third person of the verb 'to capture' in many Maya languages today. With the publication of Proskouriakoff's work, the phonetic interpretations of Knorosov began to gain acceptance.

These initial understandings of the nature of the Maya script changed the way scholars perceived of the ancient Maya. The first group of glyphs deciphered showed them to have been territorial; the next stressed the role of individuals and their quest for power at various Maya cities. With a few strokes of the pen, the notion of a peaceful Maya had become obsolete and insupportable. Subsequently, scholars have begun to seek evidence for similar patterns of behavior throughout Mesoamerica.

The Zapotec writing system was also used to record names and places. Names were indicated by their position in the 260-day calendar, and the places recorded were those conquered by the successful lords of Monte Albán. The script appears to have been ideographic, with semantic indicators.

25, 27

By means of pictographic manuscripts, the Mixtec of the Postclassic (and probably earlier as well, but the manuscripts no longer exist) recorded their genealogical histories. Names are either the calendrical day names or pictographs which first appear attached physically to given individuals. Events are symbolized by widely understood signs: an umbilical cord denotes birth, a couple seated on a reed mat marks marriage. With this kind of record, the reader must provide the words to a story for which places, dates, events, and persons are specifically indicated.

180

Among the Aztecs, dates and pictographic writing also prevailed. Writing was used by individuals for divining manuscripts and genealogies and by the state for keeping track of the prodigious tribute collected from the whole of Mesoamerica. At the time of the Conquest, Aztec writing had become sufficiently sophisticated for it

to have both phonetic indicators and a type of rebus writing, in which homophones are substituted. Nevertheless, the elegant poetry recited at the time of the Conquest was probably not written down until the introduction of the Roman alphabet, although a guide with cues could have existed.

Late Formative Art and Architecture

MONTE ALBÁN

The most spectacular early development in Oaxaca took place at Monte Albán. The city was founded at the beginning of the Late Formative, presumably as the Zapotec capital. A mountainous outcrop overlooking three important valleys of central Oaxaca was reworked into a great manmade acropolis. In the first era of occupation, a main axis running roughly north–south was established and at least some structures were erected to define the main plaza as the ritual core.

61

Monte Albán has no natural source of water, and one might legitimately surmise that it took an advanced social organization to sustain a community high above the fertile valleys below. Various ideas have been put forward to explain the selection of this remote mountain for settled life, and all depend upon the most important early temple there, the Temple of the Danzantes, and the nature of its reliefs. Richard Blanton has suggested that Monte Albán was chosen as a site of pacific unification, while others have seen it as a sanctuary or fortress.

25

The Danzantes, or 'dancers,' were so named in the nineteenth century because of their free, loose postures. In Late Formative times, over 300 individual slabs were carved with these figures, and about 140 were incorporated into the Temple of the Danzantes. About the same number were set into Mound J, a slightly later structure, and others were re-used in later contexts. In the Temple of the Danzantes, the slabs are set so that some face out, away from the main plaza, while others line a narrow passageway and yet others flank the main façade. Some, particularly those considered 'swimmers,' form a flight of stairs. No single figure is arranged with regard to another, insofar as can be determined now.

Each slab is different in its imagery, but all were worked in a simple

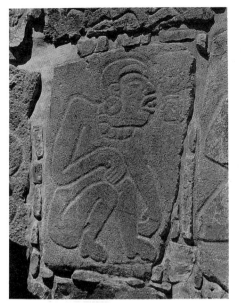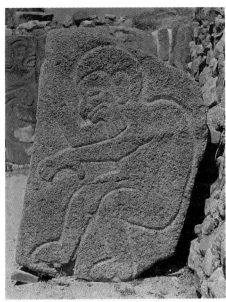

25 Danzantes at Monte Albán. These limp, mutilated figures, long thought to be 'dancing,' may be sacrificed captives of war. Monte Albán I.

incised technique with little relief. One assumes that the carver simply followed a charcoal sketch made directly on the stone. Most bodies are shown frontally or in three-quarter view, while the heads are in profile. All are male. Hands and feet hang limp. The closed eyes of most figures indicate that they are dead. Although some retain a necklace or an earplug, they are all naked, normally an indication of humiliation in Mesoamerica. Scroll motifs streaming from the groin no doubt reveal an ancient pattern of genital mutilation in Oaxaca. A few are accompanied by glyphic cartouches, probably names.

In all likelihood, these slabs show the victims of war. To Blanton, who has studied early settlement both in the valleys and on Monte Albán, the Temple of the Danzantes suggests a war memorial, erected at the beginning of Monte Albán's growth, to commemorate the end of divisive strife among the three valleys. Prisoner galleries, however, occur in later art, particularly among the Classic Maya, and in general they indicate a different sort of memorial. The north wall of Room 2

133 of the Bonampak paintings, for example, shows a group of tortured captives at the feet of victorious warriors on a flight of stairs. If we were to repopulate the 'swimmer' staircase of the Temple of the Danzantes, we would have a similar scene. In the later Maya cases, it is clear that the captives were displayed to proclaim the prowess of the victors, not to discourage the horrors of war. In accordance with Mesoamerican patterns, the message conveyed at Monte Albán is likely to have emphasized the power held by those who dominated the valley.

Somewhat later, probably after 200 BC, the Zapotecs erected
61 Mound J in the center of the plaza at Monte Albán. By this time the symmetrical guide lines of the plaza had been laid out; but Mound J was set prominently off axis and given unusual form. The structure
26 looks like an arrow pointing to the southwest, yet its unusual configuration cannot be observed from the north or east. From the northeast, the building shows only a wall of steps, flanked by broad balustrades. The pointed head of the building is honeycombed with tunnels that are vaulted with angled stone slabs. Both these odd tunnels and the unusual shape of the structure itself have given rise to

26 Mound J, Monte Albán. From the south, the dramatic, arrow-like positioning of the structure can be seen. Monte Albán II.

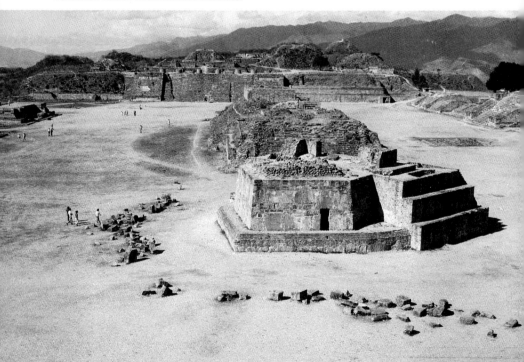

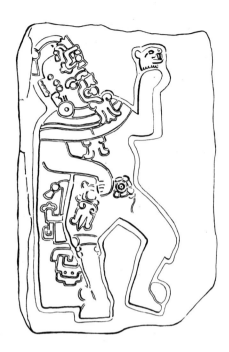

27 A Danzante from Mound J, Monte Albán. Dressed in a jaguar suit, this carved figure holds a jaguar glyph – perhaps his name – in his left hand. The tri-lobed flint in his right suggests the jaguar's talons. Monte Albán II.

the idea that Mound J may have had an astronomical function. Recent studies have borne this out. Thirty-one miles to the east, at Cabellito Blanco, a structure nearly identical to Mound J has been found. At zenith passage both mounds point to particularly bright stars. Mound J, then, is one of the first buildings in Mesoamerica that we can consider a giant chronographic marker. Its purpose was to acknowledge the passage of time, and – interestingly enough – it appears about the same time as the proliferation of the written calendrical system.

The evolution of the writing system is also evident in Mound J. Carved slabs, technically similar to those of the Temple of the Danzantes, were set along the façade, the projectile wall, and within the tunnels. On these slabs, although the genital mutilation persists, the figures show more costume details. The writing too is far more elaborate; it seems to record battles with dates and placenames, as distinct from the more general record of conquest shown previously on the Danzantes temple. The illustration shown here – a regally attired figure holding a glyph in his hand – is typical of these Mound J carvings. On others, a human head is shown upside-down under a

27

placename, indicating conquest, and the accompanying glyphs suggest a date in the 52-year calendar.

Monte Albán was very much the main center in Oaxaca during the Late Formative, but it was not unique. To the southeast, at Dainzú, another great mountainous outcrop was the focus of occupation. In this instance, the main architecture arose on the valley floor, and a large temple structure there had inset carved slabs technically similar to the Danzantes. Individuals with masks or helmets, perhaps ballplayers, form the majority of the representations. Above, on the peak itself, steps and chambers were carved from the living rock, and the site may have functioned as a religious shrine.

The careful excavation of the tombs at Monte Albán produced a dependable chronological sequence long before radiocarbon testing could provide a second check. The two earliest periods are known as Monte Albán I and Monte Albán II. Ceramics show the most periodization; other architectural innovations of the Late Formative, such as the construction of masonry ballcourts or the use of columns, show a steady development into Classic forms.

Most of the tomb goods from Monte Albán I were simple offerings of gray-colored ceramics. Strong affinity with Olmec conventions of physiognomy can be seen in the earliest effigy pots, the best of which come from Monte Negro, also in the modern state of Oaxaca. Slightly slanted eyes and a strongly downturned mouth are typical of these early wares. By Monte Albán II, the technical qualities that characterize later Monte Albán tomb offerings are evident, although stylistically distinct. Many large full-figure hollow effigy sculptures were made in animal and human forms. Technically, large ceramic figures may have derived from Olmec precedents, but the imagery is particular to Oaxaca.

cf. 16

28 The Scribe of Cuilapan (so called for the glyph he wears) is a fine clay sculpture of this period. The uneven shoulders draw our attention to the slight asymmetry of this young man's features; his partly open mouth and eager expression reveal the artist's interest in portraiture. Life-size hollow pumas and jaguars were also recovered from tombs of this era. They wear scarves or other accoutrements, indicating supernatural qualities – no doubt such ceramic beasts helped deter potential tomb robbers!

Fine pieces of Olmec jade have been collected in Oaxaca, perhaps treasures originally held by early Zapotecs. By Monte Albán II, the

28 *(left)* The Scribe of Cuilapan, Monte Albán period II. Subtle detailing reveals the portrait of this young man in fine-grained terracotta.

29 *(right)* An early Monte Albán king was buried with this jade bat assemblage. He probably once wore it at his waist, in a fashion also demonstrated by later Maya lords (cf. ills. 84 and 86). Monte Albán II.

Zapotecs themselves were skilled lapidaries. One of the most splendid of their works of this time is the jade bat belt assemblage. This object would have been worn at the waist, the three shiny jade plaques dangling. (The so-called Leiden Plate was once part of such an assemblage made by the Maya.)

29

86

WEST MEXICO

The history of ancient West Mexico is in many ways one of separate development from the rest of Mesoamerica. There is, for example, no

53

evidence that the Mesoamerican calendrical systems were known or used. The relationship of the region to the high civilizations also remains obscure: neither the art nor the architecture indicate direct contact. Moreover there is no clear florescence of culture during one era, and it seems likely that the political developments of the Olmecs or the Aztecs never touched the region. This does not mean, however, that the works of art produced there lacked subtlety or craftsmanship. Far from it. West Mexican ceramic figures and groups – almost all of which have no archaeological provenance – are among the most directly appealing of all Mesoamerican artworks. Charmed by their apparent lack of elite symbolism, the modern artist Diego Rivera made a large collection of them – now in the Anahuacalli Museum in Mexico City – and regularly incorporated images based on their styles in his murals. American movie stars also collected the figures in the 1950s, while for several years now the Kahlua company has advertised its products using them. Needless to say, this demand for West Mexican ceramic sculptures has not only promoted the looting of ancient tombs but also nurtured an industry of modern forgeries and pastiches.

For the sake of convenience, West Mexican artifacts are grouped here under geographic headings, principally the modern states of Colima, Jalisco, and Nayarit, plus one river, Mezcala. What links these finds together is the context in which they were deposited – the shaft tomb. At anywhere from one to six meters below ground level, such tombs consisted of a chamber opening out of a narrow shaft. In the chamber lay multiple burials, often deposited over a considerable period of time. Convincing dates for the tombs are rare, but most belong to the Late Formative, although the chronological span extends from the Early Formative to the Early Classic.

The earliest documented works from West Mexico are from what is known as the Capacha complex, in central Colima. Shaft-tomb goods there have been dated to 1500 BC by radiocarbon techniques. Early vessels include stirrup-spout types remarkably similar to those found in contemporary contexts on the north coast of Peru. Does this imply links between the two areas? On the whole, contact between Mesoamerican and Andean civilizations is believed only to have been intermittent, if it occurred at all (the Aztecs, for example, knew nothing of the Inca at the time of the Conquest); but these early vessels may provide evidence for such contact. Crops, weaving and ceramic techniques, as well as elite lore, may have been shared at just this

54

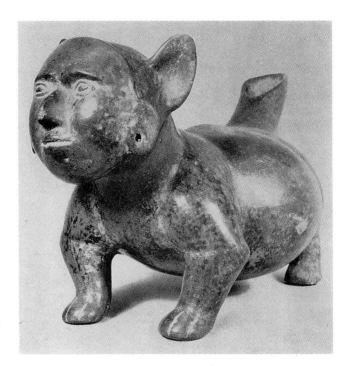

30 A terracotta dog with human mask, Colima style. Great numbers of native hairless dogs were immortalized in Colima clay sculpture, but the mask of this one makes it an overtly supernatural creature.

horizon, perhaps via Ecuador. On the other hand, the stirrup-spout jar, a convenient vessel for carrying water without spillage or evaporation, could well have been invented simultaneously in response to similar needs in both areas.

Two principal types of figures have been found in Colima, and they probably reflect a chronological sequence. Flat figures – often considered to be the earlier type – use a slab-and-appliqué technique, with animated postures, and are sometimes grouped together. Better known are the hollow figures of reddish clay, burnished to a high luster, which have black mineral accretions spotted all over them from the tomb walls. The majority of such figures also double as vessels, whose pouring spouts are usually the tails of the animal effigies. Indigenous hairless dogs were worked in particularly lively forms: playing, sleeping, even nipping one another. Others, such as the dog *30* with human mask, may have a meaning that goes beyond anecdotal charm. Headrests were made in the form of half-dogs, and the resultant image was of a human head on a dog's back. Dogs may have

31 Players in two teams compete on this Nayarit-style clay model of a ballcourt while spectators watch in eager anticipation of the outcome.

been perceived as beasts of burden in the afterlife. Colima potters also drew on vegetable products, in the main squashes and gourds, which no doubt served as perishable containers in the afterlife as well. Human figures are generally men with clubs or with an arm raised to strike. Like the large felines of Monte Albán II tombs, they may have warded off unwanted visitors, but the single horn protruding from the forehead of many of them suggests too that they are shamanistic figures for communication between the living and the dead.

Shaft-tomb deposits from Jalisco are stylistically distinct from other West Mexican ceramics, although not unrelated technically. The potters of this region produced both small solid figures and larger hollow ones. Some of the smaller ones, with pointed heads, and typically showing musicians and performers, have been recovered in lively groupings.

Limited ceremonial architecture has been discovered in West Mexico. The most important stone structure is at Ixtlan del Río, Nayarit, where a tiered round platform like a wedding cake came to light. Although the platform may be late in date, other round buildings like it but of perishable materials have been found in West Mexico, and it is a type that seems to have lasted for generations. We should not therefore be surprised to discover that round architectural features often occur in ceremonial groupings of Nayarit figures, and in general Nayarit ceramics include more architecture than the other regional styles. One of the most common themes is of figures in or near thatched houses, and the groups that show tiny figures underneath houses have been interpreted as funeral scenes related to the act of interment.

Ballcourts also have a prominent place in the group repertoire, and one day actual stone courts may be located in the Nayarit region. The figural scenes at any rate demonstrate the importance of the ballgame

32, 33 A male and female couple, Nayarit style. Such male–female pairs were frequently placed in shaft tombs, perhaps to accompany interred married couples.

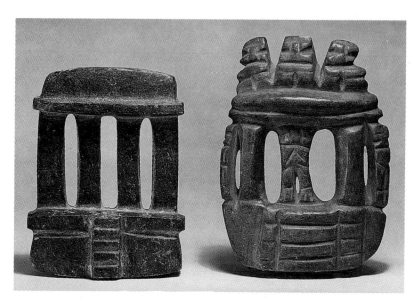

34 Stone temple models, Mezcala style. Miniatures like this may record the perishable temple façades of long-lost architecture.

31 at an early date in the area. The court grouping illustrated here shows three or four men in a team, playing with a soccer-sized ball. Dozens of spectators look on: they huddle together under a blanket or gently hug a child in an artistic expression that captures the warmth of everyday life.

The Nayarit potters also made large, hollow figures, often in male-female pairs, which are perhaps marriage portraits interred with the dead. The bright patterning of the ancient textiles worn in Nayarit is recorded in the slip painting of the figures' costumes. The shifts donned by Nayarit men are uncommon in ancient Mesoamerica, and Patricia Anawalt has drawn attention to the presence of this sort of garment in the Andes during the same period, possibly showing 32, 33 contact. The couple in the example here may be of high status, to judge by the elaborate ornaments they wear in ears and nose, and they bear instruments, perhaps to provide musical accompaniment in death.

The drainage of the Mezcala River in West Mexico has yielded a great number of fine stone pieces of unknown date. The Aztecs

58

coveted these serpentine, granite, and cave onyx (the Aztec *tecali*) carvings so much that they collected a few of them and interred them in the Templo Mayor in Tenochtitlan. Whether such works were contemporary with other West Mexican developments remains unknown.

Small temple models were produced in abundance, probably by a string-sawing technique. The temple façades they represent are not matched by the architecture so far known from the region, and they suggest a familiarity with developments in Oaxaca. Some of these façades, for instance, resemble those of Mound X at Monte Albán, which dates to the Late Formative, and it is interesting to note that temple models have been recovered from Monte Albán II contexts.

34

Many functional stone pieces were also made by the Mezcala people: blades, axes, and bowls are known. What makes these materials so attractive to us is their lithic quality. The stone itself was admired by ancient Mezcala craftsmen, and its inherent 'stoniness' appeals to the modern eye.

THE MAYA REGION

Important developments occurred in the Maya area during the Late Formative. During the Middle Formative, the Olmecs had sustained contact with the Pacific coast, and their carvings have been found from Chiapas to El Salvador. During the Late Formative, various population centers emerged where art and architecture of an apparently indigenous style was erected, particularly in the Chiapas/ Guatemala highlands, at Izapa, Kaminaljuyú, Abaj Takalik, and El Baúl, and by persons who may not all have been ethnically 'Maya.' Excavations in the Central Petén – at Uaxactún and Tikal, the loci of Early Classic florescence – have shown that settlements had been established at both these places by the Late Formative. It was another Petén site, however – El Mirador – which apparently outstripped them in size and importance at this early date. Elsewhere, along the Caribbean coast, Cerros is the best-known site.

Late Formative building materials were often perishable, leaving only large collapsed adobe mounds in the highlands. Moreover, at Kaminaljuyú (with very probably the most substantial highland Late Formative architecture of all), only a handful of structures could be excavated before the modern real estate development of Guatemala

City covered the greater part of the ancient ruins. In other locations, later structures still house earlier constructions. Probably the finest of known highland buildings is the great platform E-III-3 at Kaminal-juyú, which covered two rich tombs, in the pattern that Classic Maya architecture later followed.

However, at Cerros, in modern Belize at the mouth of the New River, we see dramatic new architectural expressions that were critical to the formation of Classic Maya patterns. About 100BC there was an unprecedented spurt of building. All previous constructions were razed and new ones, some exceeding twenty meters in height, were built with clean, new rubble cores. At Lamanai, farther up the New River, even taller structures rose to adorn the city. Giant stucco mask façades flanking the stairs are common in these new buildings at Cerros and Lamanai. The masks seem to display a new, codified imagery. *K'in*, or sun, symbols decorate the cheeks of great supernatural faces, in association with jaguar elements. The masks would thus seem to refer to the jaguar sun, an iconographic identification of the sun at night, and a prominent supernatural force among the Classic Maya. This combined imagery and architecture spread – almost as if it were some new orthodoxy – to other places, probably including the Central Petén, and perhaps instilling an ideological unity that gave force to the Early Classic within a few generations.

Some of the most exciting excavations of recent years have taken place at El Mirador, in the Petén, where a hitherto unobserved florescence of Maya civilization in the Late Formative has been discovered. Among the largest pyramidal forms ever constructed in ancient Mesoamerica were erected here, and El Mirador was probably the most important center of its era. Whether or not it was the source for, or recipient of, the great mask façades known at Cerros remains unclear, but El Mirador certainly subscribed to the same imagery. A few carved fragments of stone sculpture have been recovered from the very limited excavations carried out so far, and they suggest a relationship to Early Classic Maya works – but by that era El Mirador was apparently in eclipse, as Tikal and Uaxactún grew in importance.

At the same time that such dramatic changes were taking place in the lowlands, the highlands too were seeing new developments. Perhaps following an earlier use of perishable materials or perhaps deriving directly from Olmec forms, highland societies began systematically to erect monumental stone carvings during the Late

35

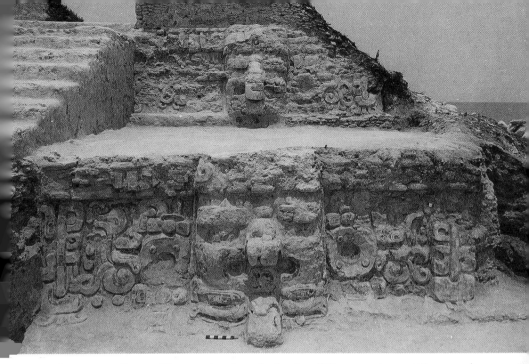

35 Structure 5, Cerros. Huge masks adorn the façades of Maya structures at Cerros and give evidence of the sudden rise of a solar cult. Late Formative.

Formative. Boulder carvings – the ones most likely to have had Olmec precedents – were made at many sites, but other forms, the stela and altar, predominated. Despite the proliferation of the stela 'cult,' as it is often called, imagery and style remained distinct at the various highland centers: Izapa, Kaminaljuyú, and Abaj Takalik.

The Late Classic Maya reset the monuments of Izapa, but most of the stelae and altars there were carved during the Late Formative. Many of the altars (no doubt used as thrones by the lords) appear in the shape of large toads and frogs, perhaps symbols of the earth. A supernatural world is illustrated on the stelae, and at least two deities important to the Classic Maya and known as GI and GII would seem to have made their first appearance at Izapa.

On Izapa Stela 3, a deity figure holds an axe and stands on one leg, *36* while the other leg turns into a serpent. This image may be the source of the Classic deity known by three names to modern students (God K, the Manikin Scepter, and GII); in the prolific later images, this figure generally doubles as a small–scale staff held in the hand by

61

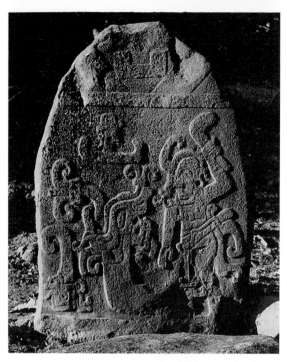

36 Stela 3, Izapa. One leg of the supernatural illustrated on this monument twists and turns into a serpent, much like the later God K of the Classic Maya.

37 *(below)* Stela 5, Izapa, may explain Izapan beliefs of world origins: beings both human and supernatural flow from the central tree while an old couple casts lots at lower left. Sky symbols mark the upper margin, and water defines the lower. Late Formative.

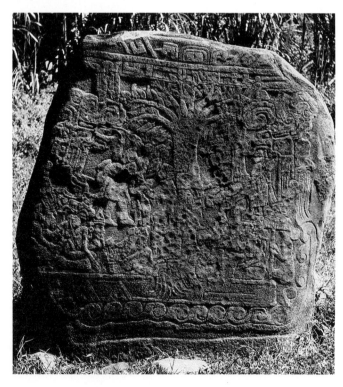

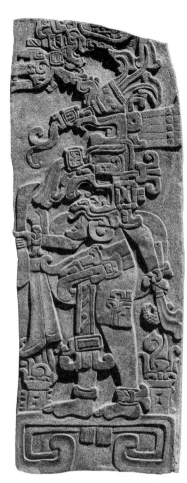

39 A silhouette sculpture in Kaminaljuyú style, reportedly collected at Santa Cruz Quiché in the nineteenth century. The 'bowtie' at center is typical of weapons of sacrifice, and the beaded lines above may indicate blood. Late Formative.

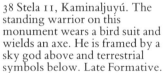

38 Stela 11, Kaminaljuyú. The standing warrior on this monument wears a bird suit and wields an axe. He is framed by a sky god above and terrestrial symbols below. Late Formative.

40 Stela 5, Abaj Takalik. Lords in profile flank a column of text that records a date in the year AD 126.

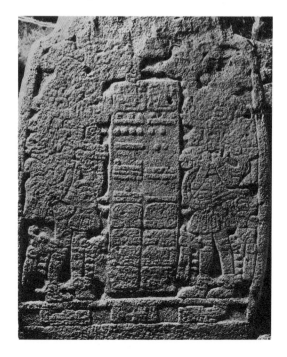

rulers. Stela 1 shows an aquatic figure, perhaps the prototype for GI,
the fishy creature later associated with human decapitation. Mor-
phologically, the image is very close to the Late Classic scene of three
squabbling GI's and their fish recorded on a pair of bones from Ruler
A's tomb, Tikal.

Stela 5 depicts a mythic origin from a central tree. Representations
of natural flora are rare in Olmec and Maya art – the two traditions
most clearly related to Izapa – and the tree of Stela 5 is a supernatural
one, from which human forms flow, as if released by the large figure
to the right, who uses his nose to drill an opening into the trunk. The
scene may be designed for oral reading, with components recorded as
if in simultaneous narrative. The old couple at lower left who divine
with kernels may be the ancestral couple (referred to in later Aztec
sources) from whom all subsequent human beings descend. World
trees, perhaps related to this earliest one at Izapa, appear also at
Palenque and in Mixtec and Central Mexican manuscripts.

Borders above and below the Izapa scenes would seem to mark
heaven and earth, quite possibly the first use of such conventions. Like
the rest of Izapa monuments, these stelae emphasize mythological or
supernatural scenes. As far as can be determined, the preoccupation
with history evident on later Maya monuments is missing at Izapa.

The greatest florescence of the Late Formative in the highlands took
place at Kaminaljuyú, where the richest burials of the era have been
recovered. Fine carved stelae show both supernatural figures and
humans. Stela 11 shows a standing human figure in costume, and only
his human eye and mouth can be seen under the great headdress that
almost entirely obscures his face. What is probably an ancestor figure
floats in the sky, and two braziers of burning offerings are at his feet.
His costume is similar to that of the supernatural figure on Izapa Stela
3. Other human figures are worked in silhouette, as is the unusual one
illustrated here. This odd monument would seem to be a personified
eccentric flint. Beaded elements appear here on the 'blade' of the
monument. Such 'dots' or 'beads' often represent blood in Classic art,
and this monument may commemorate ritual sacrifice in a bloodied
blade.

At Abaj Takalik, stone monuments were also erected in stela/altar
combinations, as they were at Izapa, but the imagery is different. Stela
2 shows two figures flanking a central column of text with a Cycle 7
(that is, before AD 41) date. Like La Venta Stela 3, Kaminaljuyú Stela

cf. 82, 83

11, and the Early Classic portraits of Tikal, the upper margin has a supernatural character. The two humans below were probably historical figures. On Stela 5, two persons also flank a column of text, *40* in this case a legible Long Count date of 8.4.5.17.11, or AD 126. The impossible posture of frontal torso with profile legs and face was a widespread convention later to prove typical of Early Classic Maya representations as well.

The second century AD brought an end to these achievements in the Guatemalan highlands, and the focus of progress shifted to the Central Petén, where the Early Classic began to take shape. From the forms established at Izapa, the Early Classic Maya derived mythic imagery; from Abaj Takalik, the conventions of historical portraiture. When the Early Classic emerged in full flower at Tikal and Uaxactún, it clearly drew upon precedents in the highlands for sculpture and from the Caribbean coast and El Mirador for architecture. Indeed, in most of Mesoamerica, Classic achievements in art and architecture were founded upon those of the Late Formative.

CENTRAL MEXICO

During Early and Middle Formative times an Olmec presence had made a profound impact on sites – and their grave goods, in particular – in the valleys of Central Mexico, but this presence ended in the Late Formative period. These established centers were not cities, and they did not have major ceremonial centers. We might consider them elaborate villages. At Tlatilco, for example, during the Late Formative period, figurines continued to be made; to the west, at Chupícuaro (now under an artificial lake in Guanajuato), charming figurines and vessels with distinctive red geometric slip patterning were produced.

By 100 BC at the latest, two new centers had emerged in the Valley of Mexico, Teotihuacan to the north, and Cuicuilco to the south. Positioned like rivals at extreme ends of the Valley, each grew dramatically in size and population. At Cuicuilco, a huge (135 meters in diameter at the base) round platform was the focus of construction, rising in four concentric tiers like a giant wedding cake. About 50 BC, the volcano Xitli erupted, burying much of Cuicuilco. Another eruption occurred about 150 years later. Like Pompeii's population, the inhabitants of Cuicuilco fled. Teotihuacan no longer had a rival, and it grew rapidly in power and size.

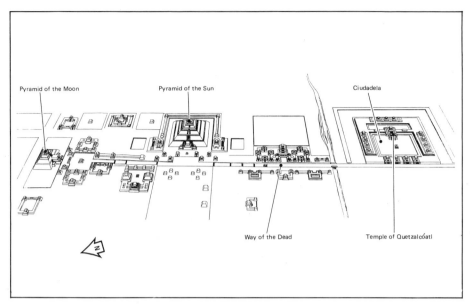

Pyramid of the Moon

Pyramid of the Sun

Ciudadela

Way of the Dead

Temple of Quetzalcoatl

N

41, 42 Teotihuacan: an isometric view *(above)* of the main north–south axis, the Way of the Dead; and an oblique airview *(below)* from the north. The interstices of the grid were completely filled with buildings near the center of the city.

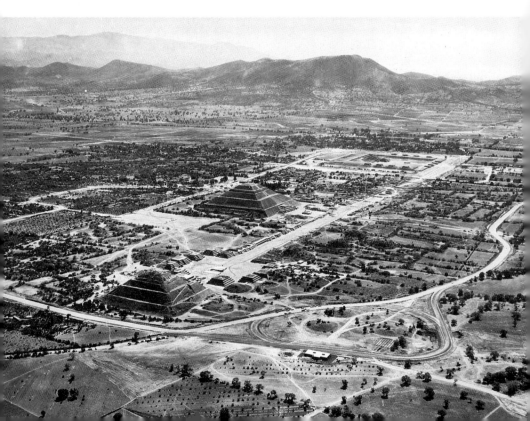

Teotihuacan

The great city of Teotihuacan – a metropolis in the Valley of Mexico of perhaps a quarter of a million people at its height – had an impact on both commerce and art in the ancient New World comparable with that of Constantinople in the Old. It was a city of prestige and influence rivaled only by the later Tenochtitlan, capital of the Aztecs. Even as a ruin, Teotihuacan retained great importance, and it was never 'lost.' For the later Aztecs it was a setting for cosmic myth, and their last ruler, Motecuhzoma II, made regular pilgrimages to the site. Detailed mapping of Teotihuacan has been carried out by the University of Rochester under the direction of René Millon. No other Mesoamerican city plan is so well known.

The notion of a 'Classic' era was first conceived to define the span of time during which the Maya used Long Count inscriptions, or about AD 250 to 900 – a period originally thought of as peaceful and theocratic throughout Mesoamerica. Though the idea of peaceful theocracy has since been abandoned, the term Classic remains in use, if only to characterize the richness, variety, and growth of the art and society of the time. Recent archaeological studies have shown that the Classic era in fact began by at least AD 150 in Central Mexico with the rise of Teotihuacan. The Classic era survived the burning of Teotihuacan in AD 650, and Classic traditions were sustained for at least two more centuries, particularly at Cholula, in the Valley of Puebla.

ARCHITECTURE

Following an earlier, more random settlement during the Late Formative, the two great axes of Teotihuacan were laid out perpen- *41, 42* dicular to one another, approximately north–south and east–west. The Pyramid of the Sun was oriented according to this city plan and begun before AD 150. Some fifty years later, the Pyramid of the Moon was under construction at the end of the north–south axis, the Way of the

Dead. Following the grid established by the axes, apartment complexes filled the interstices, and the great cosmopolitan center flourished, reaching its apogee about AD 400. Archaeology has produced evidence of ethnic neighborhoods and barrios of craft specialists, yet all lived along the immutable grid of Teotihuacan. Miles away, isolated structures still conformed to its right-angle geometry and its perpendicular axes along the cardinal points. No other city in Mesoamerica ever adhered to such strict geometric precepts.

At Teotihuacan, the architecture is of both mass and space – mass in the great temples, open space in plazas, temple enclosures, ritual walkways, and interior space within the palace compounds. Although it is often difficult to distinguish palatial or bureaucratic structures from religious edifices or domestic dwellings in ancient Mesoamerica, the distinctive profile known as 'talud-tablero' delineates much sacred architecture at Teotihuacan, particularly among the smaller structures

43 and within palace compounds. The sloping *talud* (talus) supports the vertical *tablero* (entablature), which is often the surface for architectural ornament or stucco paintings. Perhaps more than any other aspect of its culture, talud-tablero architecture marks the presence of Teotihuacan abroad, and the execution of such profiles in adobe at

57 Kaminaljuyú, for example, nearly 700 miles to the south, is a provincial manifestation of the great city.

44 The Pyramid of the Sun is one of the largest structures of Precolumbian Mesoamerica – in fact, at some sixty-one meters (even without the perishable superstructure that undoubtedly crowned it), one of the tallest and largest structures in North America until the twentieth century. During excavations to install Sound and Light at Teotihuacan in 1971, a cave was found under the pyramid. Ancient

43 The vertical *tablero* sits on the sloping *talud*. This schematic drawing shows the sort of workmanship typical of many Teotihuacan structures. The exterior is finished with fine plaster and polished.

TABLERO →

TALUD →

68

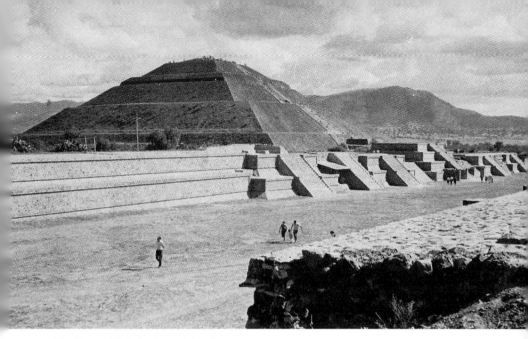

44 The Pyramid of the Sun at Teotihuacan.

rituals there may have hallowed the site. The cave itself features several small chambers, almost in a clover-leaf configuration. Ceramics recovered indicate the cave's use from Late Formative through Classic times, and it could well be an extremely ancient focus of worship. The later Aztecs claimed to have come to Tenochtitlan from a mythic place called 'Chicomoztoc,' or Seven Caves; might not the underground chambers of the Pyramid of the Sun have been an ancient sacred place to them as well as to the Teotihuacanos?

The Pyramid of the Sun also marks the movement of the sun, east to west, and the rising of the Pleiades, the 'sun passer,' on days of equinox, so perhaps its name, given to us by the Aztecs, is ancient. Although L. Batres' reconstruction for the 1910 Mexican Centennial is often criticized as inaccurate, the five distinct levels are clear in nineteenth-century paintings by José Maria Velasco. The broad staircase is the focus of the building. A single flight of steps divides into two and then merges together again: as attendants progressed up the stairs, they would have vanished and reappeared several times to the viewer on the ground, for whom many Teotihuacan structures may have functioned as backdrops for rituals and public events.

45 The slightly smaller Pyramid of the Moon (again, a name passed down by the Aztecs) lies at the far end of the Way of the Dead, stemming the flow of the north-south axis. The enclosed square in front of the pyramid recalls the configuration of the Mesoamerican completion symbol (see p. 42). A smaller talud-tablero structure abuts the pyramid. The pyramid is framed by Cerro Gordo, a mountain in the distance to the north, and its positioning may emphasize the similarity in form between pyramid and mountain. It may also acknowledge and call upon the greater rainfall and abundance at the long dormant, gurgling volcano. The setting of mountain and pyramid is visually compelling at Teotihuacan, as if man sought to place his works in perfect harmony with the landscape.

The strong north-south axis of Teotihuacan must also be considered an architectural element. The Aztecs called the axis 'Miccaotli,' or Way of the Dead, perhaps a general reference to the city's abandoned state. Such a name might also identify the small temples that line the Way as shrines to ancestors. Although the buildings have never been excavated, it is possible that they house tombs. The great processional way is sometimes considered a 'street,' but it is more than a connecting path: it changes elevation several times, forcing the pedestrian up and down stairs and commanding attention as an architectural form in its own right.

45 The Pyramid of the Moon at Teotihuacan, framed by Cerro Gordo, a dead volcano, in the distance.

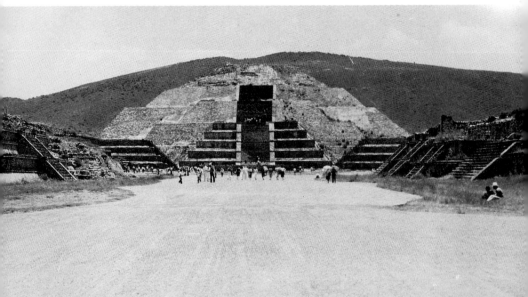

46 Isometric reconstruction drawing of the Zacuala compound, Teotihuacan. Like most Teotihuacan palaces, Zacuala offered privacy and security from the streets.

Residential compounds of various size fill out the Teotihuacan 46 quadrants. Access to these compounds was extremely restricted, often through a single door, providing security and privacy within. Given the inevitable noise and confusion in this city of busy merchants and craftsmen, the inhabitants must have felt relief at escaping from the hubbub of the street to the seclusion of their quiet residences. Such urban life can be compared to that of Old World, pre-modern cities, but it had no counterpart in the New World. Each residential grouping included three shrines and a platform for semi-public rituals, as well as many dwellings.

Such compounds sometimes housed foreigners, as discovery of a 'Oaxaca' barrio shows, where Zapotecs lived in typical Teotihuacan housing but whose mortuary rite included traditional Zapotec extended burials with Oaxaca urns. These Zapotecs at Teotihuacan imported utilitarian ceramics from Oaxaca as well. Such foreign enclaves may have been embassies or merchants' quarters. Luxury goods in foreign style for the local inhabitants may also have been prepared there. Teotihuacan was truly a cosmopolitan city.

SCULPTURE

The stone sculpture of Teotihuacan is massive and prismatic, retaining the 'stoniness' that attracted the modern sculptor Henry Moore to Mesoamerican styles. In this sense, it is similar to the architecture. The

most important Teotihuacan sculpture is the great female figure once set in the courtyard of the Pyramid of the Moon. Such a massive basalt block might even have been an architectural support, although there are no other members of this series. The cleft in her head recalls Olmec works, but the 'blockiness' bears little resemblance to the plastic three-dimensional quality of Olmec sculpture. If set on axis with the Moon, the cleft in the sculpture's head would have been

45 aligned with the depression in Cerro Gordo, and, as the figure brings her hands to her body, she seems to wring water from her *huipil*, or upper body garment. It seems inescapable that we see in her a water goddess, perhaps the prototype of the Aztec Chalchiuhtlicue.

48 An unusual sculpture was found at La Ventilla, an outlying residential compound of Teotihuacan. It seems to have been a marker for a ballgame played without a masonry court of the sort generally associated with the game in Mesoamerica. The sculpture has four individual components, each worked with an elaborate interlocking scroll design. This type of scroll characterizes Classic Veracruz stone sculpture, particularly at the site of El Tajín, where the ballgame is celebrated with no fewer than eleven courts. One of the sloping talud paintings of the Tlalocan (see below) shows small, animated figures who play a game around a monument similar to the La Ventilla piece.

Perhaps best known of all Teotihuacan sculpture are the fine masks, very likely mummy bundle masks, but usually lacking precise archaeological context. Made of serpentine, cave onyx (the Aztec *tecali*), or granite, these masks present clear, anonymous faces, neither male nor female, young nor old. Compare, for example, ill. 47 with the Frontispiece or ill. 50: these sculptures too wear the uniform face of Teotihuacan, isolated in the stone masks. Traces of deposits left in the sunken holes of ill. 47 indicate that inlay of shell or pyrites once formed eyes. A few masks have been recovered with shell and turquoise mosaic intact; although beautiful, the inlay does not alter the quality of anonymity.

Ceramic figurines were made throughout the history of Teotihuacan, and the early ones, tiny, agile, and perhaps once dressed

49 in perishable materials, are the most appealing. Like the stone carvings, these miniature figures wear the anonymous mask of Teotihuacan. They are found in great abundance, and by AD 450 or so were mold-made and mass-produced, richer in iconography but limited by their technology to static poses. In all Teotihuacan works,

72

47 Without fully-pierced holes for eyes, nose, or mouth, Teotihuacan masks such as this were never intended to be worn by the living. Inlay of shell or pyrites once gave the face animation.

49 Small clay figurines, Teotihuacan. Modeled in animated postures, these tiny figures could have been grouped to resemble their painted counterparts of the tablero of ill. 53. Early Classic.

48 *(left)* A four-part ballcourt marker, found in La Ventilla, a compound of Teotihuacan. Scrolls on this sculpture link it to works from Veracruz of the same period. In one Teotihuacan painting, teams of ballplayers compete in front of a similar object.

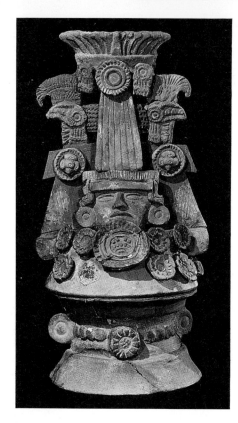

50 Mass-produced elements ornament this large, two-part urn. A human face is flanked by an elaborate headdress shaped like a Teotihuacan temple chamber. Offerings may have filled the vessel.

one sees an increase through time in the emphasis on mass production, in both ceramic art and paintings.

Large-scale ceramic sculptures also survive. Brightly polychromed urns show a human face peering out from an almost architectural construction of mass-produced, stamped elements. The flatness of the surface planes directs attention to the recessed, three-dimensional face.

PAINTING

The histories of painting and architectural sculpture at Teotihuacan cannot easily be separated, for painted ornament on early buildings would appear to give rise later to pure painting. Of all architectural ornament at Teotihuacan, the finest is that of the Temple of Quetzalcóatl, set at the western margin of a large enclosure, perhaps the palace of the ruler. On the talud-tablero façade uncovered and

74

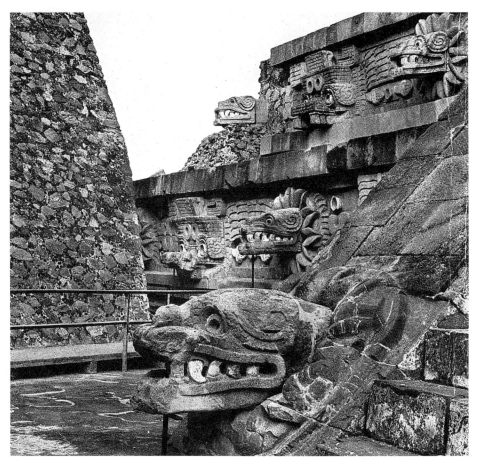

51 The Temple of Quetzalcóatl, Teotihuacan. Early in this century, archaeologists removed the exterior mantle of the structure and revealed the painted, sculptured façade of an earlier construction.

restored between 1917 and 1920, paired fire serpents and feathered serpents entwine above groundlines of seashells, perhaps in dialogue in primordial waters. Great feathered ruffs also encircle the serpents, which function as balustrades. A limited palette, mainly white and red, enhances the ornament.

In the third century AD, paintings on stucco replaced sculptured ornament, and the palette brightened, with an emphasis on clear reds that approaches the rich color of medieval tapestries. Paintings

decorated the tableros throughout Teotihuacan, and the bright blue-greens, ochers, and reds enlivened both the interiors and exteriors of structures. The netted jaguar from Tetitla is one of two such paintings flanking an open doorway. The jaguar's posture is clearly human, and he kneels on a path marked by footprints leading to a temple with an elaborate thatched roofcomb, probably typical of Teotihuacan super-structures. Such painted images were probably didactic, instructing the viewer to move along a ritual way or through a door.

In later paintings, after AD 450, fewer colors were employed, and images were so perfectly replicated that some sort of template must have been in use, perhaps a stencil. The subject matter of these monochromatic paintings emphasizes what may have been a growing militarism, for anthropomorphic figures bear arms, and friezes of stalking jaguars and coyotes loll their tongues at what may be human hearts.

One of the most remarkable of Teotihuacan paintings is the so-called Tlalocan, executed in a bright palette against a rich red background on the walls framing a patio within the Tepantitla palace compound. Each sloping talud depicts a myriad of tiny individuals who play in streams of abundant water flowing from a mountain. These figures resemble the small ceramic figurines, which may themselves have been grouped to reproduce the exuberant frolic of their painted counterparts. Painted speech scrolls suggest the happy sound that issued from these little fellows (although the longest scroll is associated with the single individual shown crying) as they play ball,

52 A stucco wall painting from Tetitla, Teotihuacan. A human in a netted jaguar suit kneels on a path marked by footprints that lead to a temple.

53 A copy by Agustín Villagra of the so-called Tlalocan painting from the Tepantitla compound, Teotihuacan. In the upper frame, acolytes attend a water goddess similar to the one depicted in the great basalt sculpture (frontispiece), and abundance flows from her fingertips. The aquatic paradise on the sloping talud below (not shown) has often been equated with the Aztec Tlalocan, a paradise for those who died by drowning.

carry one another piggyback or splash in the water. Alfonso Caso first suggested that this scene of watery abundance was the Tlalocan of the Aztecs, a paradise dedicated to Tlaloc, the rain god.

In the tablero above, a very different scene is recorded. A single frontal figure, probably a water goddess like the figure in the Frontispiece, gives forth green droplets as a pair of acolytes in profile attend and make offerings. From her head sprout plants, perhaps morning glories, along which butterflies flutter and spiders crawl. Peter Furst has suggested that hallucinogenic rituals in which morning glory seeds were consumed may have accompanied the water cult. The syncopation of talud and tablero, as well as the rich color and animation of the painting, make this painted patio the most splendid of all Teotihuacan.

Many ceramics were stuccoed, generally showing a chronology and imagery similar to the monumental paintings, while others were

54 worked in a thin orange clay (such as the one illustrated here), although often stuccoed too. Stuccoed vessels feature heavy, lipped
55 lids with paintings to match the body; tiny slab cut-outs function as tripod feet. An *olla*, or open-mouthed jar, shows a bright blue goggle-
56 eyed Tlaloc bearing an *olla* himself. At the time of the Conquest, the Tlalocs were said to pour water on earth from such vessels, and we may see the Classic representation of such mythology in the example reproduced here.

THE END OF TEOTIHUACAN

There were constant rain and water crises at Teotihuacan, exacerbated by the process of building the city. The preparation of lime for mortar and stucco requires vast amounts of firewood to burn limestone or seashells, and the more Teotihuacan grew, the more the surrounding forests were depleted. With deforestation came soil erosion, drought, and crop failure. In response, Teotihuacan may have erected ever

54 A thin orange vessel of a reclining man, Teotihuacan style. Teotihuacan merchants traded vessels of thin orange pottery throughout Mesoamerica; many had a stucco coating. Early Classic.

55 Stuccoed tripod vessel in Teotihuacan style. Symbols of Tlaloc adorn both the vessel and its lid. Tripod feet characterize Teotihuacan ceramics. Early Classic.

more temples and finished more paintings, thus perpetuating the cycle. The great water goddess must have wrung her hands without profit, however, for the city was doomed. According to radiocarbon dating, Teotihuacan was ravaged about AD 650, with the core area of temples badly burned. The perpetrators may have been semi-nomadic peoples just to the north, those most disrupted by the expansion of Teotihuacan, and perhaps occasionally in Teotihuacan employ as miners or laborers. Although some occupation of Teotihuacan continued, the city never regained its importance, and the production of fine art and architecture ceased.

During the rise of Teotihuacan, the magnet of the great city drew people from valleys in surrounding areas, causing their depopulation. Conversely, when Teotihuacan declined, other Central Mexican cities began to expand.

Far to the south, in highland Guatemala, Kaminaljuyú was apparently the means by which Teotihuacan had made contact with the Classic Maya, particularly during the Early Classic, when the Maya acquired many goods in Teotihuacan style. Kaminaljuyú had

79

56 *Olla*, or broad-lipped jar, in Teotihuacan style. A bright
blue, goggle-eyed Tlaloc worked in the stucco coating bears a miniature
olla in his arm, and it too has a Tlaloc motif. Early Classic.

flourished in Late Formative times. During the Early Classic, a number of structures were built there in Teotihuacan style, although not on a Teotihuacan grid. Principal among these is a miniature reproduction of the Pyramid of the Moon, carried out in adobe. *57* Tombs at Kaminaljuyú were filled with luxury goods, indicating the wealth accumulated by those who mediated between Teotihuacan and the Maya.

During the era of Teotihuacan's rise and development, Cholula, in the Valley of Puebla, also thrived. Curiously, about the same time as the burning of Teotihuacan, Cholula likewise underwent depopulation. During the Postclassic, however, the city was rebuilt and expanded. Although never the dominant city of Central Mexico, it had a longer history than most and served as a setting for important Postclassic stories about Quetzalcóatl.

The main pyramid at Cholula was used and rebuilt for nearly 2,000 *58* years, ending with a Colonial church on its summit. Archaeological

57 Plan and reconstruction of B-4, Kaminaljuyú. At this site, in modern Guatemala, buildings in pure Teotihuacan style were executed on a diminutive scale in simple adobe during the great city's apogee. Early Classic.

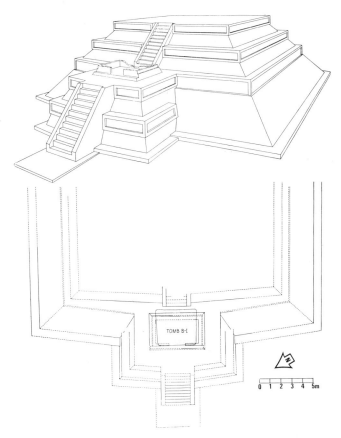

TOMB B-I

0 1 2 3 4 5m

58 The main pyramid at Cholula flourished in many periods, and it probably benefited from Teotihuacan's decline. A Colonial church caps at least 1500 years of prehispanic construction. This rather fanciful drawing from 1834 presents the great pyramid as if it were Mount Calvary.

explorations by the Mexican National Institute of Anthropology and History have revealed many aspects of the pyramid's construction. During the Early Classic, for example, paintings covered the talud-tablero temple exterior. These stucco works show great drinking rites and have suggested to George Kubler the drunken process of their very execution, for the painters would appear to have become increasingly intoxicated by the time they reached the later frames!

A longer sloping talud than that known at Teotihuacan characterizes the early pyramids at Cholula, and we may surmise that an ethnically distinct population lived there. At the time of the Conquest, Nahua speakers occupied the site. Despite years of archaeological study at Teotihuacan, however, the ethnic identity of the inhabitants there remains unknown. Were they Nahua speakers, like the later Toltecs and Aztecs, or were they Totonacs or Otomís, no longer dominant in the Valley of Mexico at the time of the Conquest? No one can say.

Classic Monte Albán, Veracruz and Cotzumalhuapa

The Classic period produced the most widespread flowering of culture in Mesoamerican history. As we have seen, in Central Mexico Teotihuacan was the largest, most powerful and prestigious city to rise in the history of the ancient New World. To the south, in Yucatán, Guatemala, Honduras, and Chiapas, the Maya were equally important, although known for their diversity and variety rather than the monolithic power and commercial zeal that characterized Teotihuacan. However, ethnic groups in other regions fostered important Classic developments as well. Independent Classic styles of art and architecture flourished in Oaxaca at Monte Albán, in Veracruz at various sites, among them El Tajín, and on the Pacific coast of Guatemala at Cotzumalhuapa. At no other time in Mesoamerican history were so many fine and different kinds of works of art and architecture created. It was also an era of great international contact: just as there was interchange between Teotihuacan and the Maya, so too was there contact between Oaxaca and Teotihuacan and between El Tajín and Cotzumalhuapa. Nor were these cities insulated from the disruptions that closed the Classic era: Monte Albán and El Tajín both suffered depopulation and subsequent abandonment, and both regions witnessed separate developments during the Postclassic.

THE CLASSIC CIVILIZATION OF MONTE ALBÁN

At Monte Albán, the step from the advanced Zapotec architectural and artistic styles of the Late Formative to a Classic stage was easily taken. Some sophisticated works of art and architecture survived from Late Formative times, and the acropolis had already been artificially flattened. Most of the structures that flank the main plaza, however, date to the Classic era, either Monte Albán IIIa (Early Classic, to AD 400) or Monte Albán IIIb (the Late Classic phase, AD 400–900, according to archaeologists). The major architectural works of the era reflect an attention to the natural topography of the surrounding

83

valleys. It is hard to capture the relationship of acropolis to mountains in photographs, but the cadence of elevation to depression in the manmade structures on the west side of the plaza – to take one instance – so precisely repeats the rhythm established by the western range of mountains that the Monte Albán acropolis becomes a microcosmic replica of the surrounding valley of central Oaxaca. If such a view is still apparent today, we can only imagine how much more vivid it must have been for the people of the time.

59

A plan designed to reproduce the rhythm of natural land forms may also help to explain the approximate bilateral symmetry of the acropolis. Structures are not laid out on an axis or grid. Unlike the plan of Teotihuacan, they do not radiate from a central point but rather frame the negative space of the plaza. In its general north–south orientation, however, the plan of Monte Albán suggests an axial orientation far more than the organic site plans of Maya cities do.

61

cf. 41

The general organization of the Monte Albán acropolis also recalls the Teotihuacan Way of the Dead. That great processional way is lined by lowlying temples and modulated by changes in elevation. The North and South Barrier Mounds of Monte Albán not only frame

59 Monte Albán, as seen from the north.

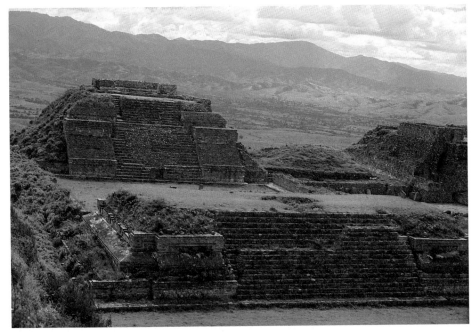

60 Sytem M, Monte Albán. This building, like System IV, is laid out like an amphitheater with spacious enclosed courts set in front of the temple.

the ceremonial core but also require movement up and down the processional way. Nevertheless, the ceremonial core of Monte Albán is small by comparision with Teotihuacan: the Monte Albán plaza with its surrounding temples could all be placed under the Temple of the Sun.

The constructions of the Classic era made the site as a whole, the plaza, and its component buildings more private. A wall enclosed over one square mile of the acropolis. Access to the plaza, both actual and visual, from the east, for example, was blocked by the replacement of numerous individual structures almost contiguous with one another. The proportion of balustrade to stair of these buildings is ponderous, and emphasis falls on the alternation between the two forms.

The corners of the plaza were no longer open: at the northeast, for example, the Zapotecs built an I-shaped ballcourt. (Such ballcourts were peculiar to this region in the Classic, but by the Postclassic the closed I-form court with sloping walls was known widely in Central Mexico as well.) On the west side of the plaza, similar compounds

were erected to flank the earlier Temple of the Danzantes. Known as
60 Systems IV and M, these buildings have been considered amphi-
theaters, where supplicants would gather in the closed court while
attending rites performed on the principal façade. As with all Monte
Albán structures, the perishable superstructures are gone. Tomb
63 façades and small stone temple models found in tombs show that the
distinctive Monte Albán profile molding was also repeated at the
cornice level. Wrapped around exterior corners, this molding consoli-
dated the structure, as did the apron moldings of Maya structures of
the same period. In its two separate layers, the molding resembles
draped cloth. It also bears a similarity to the symbol for sky, perhaps
indicating the generally sacred quality of architecture so delineated.

During Classic times the palace compound grew in size, and –
particularly during Monte Albán IIIb – it became increasingly
61 inaccessible. By the end of the period of construction, one climbed the
North Barrier Mound, passed a colonnade, and descended into a
courtyard similar to those of Teotihuacan, but on a smaller scale, and
sunken in relation to surrounding structures. One then proceeded
along a narrow passageway and up and down stairs before gaining
access to palace chambers. Such restricted access has a parallel at
Teotihuacan, particularly in the Quetzalpapálotl compound, and in
the Maya region, where for instance the core of Compound A-V at
cf. 80 Uaxactún became virtually inaccessible in Late Classic times.

Like the Maya, the Zapotecs erected stone stelae honoring their
62 leaders during the Classic period. Some individuals appear as war-
riors; others engage in dialogue with what appear to be visiting
Teotihuacanos. The Zapotecs wear tall headdresses with motifs
similar to those of the ceramic urns (see below), as distinct from the
tasseled headdresses of the Teotihuacanos. Glyphs record dates in the
260-day calendar or calendrical names. Scrolls indicate speech or song,
as they do in Teotihuacan art. Individuals are carved in profile in a flat,
linear style.

Alfonso Caso directed excavations on behalf of the Mexican
government at Monte Albán throughout the 1930s. He looked for
burials in addition to cleaning and restoring structures. Many
underground tombs thus came to light, both under structures and as
separate chambers, some within the main precinct and others in
residential areas. It remains to be established whether the structures
that flank the compound were primarily dedicated to ancestor

86

North Barrier
Mound

Ballcourt

Main Plaza

System IV

Mound H

Temple of the
Danzantes

Mound J

System M

South Barrier
Mound

0 10 20 30 40 m

N

61 Plan of Monte Albán.

62 *(opposite)* Stela 4, showing a standing ruler, Monte Albán IIIa. Like the Early Classic Maya kings, Monte Albán lords adopted the fashions of Teotihuacan. The glyph 8 Deer appears at left, indicating either a name or date.

63 The façade of Tomb 104, Monte Albán. A fine ceramic urn remains in place over the entry to the tomb. Monte Albán IIIa.

worship, as were many Maya buildings. Caso discovered fine burial chambers containing treasures from the earliest era right up to the Conquest. Many tombs of the Classic period were found to be painted, and, of these, Tombs 104 and 105 are the best preserved. Tomb 104 is thought to precede 105, a chronological separation that probably reflects the difference between Monte Albán IIIa and IIIb. The palette of 104 emphasizes blue and yellow, while 105 has many more red tones, like later Teotihuacan paintings. Both had been quickly prepared and show signs of hasty work, such as drips and spills.

Tomb 104 displays an interesting unified use of architecture, sculpture, and painting. The chamber entry is framed by a doorway *63* with the usual Monte Albán overhanging profile molding, and the door is surmounted by a very fine ceramic figure wearing a Cocijo, or rain-god, headdress. A single skeleton was found extended in the tomb, feet at the chamber door. Sets of small, identical urns had been

89

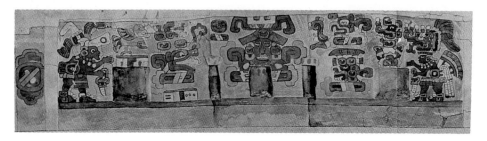

64 Interior painting, Tomb 104, Monte Albán. Hasty workmanship –
indicated by spills and drips of paint – would suggest that the final decoration
of this elaborate tomb was executed at the last moment. Reconstruction
painting. Monte Albán IIIa.

placed along the body, and other vessels positioned in the three cut-
out niches of the wall. Two painted figures flank the side walls, in
profile, attending the frontal cult image at the head of the tomb. One
of them is an old god with a netted headdress, and Michael Coe has
pointed out his similarity to the Maya God N. Compositionally, the
53 painting resembles the central scene of the Tepantitla mural of
84 Teotihuacan, the unwrapped composition of Tikal Stela 31, or even
87 the more iconic Río Azul tomb paintings. Given the emphasis on
symmetry, the source of such compositions is probably Teotihuacan.
The use of such similar conventions at Monte Albán and Tikal shows
both the profound effect of Teotihuacan and the ability of regional
artists to interpret its art for their own traditions. Curiously, tomb
paintings as fine as this one or the Early Classic Maya ones are not
known from Teotihuacan, where we find paintings set in a context for
the living rather than the dead. The discovery of a major Teotihuacan
tomb, however, could alter this perception.

65 Interior painting, Tomb 105, Monte Albán. The painters here chose a
darker, redder palette, more like that of many Teotihuacan works (cf. ill. 53).
Monte Albán IIIb.

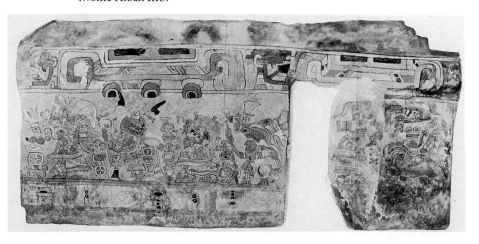

In Tomb 104, each side figure gestures to the niche in front of him, directing the process of offering, and the central cult image seems to rise out of the central niche, as if sustained by the offerings placed within. Such paintings may have guided the attendants at the funeral rites of the interred. 64

The side and rear walls of Tomb 105 show nine male-female couples in procession, accompanied by glyphs that no doubt name them. A single calendrical day sign and coefficient occupies the front wall, probably naming the occupant or the date of his death. Symbols that resemble Monte Albán moldings form the upper register, and what presumably are earth signs lie underfoot. These figures have often been thought to show the Nine Lords of the Night and their consorts, but by analogy with the tomb wall figures of the Palenque tomb chamber, they may be ancestors, who greet the interred. 65

The tradition of making large, hollow effigy vases reached its apogee in Late Formative times at Monte Albán. By the Classic era, the urn had supplanted the hollow vase as the dominant form of tomb sculpture. These urns consisted of cylindrical vessels largely hidden by the attached sculptures of human figures. Evidence of burning in the vessels is rare, and it is more likely that they held foodstuffs or beverages for the interred rather than burnt offerings. They have been 28

63, 66

66 Eyemarkings indicate that this large ceramic urn symbolizes the 'God of Glyph L' in the system devised by Alfonso Caso. Some urns may also be portraits. Monte Albán IIIa.

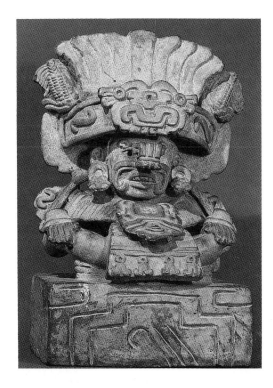

recovered both from tomb doorways and from the graves themselves, though many are without provenance. Most have headdresses of deities. Cocijo, the Oaxaca rain god, is worn by the Tomb 104 figure. Lines around the eyes of ill.66 mark it as the 'God of Glyph L.' The maize of the headdress also suggests a fertility aspect for that figure. As more and more of the imagery of ancient America has been determined to be of historical persons, so the strong individual physiognomies of many Oaxacan urns have begun to suggest portraiture.

The ornamentation of the urns was built up in layers of pliable clay slabs until a rich three-dimensional texture was achieved over the hollow human form. Eventually, just as at Teotihuacan, individual
cf. 50 elements came to be mass-produced. Some human faces are also
47 mask-like and resemble contemporary Teotihuacan stone masks. Many urns have strong rectilinear qualities, despite their three-dimensionality, and can be described geometrically within a rectangle. In this way, they conform to a geometry like that seen in many Teotihuacan paintings.

At the end of Classic times, Monte Albán suffered slow and steady depopulation, as the focus of culture in Oaxaca moved to other centers, some of them Mixtec. Finally, Monte Albán became simply a necropolis and a place of pilgrimage, and it remains a place of pilgrimage today.

CLASSIC VERACRUZ

Distinctive art styles also flowered along the Veracruz coast during the Classic era. Today, Totonacs live in the region, but it is not certain that they were the makers of high culture in Classic times. Fifteen hundred years ago Huastecs and Otomís undoubtedly occupied some of the same territory, while at the time of the Conquest the Olmeca-Xicalanca dominated trade along the coast. We will simply consider the various elements to be 'Classic Veracruz,' without ethnic assignation. Connections with Teotihuacan and the Maya area were evident during the Classic, but the art and architecture of Classic Veracruz also depended upon its Olmec heritage from the Formative era.

Architecturally, the most important Classic city of the region is El Tajín, named after the Totonac rain god. Rainfall is high here, where

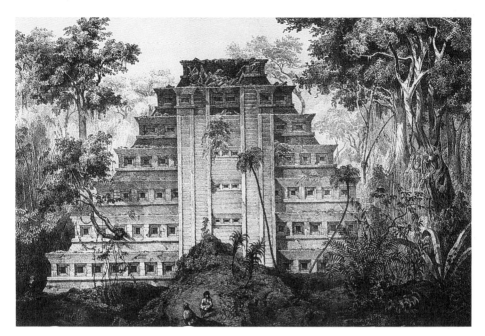

67 The Pyramid of the Niches, El Tajín, as published by the explorer Carl Nebel in his 1829 account of his travels to the New World. Early Classic.

mountain meets plain. The Veracruz coast was known for its verdant croplands even in prehispanic times, and the Aztecs coveted the maize, cacao, and cotton grown in the area. El Tajín was discovered toward the end of the eighteenth century, just about the time that Maya sites began to catch Western attention. In 1829, the German explorer Carl Nebel visited the site, and the fine color lithographs he later published evoked the same kind of mystery as Maya ruins. Early travelers believed the Pyramid of the Niches to be the most important structure *67* at El Tajín, which indeed it is in the sense that it dominates the main ceremonial core, at the center of hundreds of acres of ruins, despite its relatively small size (approximately twenty-six meters on a side and less than twenty meters high). It is generally considered to have been completed before AD 600. On a natural rise above the ceremonial core stands a group of structures known as Tajín Chico, thought to postdate the constructions below it.

The Pyramid of the Niches rises in six distinct tiers of an unusual, fussy talud-tablero and houses within it a smaller, and therefore

earlier, similar pyramid. Each entablature supports a row of niches, making 365 niches in all, which implies that the pyramid refers to the solar year. The niches are each about sixty centimeters deep, and although it is tempting to think that they held offerings, no evidence is available that they did. Perhaps the niches were for purely visual effect: on a bright day they reflect and shimmer in the sun, giving the illusion of constant motion.

The Pyramid of the Niches has some unusual features that link it to Maya architecture at Copán; El Tajín may well indeed have had some
107 direct contact with that site. Both the Hieroglyphic Stairs at Copán and the Pyramid of the Niches have balustrades with similar running fret designs. In fact if the abutments of the Pyramid of the Niches featured seated lords, the resemblance to the Hieroglyphic Stairs would be striking, albeit on a diminished scale. Moreover, the only
68 true stela from El Tajín was found at the base of the Pyramid of the Niches. In some ways it looks like a crude Maya effort, and in its three-dimensionality, costume, and posture, it bears closest compari-
122 son to the stelae of Copán.

The lowlying galleried structures of Tajín Chico were constructed using an innovative technique. A concrete accretion with a lime base was poured over a wooden framework, resulting in a strong, durable construction. Geometric patterning worked on the building façades may correspond to the contemporary designs at Uxmal, in Yucatán.

68 This stela, found at the base of the Pyramid of the Niches, El Tajín, shows a single standing lord dressed richly in ceremonial garb. The sculpture bears resemblance to certain Maya stelae, particularly those of Copán (cf. ill. 122). Drawing by Michael E. Kampen.

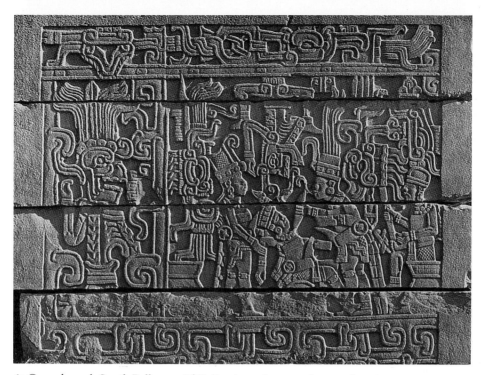

69 Carved panel, South Ballcourt, El Tajín. An unfortunate loser at the ballgame is being sacrificed by two victors while a third looks on. A death god descends from the skyband above to take the offering. Late Classic.

At least eleven ballcourts have been located in the central core of El Tajín. No other site in Mesoamerica has such a preponderance of masonry playing surfaces: indeed El Tajín was very probably a center for great ceremonial games, in the same way that Olympia served as the recognized meeting point for sportsmen from all over ancient Greece. El Tajín seems also to have been a major center for the collection of natural rubber, and perhaps the solid black rubber balls with which the game was played were made there. Various lineages could have sponsored their own court, or each successive ruler could have been obliged to commission a new one. For whatever purpose, the courts were made in profusion here, and their walls present the most extensive architectural sculpture of Classic Veracruz.

Six narrative panels relate a ballgame myth or story along the vertical surfaces of the South Ballcourt. In the first panel, the

participants dress for the event; in another, one player conceals a knife behind his back. In the illustration shown here, set within a ballcourt 69 (but oddly enough, one with an architectural profile different from that of the South Ballcourt itself), two players hold down a third and prepare to cut out his heart. A descending skeletal monster twists down from the upper margin, presumably to take the sacrifice about to be proferred, while another skeletal monster at left rises from a jar. At Olympia, the imagery on the main temple pediment recorded conflict in abeyance; in Mesoamerica, no such enlightenment accompanies the ballgame.

At the time of the Conquest, the ballgame was known to be played for various motives. As an athletic event, it was frequently the subject of much gambling. It could also be a gladiatorial contest, where a captive's or slave's strength and desire to avoid death were tried out. The sacrifice of players also informs us that the game was played in order to offer human blood to the gods. In Classic times, the game may have been played for all these purposes, not only at El Tajín, but also in the Maya area and at Cotzumalhuapa. The images in the South Ballcourt possibly record a sort of ritual warfare, as seen in one specific ballgame. The use of the ballgame as a metaphor for other struggles was known at the time of the Conquest and is perhaps most clear in a Quiché Maya text, the *Popol Vuh*, where the confrontation of life and death is couched in terms of a ballgame.

The reliefs of the South Ballcourt were probably worked *in situ*, since several flat stones form a single carving surface, like those of Chichen Itzá. A distinctive double outline is used to work all the 152 designs, but particularly the scrolls. The reliefs would now appear to have their origins in Middle and Late Formative Olmec styles, as well as in the curvilinear Late Formative style of Izapa. This double-outline workmanship is so characteristic of Classic Veracruz that it indicates the origins and relative date of materials found as far away as Teotihuacan or Kaminaljuyú. 57

Three kinds of objects – frequently decorated with scroll motifs – have been recovered in great abundance in Mesoamerica: yokes, *palmas*, and *hachas*. Most of them come from Veracruz, but at both Palenque and Copán, Veracruz ballgame paraphernalia were found in a context contemporary with the abandonment of these sites. The players on the South Ballcourt relief seem to show how at least two of 69 these objects were worn. Yokes were fitted around the waist, attached 71

70 (*opposite*) A large, hollow ceramic female sculpture, Late Classic Veracruz style. Black asphalt, a petroleum product known locally as *chapapote*, has been used to highlight the sculpture. Works of this sort continued to be made into Postclassic times.

sideways. Despite the doubt cast on whether these cumbersome stone objects could ever have been worn (the weight must certainly have altered a player's center of gravity), they were probably manageable for a skilled athlete. *Palmas* were inserted into the yokes at waist-level and extended to mid-chest height. *Hachas* may have served as markers for play. The scrollwork of the yokes is sometimes exceptionally fine and complex, and often the design cannot be understood until completely drawn out. Some motifs emphasize themes of the ballgame itself.

72, 73

Full-scale stone carvings of Classic date have been found elsewhere in Veracruz as well, particularly at the site of Cerro de las Mesas, which may be best known for the huge cache of Olmec jades discovered in a Classic context. Stone stelae at the site bear Initial Series inscriptions that correspond to Early Classic Maya dates. Stela 8 records a date in AD 514 and shows an individual who was presumably a ruler of that era. Curiously, he wears a shield emblem in his headdress of the type prominent in the name glyph of Pacal of Palenque, the Maya king who came to power by the end of that century.

76

Fine hollow clay sculpture was produced at various centers throughout Veracruz during this era, perhaps continuing a tradition established by earlier Olmec artisans. It was a tradition sustained until the time of the Conquest, with the result that the exact date of some of these pieces is in doubt. Uncertain too is the specific provenance of the majority of the sculptures. Some have been traced to particular sites, but most are isolated finds. Those of Remojadas are particularly lively and are often characterized by 'smiling' faces, which may in fact be the result of ecstatic rituals. Charming couples are found in pairs or on swings, and little animals turn on wheeled feet. Such toys are the only known use of the wheel in ancient Mesoamerica. The potters painted many of these sculptures with shiny black asphalt, locally called *chapapote*, a naturally occurring petroleum product (no other use was known in Precolumbian times for the plentiful oil of Veracruz).

75

74

Probably of later date are the large-scale hollow figures, many of which represent Postclassic deities, although the chronology is far from certain. The one shown here is of a large seated woman. Others stand with arms extended, perhaps in greeting but perhaps to warn away a violator of a tomb or cache. Snakes form their belts, and some may represent a *cihuacóatl*, or woman snake, known in Postclassic times as an evil deity who lurked at crossroads.

70

71 A stone yoke, in Classic Veracruz style. When the design of this one is unwrapped from the stone, it shows a great stylized toad. Players in ill. 69 wear yokes – perhaps of stone, or perhaps of a lighter, perishable material. Late Classic.

72 A stone *palma*, in Classic Veracruz style. The heart has been removed from this unfortunate fellow. In ill. 69 the *palma* springs from the waist, as if directly inserted into the yoke. Despite such illustrations, it is still not clear just how these objects functioned in the ballgame. Late Classic.

73 *Hachas* in Classic Veracruz style such as this one may have functioned as portable markers on the ballcourt. Late Classic.

74 A wheeled Veracruz figure of the Classic period. Small ceramic figures with wheels such as this have been found among Classic Veracruz remains, but the wheel was apparently never used for practical purposes in ancient Mesoamerica.

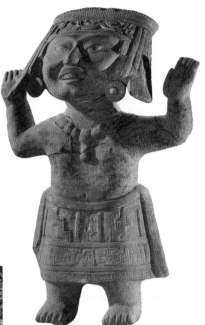

75 (above) A hollow clay figure with a 'smiling face,' perhaps from Las Remojadas, where many such ceramic sculptures were found. Late Classic.

76 Stela 8, Cerro de las Mesas. Monuments from this site show affinity to Maya works. This one bears an Initial Series date in Maya style equivalent to a day in the year AD 514.

Connections among Classic Veracruz, Monte Albán, and Teotihuacan were close during the middle of the Classic era, implying a 'Middle Classic' to some scholars, who have recently suggested that the terms Early and Late Classic are too specifically linked to the Maya sequence. We avoid use of the new term here until more secure dates can be established for many of the sites and finds in question. Nevertheless, this fresh research has brought to light the importance of the regional style of art and architecture known from Santa Lucía Cotzumalhuapa and its environs. Despite its location on the Guatemalan coast and its proximity to the Maya area, Cotzumalhuapa participated in the pan-Mesoamerican flowering, and it shared characteristics with other Classic cultures. The Isthmus of Tehuantepec may have made communication easier between Veracruz and the Pacific coast.

The makers of Cotzumalhuapa art were probably not Maya, and, although they have often been identified with the Pipil (Náhuat

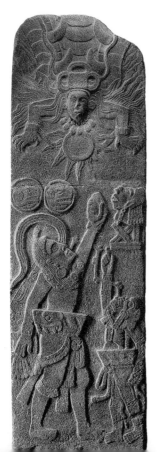

77 Stela 3, Santa Lucía Cotzumalhuapa. A ballplayer in a yoke like that of ill. 71 stands in front of a temple; reaching toward the sun, he offers what may be a human heart.

101

speakers in Guatemala at the time of the Conquest), we will probably never know their ethnicity. We do know, however, that they carved stelae and panels rife with images of the ballgame, human sacrifice, and the sun. Glyphs were inscribed in round cartouches – some appear to be part of a Central Mexican calendrical system, although none of the glyphs have been securely read. The figures on the monuments are 77 generally long and attenuated, of proportions similar to those drawn on Late Classic Maya vases from such highland Guatemalan sites as Nebaj. Right and left hands and feet are often confused in the Cotzumalhuapa depictions.

Ballgame rituals played between humans and supernatural beings 77 appear on several stelae. Whether or not divine, the individuals wear ballgame equipment similar to that of Veracruz, and abundant *hachas*, yokes, and *palmas* have been collected at Cotzumalhuapa sites. Descending solar deities on the upper parts of the monuments may prefigure the Postclassic 'diving gods' of the Caribbean coast. These deity faces are worked frontally in three-dimensional relief, in striking contrast to the low relief of the profile figures below. Some fully 78 three-dimensional monuments were also created, and they may relate to the tradition of sculpture in the round at Copán.

78 Sylvanus G. Morley kneels beside this fragmentary stela from Pantaleon in Cotzumalhuapa style. Comparable three-dimensional portraits of the Classic period are known from El Tajín (ill. 68) and Copán (ill. 122).

The Early Classic Maya

Classic Teotihuacan had already become an important center and cultural force by AD 150, but it was not until a hundred years later – about AD 250 – that the Maya entered upon their period of greatest prosperity and influence. By this time, Maya temples with corbeled vaults were being constructed, and stone stelae with Long Count dates and ruler portraits erected. All these elements appeared independently long before AD 250, but it was the beginning of their combined, continuous and widespread use that roughly establishes the Classic era among the lowland Maya.

During the first 300 years of the Maya Early Classic (AD 250–550), major growth of cities was limited to the Central Petén, particularly at the sites of Tikal and Uaxactún. Contacts with Teotihuacan were strong, and local elites adopted Teotihuacan modes of dress and burial. Toward the end of the Early Classic, however – in the sixth century – many other Maya sites started to expand, Copán, Yaxchilán, and Piedras Negras among them. Simultaneously, the profound influence of Teotihuacan waned, and Teotihuacan motifs and costume elements, although they did not vanish, became so thoroughly incorporated into the Maya repertory that they ceased to be foreign. By Late Classic times (AD 600–900), Tikal was only one of many well-established Maya cities, from Palenque in the west to Uxmal in the north, Altun Ha in the east, and Copán and Quiriguá in the south. At its height, Tikal may in fact have had a population of only 50,000, so these Maya cities were much smaller than Teotihuacan. They were united by, amongst other things, the common use of the hieroglyphic writing system, but their monumental carvings and architecture reflect both regionality and innovation.

ARCHITECTURE

Archaeological work at Tikal and Uaxactún (literally 'eight stones,' a name given by Sylvanus G. Morley to refer to the early Cycle 8 dates

there) has revealed much of what we know today about the Early Classic.

Preliminary architectural and ceramic studies at Uaxactún, initiated in the late 1920s, indicated to the archaeologists that Group E, an isolated cluster of buildings, was the oldest part of the site. In a search for the origins of Maya high civilization, Structure E-VII was dismantled layer by layer, revealing a series of building phases. The earliest one, now known as E-VII-sub, is a small, radial pyramid just over eight meters high, with staircases on all four sides flanked by giant mask façades. The principal orientation of E-VII-sub is to the east, indicated by a stela at the base of the stairs on that side. Postholes on the upper level mark the remains of a perishable superstructure, which suggested to the archaeologists that the pyramid might antedate the general use of permanent superstructures. Indeed, E-VII-sub does seem to be a Protoclassic pyramid, probably preceding the widespread erection of dated stone monuments.

Functionally, E-VII-sub works as a simple observatory. From a point on the eastern stairs, the lines of sight that can be drawn to the three small facing pyramids mark the lines of sunrise on the days of the solstices and equinoxes. The maltese-cross plan of E-VII-sub resembles the Maya completion sign, as do plans of other radial structures, and most such structures record the completion of some period of time. At E-VII-sub it is the solar year that holds significance, as it is at the Castillo, Chichen Itzá, built much later. Twin radial pyramids at Tikal were erected on platforms to commemorate the completion of *katuns*, the twenty-year periods, during the Late

79 E-VII-sub, Uaxactún, a radial pyramid, was probably completed before the first Early Classic stone monuments were raised at that site. A perishable thatched structure once stood on top of the pyramid.

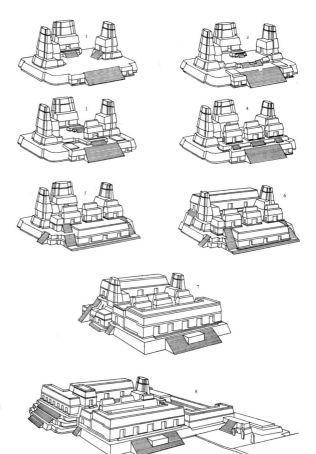

80 Based on the archaeological exploration of Uaxactún, Tatiana Proskouriakoff drew reconstruction drawings (after which these are adapted) of the eight major phases of architectural development at the site. Single shrines of the Early Classic eventually gave way to multi-chambered galleries in the Late Classic.

Classic, while the maltese-cross emblem that functions as a frontispiece to the Late Postclassic Mexican manuscript Féjerváry-Mayer is a *181* 260-day calendar. Thus radial configurations, from their earliest appearance at Uaxactún until the Conquest, indicate the passage of time, and structures in such form are generally giant chronographic markers.

Excavations in Group A at Uaxactún revealed a different pattern of construction. A three-temple complex, A-V, was transformed over a period of at least 500 years, its growth inspired by ritual interments of *80* both important people and stone monuments. The term 'temple' generally refers to an elevated platform with a relatively small superstructure where offerings were made. Because new temples were

105

erected over rich tombs of important individuals, or in some cases the inscribed records of those individuals, one can only suppose that the structures were shrines to memorialized ancestors. As we shall see, a focus of Classic Maya religion and architecture was ancestor worship.

At complex A-V, by the end of the Early Classic, small temples obscured the courtyard of the three original temples, which had also been expanded through time. During the Late Classic, these single-chambered shrines of A-V gave way to multi-chambered galleried structures, the type of building normally considered a palace (and often called 'range-type' structures by archaeologists). These palace buildings drastically altered access to the old interior platform and shrines, and presumably function changed along with form. Although burials were deposited in the new structures, they were not elaborate and were limited to women and children. At the end of its life, when galleries had replaced all but one of the shrines, A-V had become a great administrative or bureaucratic complex, where most events took place away from public view, and where secular activities dominated sacred ones. A separate temple raised beside A-V can be interpreted in this light as a new focus for religious activity, and it probably housed a rich tomb.

Many elements of Maya city planning can also be observed at Uaxactún. The gently rolling karst limestone topography of the Petén provides islands of solid foundation separated by swampy *bajos*. Typically, the Maya built their sites so that clusters of monumental architecture on firm ground were connected by *sacbes*, elevated, stuccoed white roads which spanned the swamps. The result is a skyline of towering structures broken by open stretches. We might compare the result with modern Manhattan, where less firm rock has to date precluded the building of skycrapers between Midtown and Wall Street. The skyline thus appears as islands of construction, connected by the great north-south avenues. At Uaxactún, Groups A and B are connected by a single causeway, and address one another across the north-south axis of the *sacbe*.

At Tikal, fourteen years of large-scale archaeological exploration by University of Pennsylvania archaeologists in the grandest of all ancient Maya cities has revealed an intricate pattern of architecture and urban planning. Before AD 250, the North Acropolis and the Great Plaza were laid out to define the strong opposition of mass and space, north-to-south, that prevailed for the rest of the city's history. (The

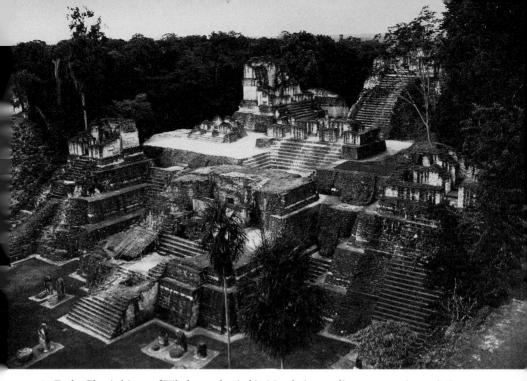

81 Early Classic kings of Tikal were buried in North Acropolis structures (center). In the Late Classic, Temple II (at left, out of the picture) and Temple I (from where this picture was taken) framed the ancestors.

equally strong east–west axis created by Temples I and II was not established until Late Classic times). Massive temples clustered on the North Acropolis functioned primarily as funerary monuments to the *81* Early Classic rulers of Tikal. Structure 34, for example, housed the richly furnished tomb of the king archaeologists have nicknamed Curl Nose. Abundant grave offerings refer to this individual. After his death, Stela 4 (his accession monument) was placed in front of the tomb. Once completed, the North Acropolis must have embodied the spirit of ancient kingship.

Typical features of these Early Classic funerary pyramids are their squat proportions and the massive apron moldings that wrap around corners. Some of the pyramids feature large mask façades on either side of the single staircase.

South of the Great Plaza lies the Central Acropolis, where Early

Classic palatial structures may well exist buried beneath the ones now visible. Southwest of the Great Plaza stands the so-called Lost World pyramid, a huge radial building of early date, with badly damaged giant masks. The plan resembles a Maya completion sign and, like other radial designs, may refer to the passage of time.

In these Early Classic Tikal and Uaxactún structures, we see the most prevalent types of architecture to survive from the Classic Maya era: great chronographic markers, memorials to ancestors (probably religious structures), and bureaucratic structures. Were we to examine buildings of such different function from another part of the world, we would probably find that they were executed using different forms, perhaps separate architectural orders. Among the Classic Maya, there was no architectural style linked exclusively to, say, religious structures. All Maya architecture was composed of elevated platforms and corbel-vaulted chambers, organized in a variety of configurations. This makes the precise identification of function not always an easy task.

The corbel vault has sometimes been disparaged as a false arch, but the true keystone arch was not a goal of Maya architecture. To form a corbel, masonry walls were built to the desired height. At the spring of the vault, flat stones were placed closer and closer together until they could be spanned by a single capstone. The weight and mass of the walls helped prevent collapse, as did cross-ties, many of which remain in place today. They were probably useful in raising the vaults. Exterior mansard roof profiles often followed the lines of the corbel, resulting in a stone architecture that almost perfectly reproduced Maya thatched houses, still made by Maya Indians today. The stone capstones conform to the hip roof of the thatched house, and it seems likely that this was a desired effect. At Palenque, the conceit of the thatched house was emphasized in the buildings of the Palace, where sheets of shale were sheared off to look like thatch at the overhang of the mansard. On Late Classic buildings throughout the Puuc region, where sleek vertical lines supplanted the mansard profile, the architectural ornament at vault level featured thatched Maya houses, as if to inform the viewer of the relationship of permanent stone constructions to the humble, perishable dwelling. Almost all Maya interior spaces, then, repeat the forms of the Maya house. It is not a 'false' anything, but a 'true' Maya transformation of simple forms into elevated permanent ones.

82 Stela 29, Tikal, records the earliest contemporary Maya Long Count date, 8.12.14.8.15, corresponding to a day in the year AD 292. University of Pennsylvania archaeologists recovered the monument in 1959 from debris near the Great Plaza. Drawing by William R. Coe.

SCULPTURE

At about the time that the Maya began to use the corbel vault, they also started to erect stone monuments carved with portraits of rulers and information about those rulers. A system of hereditary kingship had evidently become established. Royal individuals now commanded the power to have themselves honored in a permanent medium during their lives, and probably to be commemorated posthumously as divine. The earliest of these new monuments with secure date and provenance is Stela 29 at Tikal, recovered from a garbage dump by archaeologists. (Other stelae were found tossed into piles of refuse or

109

cut into building stone, but some had been reverentially buried and still others had evidently never been removed from public view in Maya times.) The roughly hewn shaft of Stela 29 was carved on one surface with a portrait of a seated Tikal ruler; the other face records a Long Count date, 8.12.14.8.15, or AD 292. Such dates denote important events and the names of their protagonists; unfortunately in this case the butt of the stela was broken off and lost in antiquity, thus depriving us of the complete record.

Typical of the representation of these early Maya lords are the very round and irregular forms. The right hand is drawn curled, as if in a mitten, and it presses a ceremonial bar to the body – many Maya kings throughout the Classic period are shown carrying this object. What is generally thought to be an ancestor figure looks down from the upper

83 Stela 4, Tikal. An Early Classic ruler called Curl Nose by archaeologists is depicted at the time of his accession, c. AD 380. The frontal face of the ruler and the trimmed feathers of his costume are characteristic of Teotihuacan depictions of the same period.

portion of the stela, in a manner similar to the deities in the upper margin of late La Venta stelae. With his left hand, the ruler supports an image of a supernatural figure generally known as the Jaguar God of the Underworld, identified by his tau-shaped tooth, jaguar ear, and 'cruller' over the nose. All early Tikal rulers carry this deity, and he is probably a patron of the city. *cf. 5*

Stela 4, perhaps reset on the Great Plaza in Late Classic times, records the accession to power in AD 380 of the ruler known as Curl Nose. Technically, the monument is very similar to Stela 29, with its uneven surfaces and low relief, but the image is distinct. Curl Nose is seated, like his predecessor, and he bears the Jaguar God of the Underworld on his right hand, but he is shown with a fully frontal face. He wears a headdress comprising a frontal head of a plumed jaguar and a collar of pecten shells. This attire mimics Teotihuacan fashions, as does the frontal face, and along with a few eccentricities of the inscription this has led to the suggestion that Curl Nose may have been a usurper, a foreigner married to a Tikal woman, or perhaps a Mexicanized Maya from Kaminaljuyú in highland Guatemala. It may also simply show the desirability of acquiring Teotihuacan goods and imitating Teotihuacan styles in the fourth century. *83*

About 9.0.10.0.0, or AD 445, Tikal Stela 31 was erected by a ruler today called Stormy Sky. Like Stela 29, Stela 31 too was removed from public view in antiquity; during Late Classic times, its broken shaft was hauled to the top of Structure 33 and interred with burnt offerings under a shrine. Stormy Sky had himself carved in a manner similar to the ruler on Stela 29, in what one takes to be an intentionally conservative style, perhaps invoking the legitimacy of the past. Stormy Sky bears abundant ritual paraphernalia, possibly tokens of his high office. He holds the Jaguar God of the Underworld in the crook of his right arm, but this time the deity wears the twisted-strands-and-knot symbol emblematic of Tikal, and he and the man who carries him probably both symbolize the site and its lineage. Although we can consider this sort of sculpture a portrait, it is more a portrait of the trappings of office than the representation of a particular man. *84*

Unlike Stela 29, 31's surface is smooth and uniform, a finer-grained limestone having been selected for the carving. Also, unlike Stela 29, Stela 31 was worked on all four surfaces of the stone prism. If we unwrap the design, Stormy Sky is flanked by a pair of individuals

84 Stela 31, Tikal. Stormy Sky, as this ruler is known, is shown on the front of the monument. He is flanked on the sides (not shown) by warriors in Teotihuacan style dress, or perhaps just two sides of the same warrior, and the long text at the back recalls the Early Classic Tikal dynasty, up until 9.0.10.0.0, or AD 445.

85 The so-called Po panel. Named for the glyph that appears on the thrones on which the two figures sit, this wall panel shows two Bonampak rulers of the Early Classic.

attired in more simple Teotihuacan garments, who also bear *atlatls*, or spearthrowers, in one hand and a shield in the other. We might also see this as two side views of the same individual, standing behind Stormy Sky, for shield and weapons are reversed. The more visible shield bears an image of Tlaloc, generally thought to have been a Teotihuacan rain deity, but now known also to have been associated with war and sacrifice in all Classic cultures. Although it is tempting to interpret these two figures as evidence of a Teotihuacan military presence in Tikal, it is just as likely, given the text above, that these figures represent Stormy Sky's father, Curl Nose, who is shown in what may be considered 'period' costume.

Most Uaxactún monuments have suffered such serious erosion over time that few remain legible except for their Long Count dates. At the end of the Early Classic, monuments were erected at many other sites. In a number of cases, even these first hesitant works indicate the regional styles that later flourished at these places. Monument 26 from Quiriguá shows a ruler in frontal pose, like all later monuments at that site. In style, it probably drew on both the wraparound conventions of Central Petén stone monuments and early cache vessels: portable *92* goods might have influenced provincial developments. At Yaxchilán, the earliest figural monument shows a standing lord in profile who makes a 'sprinkling' or 'scattering' gesture. Multifigural designs

appeared first far from the Petén, and the so-called Po panel may be the earliest work in stone where two lords face one another across a panel of glyphs. Nevertheless, despite these developments, Early Classic stone sculptures were restricted in composition and theme, especially when compared with the exuberant Late Classic works.

In 1864, workers digging a canal near Puerto Barrios, Guatemala, came across one of the most remarkable of Early Classic sculptures, together with a Postclassic cache of copper bells. Now known as the Leiden Plate, this beautiful piece of translucent jade was once a fancy costume element, one of three jade plaques hanging from a head worn at the waist. The imagery suggests that the object may have been a kind of portable stela, for the ruler portrait on the front and the inscription on the back conform to monumental Tikal works of the time. The Maya lord stands over a prone, bound captive, and bears a pliable serpent bar in his arms. Mitten-like hands and the parted profile legs also indicate the early date.

86 The Leiden Plate. On this handsome jadeite ornament – perhaps it was a 'portable stela' – a Maya lord proudly stands on the captive underfoot. The date recorded, 8.14.3.1.12, corresponds to a day in the year AD 320.

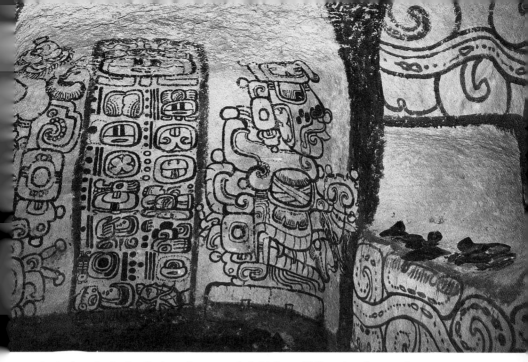

87 Archaeologist Ian Graham first recorded this beautifully painted monochromatic tomb at Río Azul, after grave robbers had uncovered it. Early Classic kings were buried here, possibly with more elaborate offerings than those at Tikal. A Long Count date of 8.19.1.9.13, or AD 417, is inscribed. The glyph at the bottom of the left-hand column indicates birth – perhaps to mean rebirth in the underworld.

PAINTING

Several Early Classic wall paintings have survived the ravages of time. Perhaps the most beautiful of these is the tomb painting first encountered by looters at Río Azul, in northeast Petén. A fourth-century Maya date and text are framed by deities, including the Maya sun god, at right, with a glyph for *k'in*, or sun, in his cheek. The side walls are marked with wavy, beaded symbols that indicate liquid, probably the watery surface of the underworld. The deceased would have been laid with his head at the text, and his body just within the liminal, watery world that the Maya perceived as the entrance to the afterlife.

The Río Azul painting is monochrome, a simple black pigment on white stucco, and the line is sure, strong, and highly calligraphic, each stroke ending in a whiplash. The artist may have used a turkey feather as his brush. Contemporary paintings at Tikal (Burial 48) are by

87

comparison less well executed, although the configuration is similar: a Long Count date is surrounded there by symbols of precious liquid, asymmetrically painted across the walls of the chamber. A bright polychrome scene found at Uaxactún shows musicians, families, bloodletting, and a meeting of a Maya and a Teotihuacan lord.

FUNERARY RITES AND OFFERINGS

The great tombs uncovered in the North Acropolis excavations at Tikal brought to light the finery and pomp of Early Classic funerary practices, and in many cases also gave meaning and context to the many objects known without such clear provenance. When Maya kings were prepared for interment, they were splendidly equipped for their journey and transformation in the underworld, and funerary furniture often reflected these concerns in its iconography.

Curl Nose died about AD 425. He was borne on a litter into his tomb – at first a perishable structure at the base of what would become after his death the building we call Structure 34. He was probably accompanied by a great procession of musicians who laid down their instruments, turtleshells and deer antlers in the tomb. Others in the procession, like those depicted in the later Bonampak murals, may have worn exotic costume: a set of crocodile scutes was also recovered from the tomb. Nine individuals, perhaps those very procession members, were then sacrificed and placed alongside the dead king. Many fine ceramics were placed in the tomb, some of them no doubt filled with perishable contents. Many of these pots show strong Teotihuacan influence in terms of imagery, shape, and technique, but none are thought to be Central Mexican imports. Many resemble those also produced at Kaminaljuyú, in the Guatemalan highlands. In fact, burial complexes there contained a similar configuration of exotic materials, and both may reflect a Teotihuacan tradition, although there are no known royal Teotihuacan burials with which to make comparisons.

Lidded, stuccoed tripod vessels predominated in Maya royal funerary offerings during the late fourth and fifth centuries. Shape and technique are similar to and perhaps derived from contemporary Teotihuacan pots, but the Maya products taper at the 'waist,' and the less weighty Maya lids often have anthropomorphic or zoomorphic knobs. The human head of the lid in the illustration here in fact

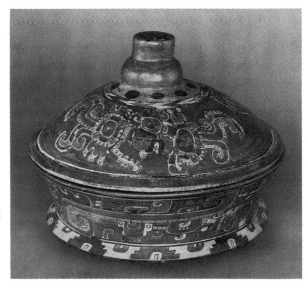

88 A large basal flange bowl and lid, Early Classic. Disembodied heads float against a deep red ground on the lid – the bowl is banded by water markings.

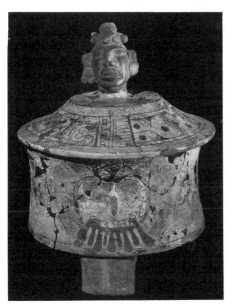

89 An early Classic Maya tripod vessel, Burial 10, Tikal. This vessel in Curl Nose's tomb was made with the tripod feet typical of Teotihuacan pots of the time, but the anthropomorphic lid was a purely Maya device.

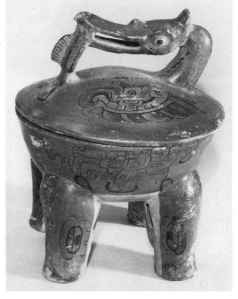

90 Two-part quadrupod ceramic effigy in the form of a water bird. Many Early Classic funerary vessels show the fauna of the liminal 'underwater world' through which the deceased would pass.

suggests that the vessel itself is human. In certain instances the stucco technique is combined with incision of clay at its leather-hard stage, and the two techniques are occasionally worked together with dazzling finesse. Some of the pots, among them the recently excavated ones from Río Azul, have 'screw-top' lids; and others have rattles in the base of the bowl. Many ceramics of this era depict purely Maya imagery in the stucco painting, but Teotihuacan influence is also strong: a ring-stand bowl from Curl Nose's tomb shows Central Mexican deities.

91 Two-part ceramic effigies have also been recovered from Early Classic tombs. An especially fine one was placed in Curl Nose's tomb. The old squat deity sits on a stool of crossed human femurs and holds a human skull in his hands. About twenty-five years later, a Tikal lord was interred without head, femurs, or feet. Although he might have been brought back from the battlefield in this state, his mutilated skeleton could also bear witness to the practice of collecting relics from royal persons. Years later, Ruler A of Tikal was buried with a collection of carved bones, some of them cut from human femurs.

Other types of fine ceramics were made in Early Classic times. Basal-flange bowls probably pre-dated the advent of tripod vessels in

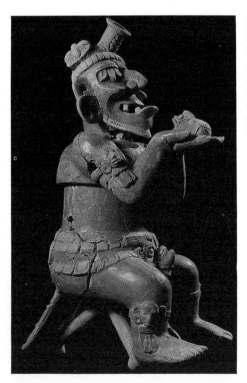

91 This two-part effigy was also found in the tomb of Curl Nose at Tikal. Smoke from burning incense placed within would have billowed from the mouth and forehead tube of the old deity, who holds out a severed head in his hands. He sits on a stool of crossed femurs.

the Maya area, and many had dome-shaped lids. Generally, they were painted with colored slips, and the one shown here has an especially glossy red surface. Disembodied human heads float against the red, which is punctuated by symbols generally associated with precious liquids. Quadrupod vessels occur with the basal-flange bowls, and many are jaguar or bird zoomorphs. The finest are of dark clay, incised at the leather-hard stage and then burnished after firing. The artists enjoyed the interplay between two and three dimensions on these vessels, in a fashion similar to contemporary Moche ceramics in the Andes. In the accompanying illustration, a three-dimensional bird eagerly consumes a fish drawn in both two and three dimensions.

Carved and appliquéd cache vessels are also found, many of them formed of two parts – the lower part often with a human face, the upper, one or two supernatural headdresses. Others simply show deities, and one imagines that offerings were placed in these pots. The deity GI (one of a trio of numerically named gods, GI, GII, and GIII) occurs many times on such vessels. He is marked by the curl in his eye, shark tooth, fish fins on cheek, and shell over the ear, and it is in this guise that a Tikal ruler appeared on Stela 2. A fine Early Classic jade mask of GI is also known, and it was probably placed over a ruler's face in the tomb.

Early Classic jade was generally worked in soft, curving lines, rather than with the sharper drill-and-saw technique of the Late Classic. In some cases, the jade was merely incised; in others, the hard stone was cut into human and animal shapes. Thomas Gann brought a large, fine Early Classic jade from Copán to the United States at the turn of the century, and it probably shows an early sixth-century Copán ruler.

EXTERNAL RELATIONSHIPS

One of the most important questions still to be answered about the Early Classic Maya is the nature of their relationship with Teotihuacan. Military domination by the latter has been suggested, as has an economic stranglehold. Both ideas stem in part from our knowledge of the later Aztec domination of Mesoamerica. There is certainly evidence for profound and sustained contact between Central Mexico and the Maya region, and in the highlands provincial architecture in Teotihuacan style at Kaminaljuyú may well support the

notion of direct Central Mexican occupation there. But what of the lowlands? Although rulers at Tikal and Uaxactún adopted Central Mexican styles of dress, they bore Maya insignia of office, and the very records of their reigns were inscribed on a Maya invention – the stela – in the Maya script. It is true that Central Mexican religious imagery was so common that we may suspect the presence of a foreign cult. And Teotihuacan pottery forms and techniques were re-interpreted by the Maya. Nevertheless, all these clues tell us only that the Maya imitated their Central Mexican contemporaries and acquired similar material goods, not that Teotihuacan people invaded and occupied the Petén. We do not, after all, suppose that the late nineteenth-century denizens of Boston, who wore China silk, ate from Chinese porcelain, and sat on Chinese furniture, were actually under the sway of the Chinese.

The salient physical characteristic of the city of Teotihuacan is its city plan, with its grid of right angles and its architecture of right-angle geometry. It bears no resemblance to the more random, asymmetrical and clustered plan of Tikal, with its architecture of rounded moldings and variable proportions. Only a single structure has been excavated at Tikal in what appears to be true Teotihuacan *talud-tablero*. Nearby Yaxha, where Teotihuacan influence was strong, developed an urban layout that in part followed 'streets,' perhaps an accommodation of Teotihuacan city planning to Petén geography; but it too is truly a Maya city, with causeways and clusters. Contact with Teotihuacan resulted in an increasingly cosmopolitan and luxurious life for the royalty of Tikal, but it did not necessarily deny the essential Maya character of Early Classic Maya civilization, particularly as expressed in writing, architecture, and much of the iconography.

Few inscriptions are known at any Maya site dating from AD 530 to 580, and there seems to have been a considerable falling off in cultural activity at this time, especially at Tikal and Uaxactún. Teotihuacan influence ceased abruptly. Few buildings or ceramics and no monu-ments can be securely placed in this half century in the Petén, although the 'hiatus,' as Sylvanus G. Morley named it, is not so complete in the peripheral regions. One can hypothesize possible causes (economic depression, disease, or conflict with Teotihuacan), but all we know for certain is that the lapse was temporary. When the Maya became more active again at the end of the sixth century, styles in art, architecture, and ceramics all showed dramatic changes.

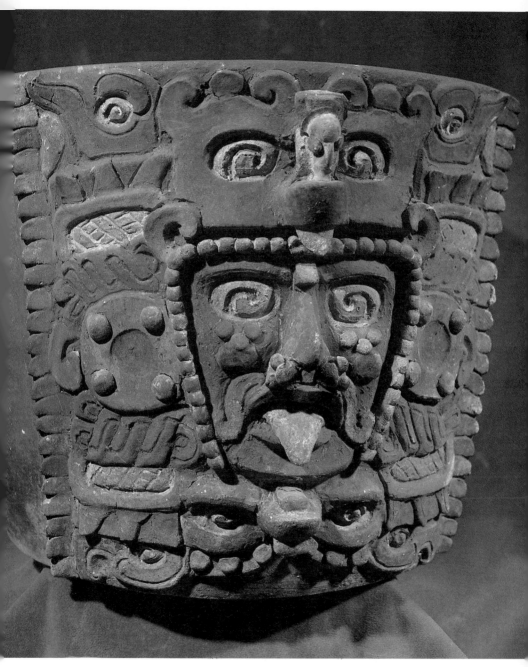

92 The deity GI is worked in appliqué on this Early Classic cache vessel. The fishy cheek barbel and scroll in eye characterize this important supernatural figure. Here he lacks the bivalve earpiece and quadrupartite badge he normally wears.

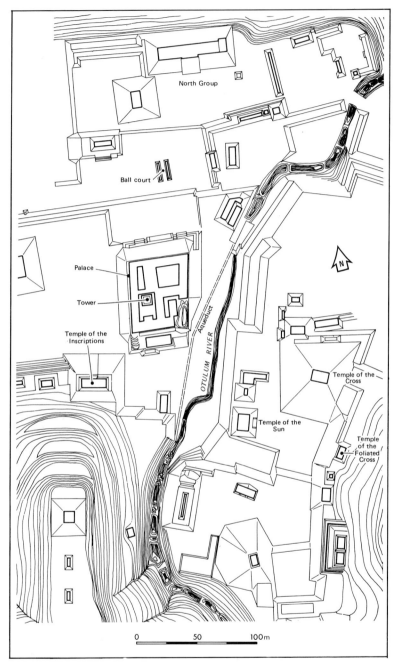

North Group

Ball court

Palace

Tower

Temple of the
Inscriptions

OTULUM RIVER

Aqueduct

N

Temple of the
Cross

Temple of the
Sun

Temple
of the
Foliated
Cross

0 50 100m

93 Plan of Palenque.

CHAPTER SEVEN

The Late Classic Maya

Of all Mesoamerican art and architecture, that of the Late Classic Maya has long been the most esteemed. Even before the travels of John Lloyd Stephens and Frederick Catherwood brought the great temple pyramids and stone carvings to public attention in the 1840s, Alexander von Humboldt had remarked upon the naturalism of much of Maya imagery, and students of ancient art had praised the ability of the ancient Maya to draw the human figure. Late Classic Maya art is undoubtedly very human, and the attention to the individual, whether in the courtly Bonampak paintings or the solemn, three-dimensional stelae of Copán, has always attracted the modern, western viewer, as has the remarkable preservation of Late Classic buildings. Moreover, the art and architecture of the period are more abundant than those of any other style or date in Mesoamerica. Having already been abandoned to the tropical rainforest for centuries by the time of the Spanish Conquest, most Maya cities were too remote and ruinous to be pillaged in the sixteenth century, and the jungle has helped slow the exploitation of the ruins in modern times. Only since World War II have roads opened the realm of the ancient Maya to the modern visitor.

During the sixth century, the cities of the Petén went into decline. Simultaneously, peripheral regions – Chiapas, the Usumacinta drainage, Belize, and the southern lowlands – began to flourish, perhaps siphoning economic power and cultural energy away from the center.

ARCHITECTURE

Just about the year AD 600, in the foothills of the Chiapas altiplano, Palenque, the most westerly of major Maya cities, embarked upon a period of expansion. Over about 150 years and under the aegis of just a handful of rulers – in large part, the great king Pacal (whose name can be read phonetically in Maya and which means 'shield') and his two sons – the city grew in size, splendor, and importance. Its layout

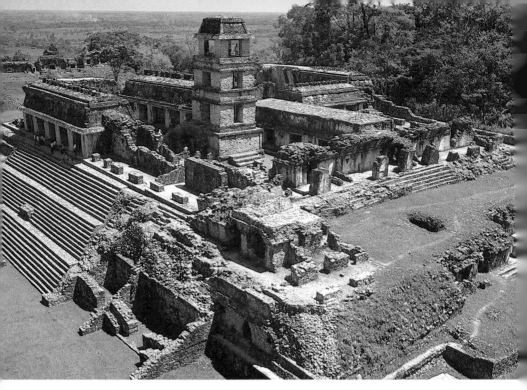

94 The Palenque Palace as seen from the southwest. Behind the tower lies the East Court, famous for its carvings of captives (ill. 95). Subterranean passages honeycomb the section of the Palace in the foreground. Late Classic.

follows the rolling topography of the site, and temple structures crown and emphasize natural rises. The Otulum River passes through the city, and part of it was canalized to bring running water to the Palace. No *sacbes* characterize the architectural plan, but three distinct levels of construction can be discerned down the hillside.

Early Classic Petén masonry was clumsy and heavy, weighty roofcombs leaving little interior space. At Palenque a different aesthetic prevailed, and its architects set corbeled vaults parallel to one another, with a light, cut-out roofcomb over the central wall. Not only did this allow for greater interior space, but it also stabilized the whole construction, and it is partly because of this innovative technique that Palenque architecture is so well preserved today. Solid mass gave way to a web-like shell for the first time in Mesoamerican architectural history.

124

What one sees today of the Palenque Palace was probably built over a period of 100 years, the interior north-south buildings pre-dating the exterior colonnades and the tower. Panels celebrating the accession of several rulers were set inside Palace structures, and scenes on such panels undoubtedly reflect the luxury of courtly life at the time. The fine throne of House E was set under the Oval Palace Tablet, and the doorway to the east court was framed by a stucco bicephalic dragon of the sort that provides the border on accession stelae at Piedras Negras. The east court was ornamented with large slabs of coarse limestone carved with subservient figures. One imagines that sacrificial rituals also took place within the Palace; the proximity of accession and sacrificial iconography probably indicates their close relationship in the rites of kingship.

The final phase of construction in the Palace gave rise to the graceful three-story tower, unique in Mesoamerican architecture. Narrow stairways wend around a solid core. Although the very idea of a tower has led several scholars to think in terms of an astronomical observatory, the building may also have had a defensive function, for from its upper story one can survey the whole plain to the north.

95 Individual carved slabs were placed together to create the great sloping talud of carved captives in the East Court of the Palenque Palace. Lords of the region would have entered the court by the staircase that these humbled figures flank. Late Classic.

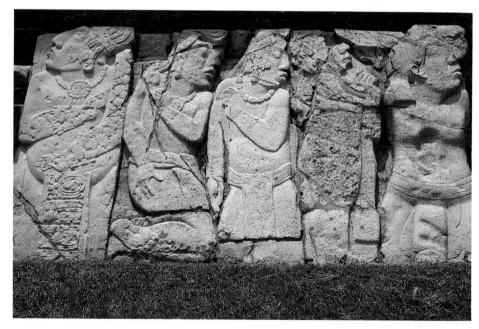

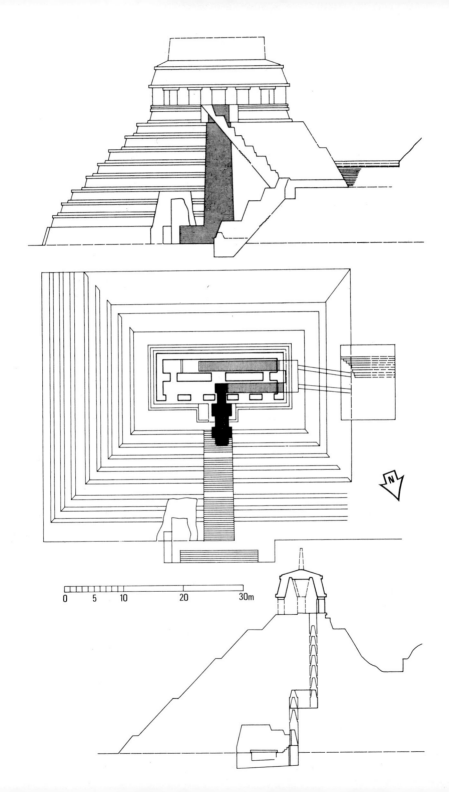

96 Sections, elevations, and plans of buildings at Palenque. *(Opposite)* Elevation, plan and section of the Temple of the Inscriptions. *(Below)* Plan, elevation and section of House E in the Palace. *(Right)* Cutaway model of the Temple of the Cross showing the light roofcomb resting on the central wall dividing the two parallel corbeled vaults.

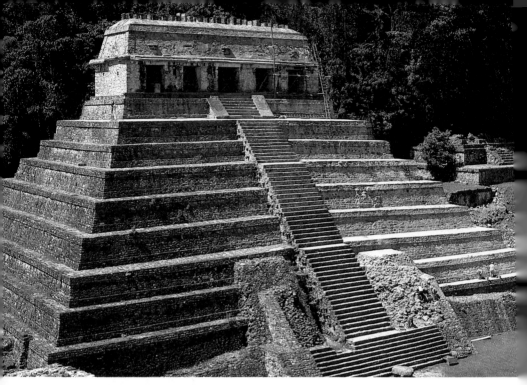

97 The Temple of the Inscriptions, Palenque. The tomb of Pacal lay at the base of this pyramid, accessible for some time after the entombment by an interior staircase that ran from the tomb to the chamber at the top of the structure. Seventh century AD.

Fitted with plumbing that draws on the ancient aqueduct, the Palace was a comfortable building. It seems to have served as the focus for the various royal ceremonies, rather than as a residence for the king's family. It was not filled with the sounds of children or the smells of cooking. Instead, domestic structures no doubt adjoined the Palace, perhaps across the aqueduct.

97 The nine-level Temple of the Inscriptions stands just south of the Palace. Set directly into the hill behind, it is highlighted and framed by the landscape. After discovering that the floor slabs of the chamber could be moved to reveal interior constructions, the Mexican archaeologist Alberto Ruz cleared the staircase and in 1952 found the extraordinary tomb at the base of the pyramid, set on an axis, north–south, with the stairs. Within, a large corbeled chamber held the uterus-shaped sarcophagus of the great king Pacal, whose remains lay 98 covered with jade and cinnabar. The sarcophagus lid shows the king at

the moment of death, falling in rapture into the maws of the underworld. The sides of the sarcophagus display Pacal's ancestors, emerging from the ground, while nine stucco attendants flank the walls. The construction was designed for eternity: even the cross-ties were made of stone (the only examples known) and a small stone tube, or 'psychoduct,' as it is called, connects the tomb to the upper level and thence to fresh air. The Temple of the Inscriptions is unique among all Mesoamerican pyramids in having been built before the ruler's death, probably to his specifications.

Three panels of lengthy inscriptions in the upper chamber relate Pacal's life, and the exterior stuccos show his son as an infant deity, perhaps to demonstrate divinity even during the king's lifetime. Immortalized within funerary pyramids, Maya kings were probably worshipped after death, great ancestors transformed into deities.

The Temple of the Inscriptions rises in nine distinct levels. At the time of the Conquest the underworld was perceived by both Aztecs and Mayas to have nine layers, and Pacal's funerary monument

98 As if in the moment of death, the seventh-century king Pacal is depicted being swallowed by skeletal jaws on his sarcophagus lid at the base of the Temple of the Inscriptions, Palenque.

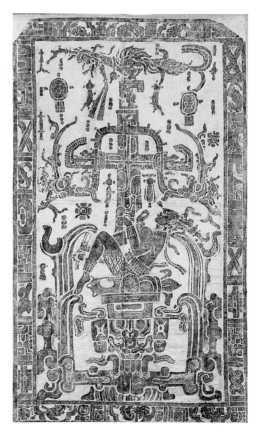

evidently conforms to the same idea of the afterlife, with the lord's tomb placed at the nadir of the pyramid. Likewise, at the Conquest, Mesoamericans believed the heavens to have thirteen levels, a vision of the universe reflected in the stratified Maya world of Pacal, for thirteen distinct corbels connect the tomb to the upper galleries.

East of the aqueduct, the three temples of the Group of the Cross (the Temples of the Sun, the Cross and the Foliated Cross) show yet another architectural innovation. In this design – common to each of the temples – the two parallel galleries are intersected at right angles by another corbeled passage, creating a great chamber. Each temple also has an inner shrine at the rear of the building. The post and lintel doorway, as well as the usual mansard roof, conceal the interior space. At Palenque the achievement of private, interior space is as significant as the negative, public space defined by the volumes of the buildings.

Commemorating the reign of Chan-Bahlum, Pacal's first son, the three Cross Group temples appear in dialogue with one another. The Temple of the Cross may indeed hold Chan-Bahlum's royal burial; the other two probably also enclose royal tombs.

The Late Classic witnessed a burst of development along the Usumacinta and Pasión Rivers too, beginning at the end of the sixth century and continuing until about AD 800. River commerce along the Usumacinta was certainly one of the driving forces behind the growth of both Yaxchilán and Piedras Negras. At Yaxchilán, the river rounds an omega-shaped spit of land. Remnants of stone pilings in the silt perhaps indicate that there was once a bridge or toll gate here. Galleried, range-type structures are set both at plaza level near the river and on the surrounding hills. Structure 40 and Structure 33 celebrate the inaugurations of the two most important Late Classic rulers at Yaxchilán, nicknamed Shield Jaguar and Bird Jaguar. Rising up from great terraces built into the rugged natural relief, both buildings have commanding views of the river.

The architects of Yaxchilán created a few buildings of the double-galleried sort common at Palenque, but in general they were more conventional in their use of interior space. Moreover, they positioned roofcombs directly over vault capstones, which exacerbated the natural tendency of corbeled constructions to collapse and made it necessary to erect ponderous interior buttresses for added support. Most Yaxchilán structures have multiple doorways, and many have finely carved lintels.

99

130

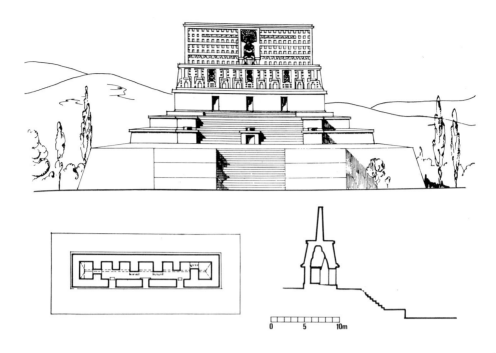

99 Elevation, plan and section of Structure 33 at Yaxchilán.

At nearby Piedras Negras, only a day or two down-river, different influences are evident. Buildings relate to one another, rather than to the river, and they cluster in groups similar to those of Palenque. The inscriptions suggest a general development of the site from south to north that took almost 200 years. The early structures to the south are heavy and massive, with great rounded insets similar to those of the Early Classic Tikal North Acropolis. The West Acropolis at Piedras Negras consists of a central palace compound flanked by two great funerary pyramids, probably the shrines to Rulers 3 and 4 in the dynastic sequence. The palace structures feature double-corbeled galleries like those of Palenque.

At Tikal, the hiatus at the end of the Early Classic seems to have lasted into the seventh century. In the eighth century, however, a program of major new building work began that was sustained for about a hundred years. Instrumental in this revitalization of Tikal was Ruler A, who was buried about AD 727 in Temple I, a pyramid located *101*

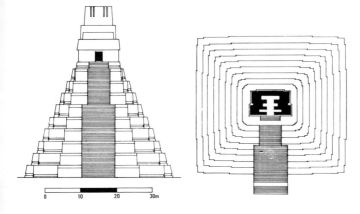

100 Elevation and plan of Temple I, Tikal.

directly across the Great Plaza from Temple II, which had itself been completed just a few years before. Temples I and II dramatically altered the core of Tikal, changing the old north–south axis (conveyed by accretions of buildings with rounded corners and fussy moldings) to an east–west one, defined by just two towering structures with clean lines.

Temple I, like the Temple of the Inscriptions at Palenque, is a nine-level pyramid, and – again like the Palenque building – it was conceived from the first as a complete memorial, from the carved wooden lintels spanning the doorways to the funerary chamber below. Such an elaborate building must surely have been planned before Ruler A's death. Unlike the Palenque temple, however, none of the construction work can have started until the body of the ruler was sealed in the tomb at the base of the temple. Temple II was presumably dedicated to Ruler A's wife (though no tomb has been found), in which case husband and wife would have faced each other through eternity, framing their ancestors to the north.

Like great beacons rising above the jungle, other temples surround the original pair of the Late Classic dynasty. These unexcavated pyramids appear to be funerary monuments of later rulers who respectfully address their forebears. Temple IV is the greatest in both mass and height, rising to sixty-five meters – only the Temple of the Sun at Teotihuacan reached a similar height in ancient Mesoamerica. The Tikal pyramids remain visible twelve miles to the north, from the last great rise before Uaxactún.

Although freestanding and devoid of many of the ornamental moldings typical of Early Classic Tikal, these pyramids of the Late

132

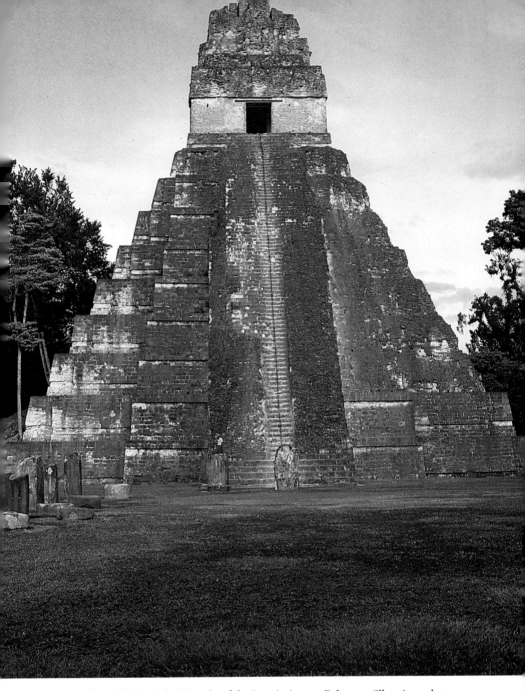

101 Temple I, Tikal and the Temple of the Inscriptions at Palenque (ill. 97) are the two most splendid funerary pyramids of the Late Classic Maya that archaeologists have yet explored. Both structures rise in nine distinct levels, as if a reference to the notion of nine levels of the underworld were incorporated into architectural iconography.

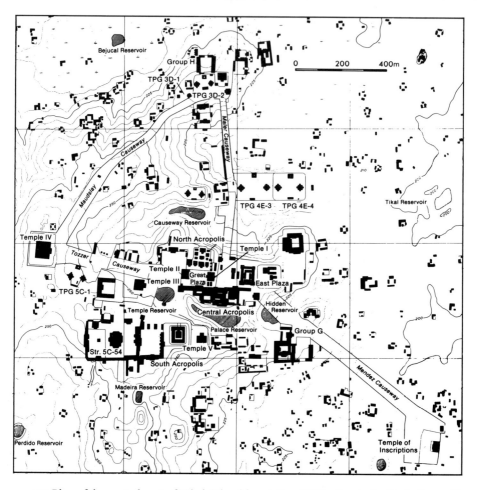

102 Plan of the central part of Tikal. The abbreviation TPG refers to the Twin Pyramid Groups or Complexes erected in the Late Classic. The Early Classic so-called Lost World pyramid is marked here as Str. 5C–54.

Classic retained characteristics of the North Acropolis that are not limited to their funerary nature. In Temple I, for example, a heavy roofcomb was set over the narrow, dark chambers that are accessible through a single doorway, and its weight runs down the spine of the structure. Inset moldings, more streamlined than those of the North Acropolis, both cover the corners of the structure and create a play of light and shadow across the surface.

134

The strong east-west orientation dominated not only the Great Plaza in Late Classic times but also the rest of the site, in outlying groups known as Twin Pyramid Complexes. At least six of these *103* architectural clusters were erected in sequence, presumably to celebrate the twenty-year *katun* cycle which is recorded in each group. The elevated platform of each cluster has the shape of the Maya symbol for completion, and the two radial pyramids on east-west axis recall the chronographic marker at Uaxactún, E-VII-sub. With a range structure to the south and a shrine to a ruler in the open structure on the north, this repeated and well-defined Tikal configuration would seem to reproduce the Great Plaza at its every appearance along the causeways.

No sculpture and little architectural ornament remain *in situ* to help us understand the function and meaning of the Central Acropolis. Its galleried chambers do, however, resemble a palace like that of Palenque, even if organized with less concern for overall plan. Furthermore, the presence of a victor and his captive in eroded stucco – recorded on one of the structures flanking a trapezoidal court at the

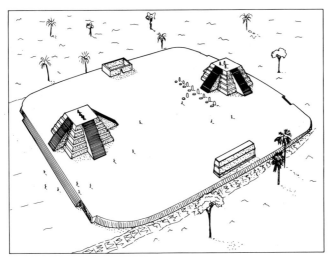

103 Reconstruction of a Twin Pyramid Complex, Tikal. Limited to Yaxha and Tikal only, these complexes were erected in the eighth century to celebrate *katun* endings. Although they might have been painted in antiquity, all the altars and stelae are plain today.

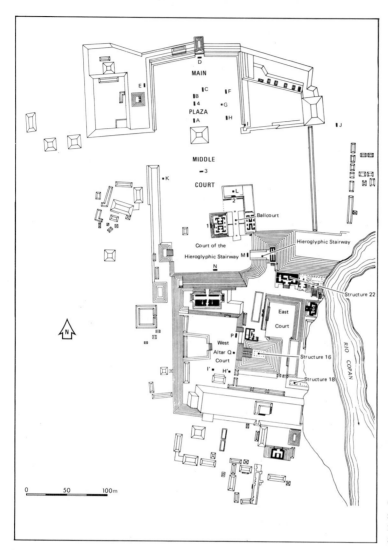

MAIN
D
C F
B
4 G
PLAZA
A H
J
MIDDLE
3
COURT
K
L
2
Ballcourt
1
Court of the
Hieroglyphic Stairway M
N
Hieroglyphic Stairway
Structure 22
East
Court
P
West
Altar Q
Court
I' H'
Structure 16
Structure 18
N
RIO COPAN
0 50 100m

104 Plan of Copán. The southern half represents the acropolis.

core of the Acropolis – hints that it may have been a place of sacrifice, like the East Court at Palenque, where humbled captives are depicted.

Other fragments of stucco ornament still cling to the ruins at Tikal. A long inscription on the roofcomb of Temple VI (also given the name Temple of Inscriptions) records a ruler unacknowledged anywhere else. In the Group of Seven Temples, stucco war shields form

95

the upper molding. The general public imagery of Maya architecture is a litany of ancient kingship: accession, ancestors, warfare, and blood sacrifice.

Using the same fundamental elements of Maya architecture – platform, stairs, and corbel vault – the architects of Copán, Honduras, developed a distinctive aesthetic. The local stone is an easily worked volcanic tuff, ranging from pink to brown to green, so that building stones could be cut and fitted together with a precision rare in the limestone structures of Palenque or Tikal. (The stone, of course, was cut with stone tools.) At Copán, however, as elsewhere, stucco coatings would have hidden any imperfections. Emphasis was placed on tuff architectural ornament, in full three-dimensional relief, and it is the best-preserved iconographic guide to the meaning of Mesoamerican architecture. Surviving façades retain a sheer vertical profile, rather than the usual mansard roof. These clean lines are echoed in the façades of Central Yucatán and the Puuc region, and may in fact originate at Copán.

The Copán valley provides superb possibilities for the dramatic siting of architecture. The ancient city planners realized this and located their buildings to take advantage of specific views of the valley and surrounding mountains, especially the saddle through the mountains to the north. The ballcourt, for example, seems to reproduce the *104* valley itself in its layout and orientation.

105 Structure 22, Copán, reconstruction of the inner doorway. One first steps through the fragmentary remains of a great monster mouth to gain access to this remarkable carved doorway. From a bench within, the last ruler of Copán, Yax Pac, presided.

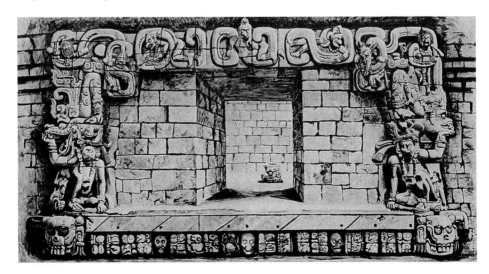

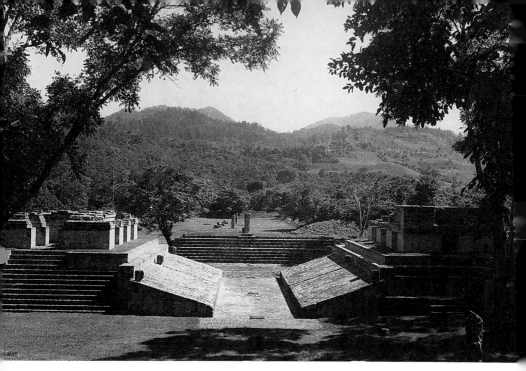

106 One of the most beautifully sited of all Maya buildings, the ballcourt at Copán guides the eye from the Main Plaza to the steep hills beyond.

Funerary pyramids and structures dedicated to the rites of kingship crowd the acropolis. Structure 22 may have been a place of inauguration for the last great Copán ruler, Yax Pac (literally, New Sun at Horizon). To reach the private, elevated rear chamber, one enters *105* through a great open monster mouth and then under the undulating body of the bicephalic dragon, an image which often frames accession scenes, as at Palenque or Piedras Negras. Young maize god sculptures once ornamented the exterior cornices, and it is possible that such symbolism proclaimed the king the progenitor of maize, or perhaps young corn itself.

Structure 18 was apparently the funerary monument of Yax Pac. Recent excavations there revealed a well-crafted interior chamber, the double four-sided corbel of which resembles the beehive tombs of ancient Mycenae. Yax Pac's tomb, unfortunately, was completely looted in antiquity. Structure 16 is the largest building on the acropolis, and consists of a nine-level pyramid, like Temple I at Tikal

138

or the Temple of the Inscriptions at Palenque. Though unexcavated, it may very well hold Smoke Jaguar, a Late Classic dynast comparable to Pacal or Ruler A.

Below the twenty-five-meter drop-off from the acropolis lies the Copán ballcourt, the largest and most beautiful of all Classic courts. *106* Like many smaller ones elsewhere, it unites two different areas of the central city. Unusual superstructures surmount the parallel buildings on its eastern and western sides. Each of these buildings has a plan cut by a central corridor running east–west, with mirrored configurations to north and south, as if ballcourts themselves.

Just to the south of the ballcourt stands the great Hieroglyphic *107* Stairway, a large pyramid whose steps are inscribed with 2,200 glyphs that relate the history of the Late Classic dynasty. Five three-dimensional rulers of Copán sit on projections from the staircase, and some are set directly over two-dimensional captive figures. In no other Maya building are sculpture, writing, and architecture more sensitively united. The carved scroll balustrade is an unusual element in Maya architecture, resembling the balustrade of the Pyramid of the *67* Niches at El Tajín.

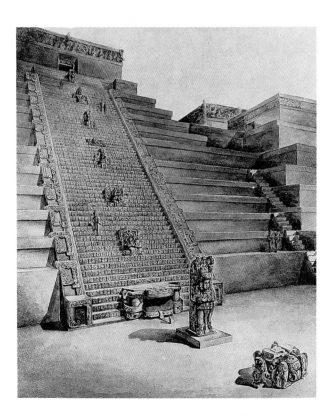

107 Carved with 2200 glyphs, the text of the great Hieroglyphic Stairway at Copán is among the longest known. Five rulers of Copán are carved in full relief at intervals on the staircase, and the text emphasizes their achievements. Eighth century AD.

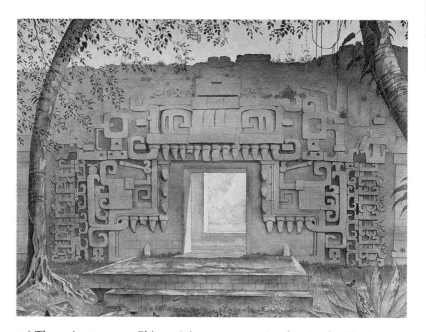

108 The main structure, Chicanná, in a reconstruction drawing by Nigel Hughes. Worked in individual blocks that were then covered with a thin coat of stucco, the façade represents a great monster mouth through which one must pass to enter the chamber. AD 700–900.

The traditions that may have originated at Copán also thrived in Central Yucatán and the Puuc region. At Chicanná, as at most Chenes and Río Bec centers, the principal structures have great monster-mouth façades – presumably here again associated with ceremonies of kingship. The mouth of the Chicanná structure is similar to the largely destroyed exterior of Structure 22, Copán, where the interior bicephalic monster framed a removed, interior chamber for private rites. Perhaps the proliferation of structures in Central Yucatán with monster-mouth façades reflects the widespread celebration of elite rituals.

Chenes structures are generally lowlying, galleried buildings. At Río Bec, great false temples frame such galleries – described as 'false,' in the accepted view, because there is no access to temple summits. In fact they may be funerary pyramids, directly combined with palaces, and conflations of the patterns established at Palenque or Tikal.

108

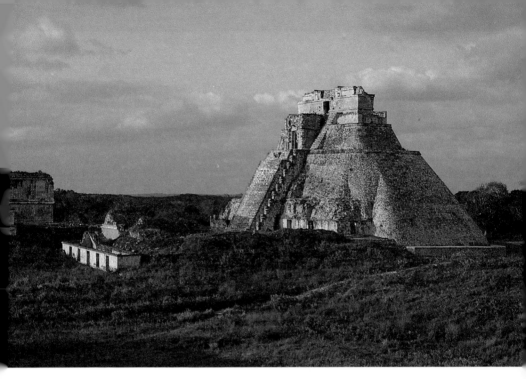

109, 110 The Pyramid of the Magician *(above)* and the Nunnery Quadrangle *(below)* at Uxmal.

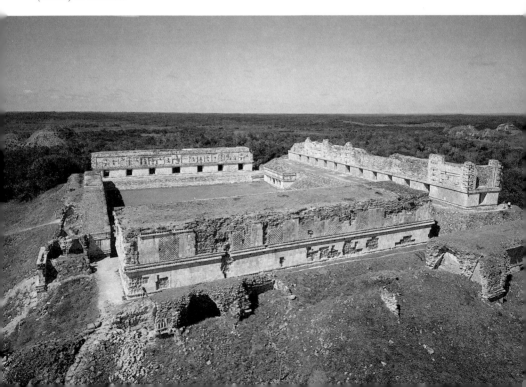

111 Frederick Catherwood published this panorama of Uxmal in 1843. He based the lithograph on drawings made with the *camera lucida*. Both he and John Lloyd Stephens suffered bad bouts of malaria while they worked there.

Late Classic Puuc architecture first captured the imagination of modern Europeans and Americans through the writings and illustrations of Stephens and Catherwood, who spent months in the Puuc region. They visited Uxmal, Kabah, Sayil, and Labná to make drawings and to study the ruins there. There is still no finer introduction to the region and its ancient remains than their report of 1843. What attracted them and what still attracts the traveler today are the elegant quadrangles, fine veneer masonry, and beautiful mosaic *111* façades that reflect shifting patterns of light in the hot clear sun of the Puuc hills.

Most of what is visible at Uxmal today seems to belong to the ninth century, although there is a sixth-century radiocarbon date from the earliest phase of the Pyramid of the Magician, and a final hieroglyphic date of 10.3.18.9.12 (AD 907). Archaeological exploration of the *109* Pyramid revealed five distinct phases of construction. Temple façades more typical of Petén and Usumacinta styles remain concealed by later reworkings: the west façade opens as a great monster mouth, in the fashion of Río Bec or Chenes buildings, and its axial staircase is precipitous. Opening towards the east is a structure of pure Puuc design, with a more gradual incline to its summit. From the Nunnery

142

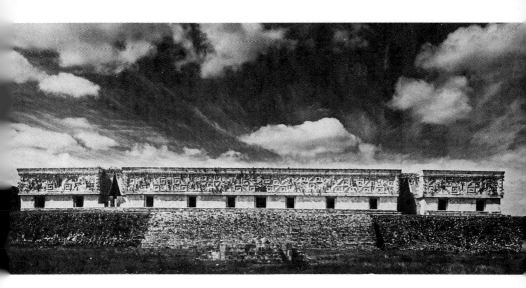

112, 113 The House of the Governor, Uxmal (together with plan). Built to commemorate the tenth-century reign of the last important ruler of Uxmal, Lord Chac, this is one of the most elegant and beautifully proportioned structures of ancient Mesoamerica.

court, one can see only this final Puuc building; it looks like a second story on the eastern side of the quadrangle.

The juxtaposition of quadrangles with pyramids such as the Nunnery and the Pyramid of the Magician recalls the Palace and Temple of the Inscriptions at Palenque, although the physical expression of Puuc architecture is new. The Palenque Palace, however, evolves from the inside out, while the Nunnery would seem to

143

114 The Great Arch, Kabah, is set just at the edge of the city. The gateway grants access to the *sacbe* or causeway linking Kabah to Uxmal less than eight miles away.

110 have been designed as a quadrangle. Indeed the Nunnery exemplifies the pioneering techniques of Puuc architecture: specialized 'boot' stones in vaults, providing increased stability and making possible some of the greatest vaulted spaces of ancient Mesoamerica; flying façades, the light, airy roofcombs set directly over the front weight-bearing wall, like the false storefronts of the American Old West; and veneer masonry, well-cut stones fitted together without mortar, hiding a rubble core.

112, 113 Many elements from the Nunnery structures are repeated and elaborated in the House of the Governor, the finest of all Puuc buildings. It, too, was probably first conceived as part of a quad-rangle, but no other structure was built. The plan of the House itself suggests three semi-detached structures, linked by sharp, corbeled doorways, innovatively used to open cross-corbel vaults within. The greater breadth of the central doorway and the uneven spacing of the flanking doorways (all of post-and-lintel construction), as first attempted in the east and west Nunnery buildings, alleviates the monotony that would result from even breadth and spacing, and the two pointed, recessed corbels vanish from view at sharp angles. The

144

slight outward lean, or negative batter, of the structure gives it the appearance of lifting off its platform. The upper part of the vertical façade is, like most Puuc buildings, covered with a rich stone mosaic. Such mosaic designs may have been emblematic of certain rituals or certain families, and could be related to textile design. The decoration on the House of the Governor includes many elements: Chac, or rain-god, masks; serpents; step frets; netted motifs; Maya thatched houses; and human busts. In the complexity of this ornament, the Uxmal artist seems to have drawn specifically on the east and west buildings of the Nunnery. The ruler of the era, now identified by Jeff Kowalski as Lord Chac, may be the figure in high relief over the central doorway. With its twenty-four rooms, the House of the Governor must have been the greatest administrative structure of its time, overseen by the ruler himself.

Perhaps the most remarkable feature of nearby Kabah is its monumental, freestanding arch, the only one of its kind. A *sacbe* 114
seven-and-a-half miles long connects Kabah to Uxmal, and the arch marks the end of the elevated roadway. Unlike European city arches, which either denoted the opening in a wall or commemorated triumph, the arch at Kabah appears simply to proclaim the entrance to the city.

SCULPTURE

At the beginning of Late Classic times, strong regional styles emerged in monumental Maya sculpture. Now, in the west, particularly at Palenque and Yaxchilán, two or three individuals were represented on a single relief, and the limestone slabs were set as wall panels or lintels, protected from the elements. Conservatism, on the other hand, generally prevailed at Tikal and the Central Petén, where stela imagery continued to conform to rigid canons established in the Early Classic; but some innovative forms were introduced, such as carved wooden lintels. In the south, an impulse to three-dimensionality transformed the sculpture of Copán, while at Quiriguá, monuments of huge proportion were erected.

The Palenque artists selected a very fine-grained limestone for the interior wall panels that record dynastic history. The Palace Tablet 115
commemorates the accession of the second son of Pacal, who became king of Palenque in 9.13.10.6.8, or AD 702. On the panel, the young king sits between his dead parents, who offer him attributes of

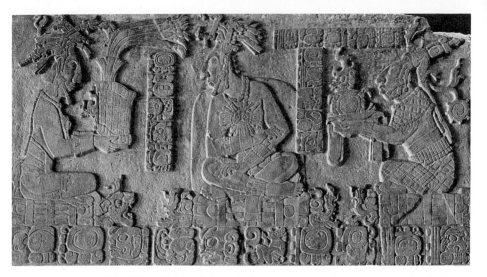

115 The Palace Tablet, Palenque. In commemoration of his accession in the eighth century, Lord Kan-Xul was portrayed in the act of receiving the symbols of office from his late parents. Pacal is shown at left, and he holds out a headdress of thin jade squares.

kingship: a jade-plated headdress and a shield. The figures are all simply costumed, and one senses that their individual identity, not simply their ritual paraphernalia, ensures their right to dominion. New, seemingly less formal postures characterize Late Classic Palenque sculpture, and the courtly scenes depicted no doubt reflect something of the actual life that went on within the Palace chambers where most such sculptures were found.

98 Technically, the sarcophagus lid of twenty years earlier compares closely to the Palace Tablet, but the imagery of death is couched within the supernatural. The reclining king Pacal, known to have been some eighty years of age at his death, is shown as an idealized youth, and the smoking tube that punctures his attenuated forehead would seem to show him transformed into the deity generally known as God K (in the alphabetic system established at the beginning of this century). God K is also characterized by a serpent foot, and Pacal twists his right foot to show the sole, perhaps to mimic the serpent. It is thus as a young deity that the dead king is commemorated.

A jade mosaic portrait mask covered the king's face, and two stucco portrait heads were found in the tomb, presumably of Pacal and his wife. Many other fine stuccos have been recovered from Palenque.

146

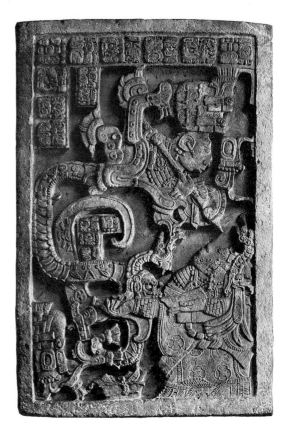

116 Lintel 25, Yaxchilán. The wife of Shield Jaguar kneels to receive a vision: a warrior, bearing a shield in hand and wearing a Tlaloc mask in 'X-Ray,' emerges from a serpent mouth. The rich drapery of the woman's garment is piled at her knees.

They reveal an interest in recording human physiognomy unparalleled in ancient America.

These fine, sensitive portraits of the ruling family find a foil in the rather gross depictions of subject persons in the East Court. The captives make gestures of submission to the individuals who would have stood above them on the terrace. On these slabs, hands, feet, and faces are crudely worked. Even the stone chosen reflects its subject: the buttery limestone of the accession panels is replaced by porous limestone less suitable for fine carving. Each figure is worked on an independent slab, and the compressed space for each person suggests oppression. The slabs may also have been re-used and re-cut to conform to a new configuration.

Often integrated with the architecture of Yaxchilán in the form of lintels or steps, the finest sculptures at this site display a regional style

in which relief was executed on two distinct and removed planes. The resulting figures look as if they have been stamped out with a cookie cutter, and the glyphs around them often suggest the local architecture. On Stela 11, the figures stand inside a corbeled vault; on Lintel 25, the woman kneels in the rear chamber of a structure. Rituals associated with royalty were often recorded on Yaxchilán monuments: capture, sacrifice, autosacrifice, and visions of ancestors. Many women are depicted too; the richly garbed royal female on Lintel 25 receives the vision of a warrior who appears in the mouth of a great serpent. Traces of red, green, and yellow polychrome remain on this and other Yaxchilán lintels, confirming what is supposed of most Maya sculptures – that they were once brilliantly painted.

On Stela 11, in the guise of the deity known as GI, the great king Bird Jaguar stands over three bound captives. Bird Jaguar's cutaway mask recalls the Oxtotitlan painting of Olmec times, and his aggressive stance is similar to that of GI on vases, where the god often decapitates his victims. The dead parents of the ruler sit above, separated from the scene by a skyband, which may indicate their posthumous place in the heavens. Whether presiding over a scene or

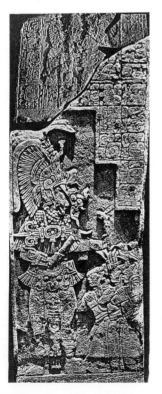

117 Stela 11, Yaxchilán. *(Left)* on the rear, Bird Jaguar, in an 'X-Ray' mask, wields an axe over three captives. *(Right)* the obverse shows Bird Jaguar (right) with his heir. Mid-eighth century AD.

flanking it, as at Palenque, dead parents were frequently recorded, as if to confer legitimacy on a descendant.

The obverse of Stela 11 shows the accession of Bird Jaguar, an event supported by the military success on the other side. Stela 11 and Lintel 25 were probably carved by a single sculptor whose work spanned two generations of rule. Subsequent sculptors emulated his craft, but none equaled it.

The Yaxchilán artists also pioneered the introduction of new, active postures into normally staid stone sculpture. Lintel 8, for example, *24* shows Bird Jaguar and another lord grasping the hair of some captives, who bear their names emblazoned on their thighs. As Tatiana Proskouriakoff pointed out over twenty years ago, Tlaloc motifs adorn the victors here, and throughout Late Classic art the Tlaloc costume appears in scenes of warfare and sacrifice, as can also be seen on Lintel 25.

A higher relief distinguishes the sculpture of Piedras Negras. Here *118* special attention was given to human faces, which were worked in three dimensions, especially on the handsome niche stelae. These monuments commemorated the accession to office of the various

118 Stela 14, Piedras Negras. Rulers of this site were portrayed within niches at the moment of their accession. This young eighth-century lord bore the glyphic title 'Turtleshell.' His mother stands in front of him.

119 *(right)* Stela 12, Piedras Negras. The last dated monument (AD 795) of Piedras Negras shows a ruler presiding over a group of naked captives. At lower right, the sculptor has carved an old, humble man with great realism – perhaps a portrait.

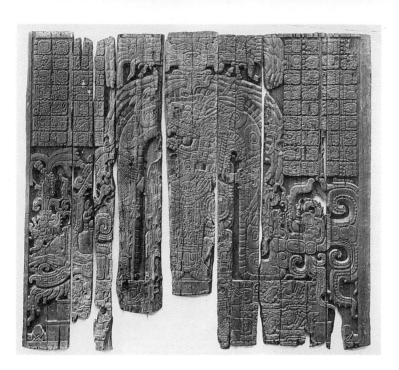

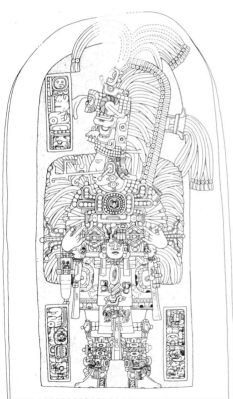

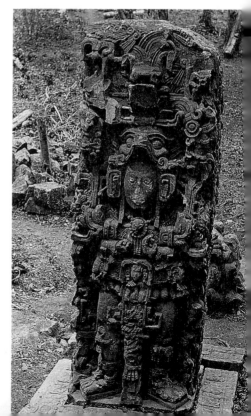

120 *(left)* Lintel 3, Temple IV, Tikal. Ruler B is borne high on a litter in this depiction – tied beams can be seen at lower right and left. The sapodilla wood of which the lintel is made is about 1200 years old.

121 *(far left, below)* Stela 16, Tikal. On this stone monument erected to celebrate the *katun*, or twenty-year period, Ruler A holds a ceremonial bar and wears a great feather backgrame.

122 *(left, below)* Stela N, Copán. Soft tuff quarried near Copán facilitated the rich three-dimensional quality of sculpture at that site. Yax Pac, the last ruler of the city, is shown here in an official portrait. His father is portrayed on the back of the monument, which was probably erected *c.* AD 780.

123 *(right)* Stela F, Quiriguá. The tallest Maya monuments were erected at Quiriguá, during the reign of Cauac Sky – depicted here – who claimed to have bested the Copán king in mid-eighth-century battle. Most such stelae were double portraits, carved both front and back.

124 *(below)* Zoomorph P, Quiriguá. One of the latest known rulers of Quiriguá sits within the open maw of a great monster on this carved river boulder.

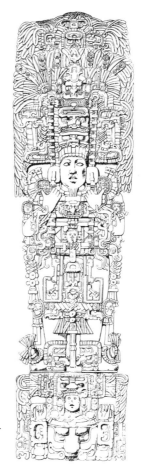

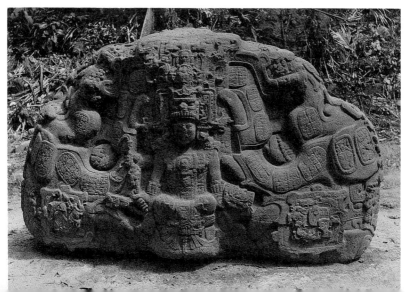

Piedras Negras rulers. On Stela 14, the young lord is handed a symbol of office by his mother, who is carved in much lower relief. Footprints mark the cloth draping the scaffold or ladder set in front of the niche, and swag curtains are pulled back at the top of the niche, as if the scene has just been revealed.

Life along the Usumacinta River may have been interrupted more frequently by periods of conflict than elsewhere in the Late Classic Maya realm. Many war or sacrifice scenes were recorded at both Yaxchilán and Piedras Negras. The complexity of life, war, and dynastic succession possibly helps to explain the complexity of both Lintel 3 and Stela 12 of Piedras Negras. No other Maya stone monuments show so many different individuals. Ancient Mayas probably damaged Lintel 3 at the time of the collapse of their civilization, but the courtly palace scene is still legible, and perhaps records the resolution of dynastic difficulty in the eighth century.

119 Twelve individuals are grouped on four levels, probably steps, in a pyramidal composition on Stela 12. Eight captives are tied together in the lower register, and many show signs of torture. Two captains deliver the well-dressed, uppermost captive seated on draped cloth to the lord above. The text records a war event, and we probably see its aftermath here, victorious Piedras Negras displaying its trophies. Interestingly, the victims may be from Pomoná, a site known for its fine, Palenque-like carvings; indeed the workmanship of this monument resembles that style, not the more three-dimensional style with frontal faces of Piedras Negras. Artistic tribute may have been an aspect of elite warfare, and captives at other sites – Toniná, for example – were worked in the manner of their place of origin.

Static, single-figure compositions prevailed in the Central Petén throughout the Late Classic, conforming in some instances to canons established earlier. At Tikal, the texts on stone monuments were also laconic, unlike most monuments of the western region. Stela 16 *121* presents a formal, frontal view of Ruler A, the king later buried in Temple I. Less public sculptures, such as the carved sapodilla-wood lintels of Temples I, II and IV, display more complicated imagery and texts. The two lintels of Temple IV show Ruler B within a *120* supernatural world. One depicts him being borne on a litter and enthroned under an overarching feathered serpent. On the other, he sits enthroned over a flight of steps marked with symbols of rope and the main sign of the glyph emblematic of the site of Naranjo. A giant,

anthropomorphic Jaguar God of the Underworld forms an architectural frame over the ruler.

At Naranjo, many monuments depict female dynasts, and the woman on Stela 24 stands over a humiliated captive. The cramped space of the lower register heightens the abject state of the prisoner. In two-dimensional carvings, frontal faces were generally reserved for captives.

An impulse to frontality may be seen in Early Classic Quiriguá Stela 26, although the contemporary Copán stelae resemble the works of the Petén. In the Late Classic, sculpture at these two southeastern sites retained the frontal view. At Copán, larger-than-life portraits of standing rulers were carved nearly in the round. On Stela N, two different rulers appear to have been honored – the last great king, Yax *122* Pac, and his predecessor. As at Tikal, many stelae were erected on the Main Plaza. By the reign of Yax Pac, the open space was heavily populated by royal ancestors. During his reign, however, there was also a return to two-dimensional works, perhaps re-introduced by his mother, a woman from Palenque. Carved steps, benches, and altars record numerous seated two-dimensional figures in profile. Altar Q, set in front of Structure 16 – the largest funerary pyramid at Copán – shows the sixteen rulers of the city. The last ruler is handed a staff of office by the first.

During the reign of Cauac Sky, nearby Quiriguá grew wealthy, and according to the inscriptions this monarch captured his fellow ruler at Copán, 18 Rabbit. Cauac Sky was commemorated by a series of stelae, among them Stelae E and F, the tallest stone carvings of the *123* ancient Maya. Cauac Sky's face is worked in high relief, but the rest of his features are shown in two dimensions. Like their counterparts in tuff at Copán, these great prismatic shafts of sandstone were laid out in the clear expanse of the open plaza.

Later rulers at Quiriguá developed one of the most innovative types of Maya sculpture, the zoomorph. Huge river boulders were carved *124* on all exposed surfaces as great composite jaguar, toad, crocodile, or bird forms. On Zoomorph P, a ruler emerges from a gaping front maw as if set within supernatural architecture of the sort created in Structure 22, Copán. Elaborate full-figure personifications of hieroglyphs were often inscribed on these great boulders as well, turning script into narrative sculpture.

125 *(left)* A jade mosaic vessel, Burial 116, Tikal. Placed as an offering in Ruler A's tomb in the early eighth century, this Late Classic vessel recalls the form of ill. 89.

126 *(right)* Collected by Thomas Gann at Teotihuacan at the turn of the century, this fine Maya jade plaque shows an enthroned ruler attended by a court dwarf.

MINOR SCULPTURE

125 Most fine Maya objects of small scale have been recovered from royal burials, and many carry information relating to the life or afterlife of a given individual. The jade mosaic jar from Ruler A's tomb at Tikal, for example, is probably a portrait of the dead king. Jade-plated vessels of this sort are known only from Tikal, and the type is conservative, retaining Early Classic characteristics, such as the knob in the form of a human head. An extraordinary jade mosaic portrait mask was placed over Pacal's face in his crypt, as we have seen, with

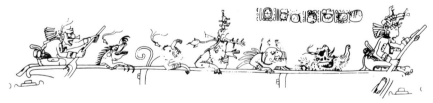

127 Many finely carved bones – some of them human – were recovered from a single deposit in Ruler A's tomb at Tikal. On this one, paddlers guide a canoe and its occupants through underworld waters.

128 To make this eccentric flint, stone was flaked away leaving a design in silhouette. A great earth monster bears Maya lords into the underworld, an image similar to that of ill. 127.

pounds of jade jewelry covering his body. At Altun Ha, a ruler was interred with a 9.7-pound (4.42-kg), three-dimensional carved jade head, perhaps simply a personified *ahau*, or lord, glyph. Its shape suggests a miniature zoomorph. Fine jade plaques showing rulers accompanied by dwarves have been recovered from Nebaj, in the Guatemalan highlands, but they have also been found far from the Maya region.

126

A number of incised bones (some human) were deposited as a single cache in Ruler A's funerary chamber, the scenes on some of them illustrating what we can presume to be the posthumous journey. On one pair of bones the artist delicately incised and then filled with red cinnabar a drawing showing Ruler A in a canoe, being paddled to the underworld in the company of howling animals. In a gesture of woe, the king raises his hand to his brow.

127

Flint and obsidian were worked by Maya craftsmen into many shapes, and these are generally termed 'eccentrics.' Some of the eccentric flints, such as the many examples that reveal the profile of God K, might have been scepters carried by a lord. Others were perhaps designed as funerary offerings. An extraordinary example in the Dallas Museum of Art shows an earth monster with human figures on its back, and it may illustrate a concept of the afterlife.

128

129 Carved shell, Jaina Island. Along the
Campeche coast, where the material abounded,
conch was cut and carved into fine objects. Here a
Maya lord seems to ride a fish monster. The piece
may once have been inlaid with precious
greenstone.

130 Young moon goddess and old deity, Jaina
Island. Numerous figurines have been found of
the young goddess in the embrace of aged deities,
perhaps to symbolize the phases of the moon.
This example is also a whistle.

FIGURINES

For many years, figurines and shell carvings of high quality have been
found on Jaina Island, just off the Campeche coast. The island may
have functioned as a necropolis, and people of the Late Classic interred
huge numbers of offerings there. Conch was a common material,
129 sometimes ornamented with inlay. Figurines must have been manu-
factured nearby: hundreds and hundreds are known from the island
itself. Most were made in molds, but the finest were modeled by
hand, at least in part, and small human fingerprints are often visible
(suggesting to some that women made these objects). Tenacious
pigments were used on the finished figures, especially blue, white, and
yellow. Many Jaina figurines double as whistles or rattles.

Some supernatural beings depicted among the figurines, such as the
Jaguar God of the Underworld, can be seen on painted ceramics too,

156

but religious scenes such as the young moon goddess embracing an *130* old deity are known only from the ceramic repertoire of this small island. Recently, contemporary and even more lifelike ceramic sculptures have been found, supposedly in the Petén. Few figurine cults in the world have produced such animated, compelling human miniatures as this Late Classic tradition.

CERAMICS

Many of the scenes painted on Late Classic Maya narrative poly-chrome pottery elaborate a supernatural world, presumably the locus of the afterlife. In the illustration here a dancing GI figure prepares to *131* decapitate a baby Jaguar God of the Underworld, and a prancing skeletal deity awaits the sacrifice. Such mythic scenes probably prescribed behavior for success in conquering the underworld, a theme later recounted in the Postconquest manuscript, the Popol Vuh. Painted in a fine black line over a cream slip, such pots may have resembled Maya books, which has led Michael Coe to christen the tradition the 'codex' style. Several schools and master painters of this style have been identified.

On a vase from Altar de Sacrificios, a site at the confluence of the *132* Pasion and Usumacinta Rivers, a red rim and highlights have been added to a codex-style painting. Although often interpreted as a record of actual funerary rites, the scene would instead seem to show

131 The image on this codex-style pot has been photographically rolled out. The Jaguar God of the Underworld is about to be sacrificed by GI (left) and the death deity at right dances with glee. Painted in black on a cream slip, such vases may resemble Late Classic manuscripts, now all lost.

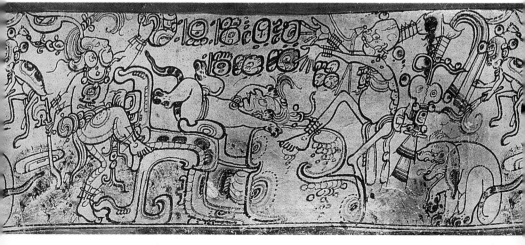

132 Maya deities dance in ecstasy on this beautifully painted pot from Altar de Sacrificios. Dressed in snakeskin trousers, the bald dancer seen here throws back his head, hurls a boa constrictor in the air, and pierces the glyphic border with his raised hand.

supernatural beings, two of whom dance in ecstasy. One wears snake-patterned trousers, and as he hurls a boa constrictor into the air, he throws back his head, closes his eyes, and presses his hand right through the glyphic border. Maya vase painting of the Late Classic is self-conscious and theatrical, sophisticated in a way never matched elsewhere in the prehispanic New World.

Other regional vase painting styles can also be identified. In the region of Naranjo, a monochrome red-on-cream style predominated. The western Petén may be the source of the 'pink-glyph' style, in which rose tones were used and figures depicted in cutaway, x-ray fashion. Carved gray slateware was characteristic of northern Yucatán. In highland Guatemala, potters generally included red backgrounds and painted the rim bands with chevron motifs. In Honduras, vases were carved from marble, perhaps by non-Mayas of the Ulua Valley, and these are occasionally found at Classic sites. At the end of Classic times, a new kind of pottery appeared in many parts of the Maya lowlands, and the iconography of these modeled and carved fine-orange vessels differs from the earlier painted ones, perhaps to be associated with new people or new trading patterns.

PAINTING

Fragments of polychrome paintings were uncovered periodically throughout the western Maya region in the late nineteenth and early twentieth centuries, particularly in the vicinity of Yaxchilán. Then, in 1946, Giles Healey stumbled upon a miraculously well-preserved sequence of remarkable Late Classic Maya wall paintings at the site now known as Bonampak, not far from the Lacanhá River, a tributary of the Usumacinta. The preservation of the paintings was a fluke: shortly after their completion in the late eighth century, water seeped through the poorly made limestone vault, building a layer of calcifications that encased the fragile stucco paint.

In Structure 1, the vaults, walls, benches, and door jambs of the three rooms had all been painted in bright colors on damp stucco. Hundreds of Mayas are depicted in a unified work celebrating the festivities and bloodshed of the last major dynastic accession at Bonampak. On three walls of Room 1, nobles in white mantles attend the presentation of a child; some ten months later – following the chronology of the painted glyphs – musicians and performers

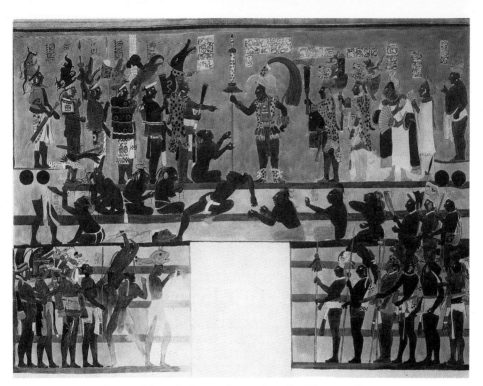

133 Copy of the painting on the north wall of Room 2, Structure 1, Bonampak. Ruler Chaan-muan stands at the top of a flight of stairs and presides over captives garnered in battle. At far left, near postholes, a warrior pulls out the fingernails of a captive; other captives stare at their bleeding hands, while members of the royal court, including women (upper right), look on. The date of Room 2, 2 August AD 792, probably the heliacal rising of Venus, was an appropriate day to sacrifice prisoners.

contribute to a great celebration in the child's honor. When another year has elapsed, a battle is waged and Bonampak emerges victorious. The battle covers three walls of Room 2. On the north wall, in a scene *133* that encompasses the open doorway, sacrificial victims are displayed on the steps. The naked, humiliated captives are among the most handsome figures in Maya art, and even their tortured, bleeding hands were rendered lovingly by the artist. Above a skyband border appear cartouches marked with star signs. These seem to be the constellations of the morning sky on the date recorded, 2 August AD 792, when Venus rose as morning star and demanded a propitious sacrifice.

History, for the Maya, seems to have been shaped by astrology and augury. In Room 3, the remaining captives are dispatched on a pyramid, and the royal family, including the little heir, perform penance by running ropes and spines through their tongues. Linked together by rope, they resemble the bound captives of Piedras Negras Stela 12. *119*

THE END OF THE CLASSIC MAYA

The momentum of Classic Maya civilization began to slacken and falter in the late eighth and ninth centuries. Stone monuments ceased to be erected from as early as AD 760 in certain areas, and gradually whole cities were abandoned. At some sites there is evidence of violence: at Piedras Negras, for example, monuments were dragged out of buildings and smashed. At Palenque and Copán, the ritual paraphernalia of the Classic Veracruz ballgame were left by late visitors. Tikal seems to have suffered a slower depopulation. Fine orange ceramics appeared at many sites. By about AD 900, perhaps slightly later in the north, Classic Maya civilization had collapsed.

For the ancient Maya, blood and blood sacrifice were the mortar of dynastic life, and sacrifice accompanied the rituals of office. At the end of Classic times, however, there is evidence that the pattern of capture and sacrifice gave way to warfare and dominion. The latest Yaxchilán monuments enumerate battle after battle; the final monument at Piedras Negras is Stela 12, where the booty of battle is laid at the ruler's feet. The Bonampak murals were never completed, and we can deduce that the little heir perished before reaching majority in a battle like that painted in Room 2. Archaeologists have sought the explanation for the Classic Maya collapse in buried material remains (did their food supply change? what happened to the soils?), but the art and inscriptions relate the Maya's own last record of life around AD 800, and that record is of warfare. Warfare was the process, if not the cause, of the Classic Maya collapse that the Maya themselves chose to record.

Mesoamerica after the fall of Classic cities

The Classic Maya collapse was a gradual affair, affecting Maya cities at a far from uniform rate. Some large centers, such as Copán, abandoned the time-honored practice of raising stone monuments well before small neighbors such as Quiriguá did so, while a large city such as Tikal continued with limited ceremonial activities for a considerable time. The burning and destruction of Classic Teotihuacan, on the other hand, marked a dramatic cessation in both the maintenance and the centralized, public use of the Way of the Dead and the major temples there, even if some residential quarters remained occupied. Meanwhile, in Oaxaca, when Classic Monte Albán was abandoned other centers of population grew up to take its place.

During this period of widespread disruption of Classic cities, their characteristic features did not disappear suddenly, nor was all knowledge of the past lost. At the time of the Conquest, for example, the Maya still wrote in a phonetic, hieroglyphic script probably perfected in Classic times, and had a literate Maya of the 1500s seen a Classic monument, he could probably have read and understood it.

Nevertheless, the turmoil of the late first millennium AD led many Mesoamerican peoples to uproot themselves and form new alliances or move to new territories. 'Foreign' influences can be observed in many places during the Terminal Classic (generally considered to be the ninth century). Mayas appeared in Central Mexico and Mexicans among the Maya. It was a time of seemingly unprecedented inter-regional contact, best seen today in the rise and fall of two cities, Tula and Chichen Itzá, one in Central Mexico and the other in Yucatán, both built in a cross-pollinated Maya-Mexican style during the Early Postclassic. During the Late Postclassic the Aztecs ruthlessly exploited the weaknesses of their neighbors in order to gain dominion over the whole of Central Mexico, and their civilization will be considered in Chapter Nine. The Maya of the Late Postclassic, however, show neither the innovation nor the craftsmanship of their Aztec contem-

poraries. Their art drew upon earlier models, and will be discussed at the close of this chapter, in conjunction with Chichen Itzá, the strongest influence on the later Maya.

One important marker used by archaeologists to chronicle change is pottery, and among elite wares there was a shift in styles and clays about AD 800 at several Classic Maya sites. Designs were now modeled and carved, rather than painted – color was no longer an element. Some designs appear to have been stamped out, or mass-produced. Even the clay used to make the vessels ceased to be local, and most scholars believe it to be of Gulf Coast origin, suggesting a foreign presence. Likewise, what we find in the art and architecture of the Maya city of Seibal argues for a Central Mexican or Gulf Coast infusion there about this time.

SEIBAL

The later buildings of Seibal exhibit a new architectural style. A great round platform was erected at the site, a rare feature in Mesoamerican, and particularly Maya, architecture. Round structures in use at the time of the Conquest were generally associated with the Central Mexican deity, Quetzalcóatl, and – as we shall see – his cult was beginning to take root during the Early Postclassic. Moreover, a new large radial pyramid at Seibal would seem to recall the unusual forms of Late Formative Uaxactún E-VII-sub or the Late Classic radial *79* pyramids of Tikal's Twin Pyramid Complexes. *103*

A stela was set at the base of each staircase of the Seibal radial structure, each commemorating the date 10.1.0.0.0 (AD 849), as if that were a momentous year. One also records four emblem glyphs: Tikal, San José de Motul, Seibal, and an unknown site, perhaps defining a diminished Maya geographic realm by that date. Most striking of all is the distinctive physiognomy depicted on Seibal monuments. Stela 1, AD 869, for example, shows a new kind of portraiture. The ruler's face *134* is not idealized, and the strong, slightly downturned lip suggests a harsh man. Unlike earlier portraits, this lord's face shows neither forehead deformation nor the extended bridge of the nose typical of most ancient Maya. Although he wears Classic Maya garb and is accompanied by a Maya inscription, he looks like a foreigner, as do most of the men portrayed on late Seibal stelae.

On yet later monuments, both inscriptions and costume change.

On Stela 3, for example, a date is recorded in a non-Maya system, and one of the glyphs used is a *cipactli*, or crocodile head, the first day name of the 260-day calendar in most Central Mexican systems. On this same monument, individuals are shown with long, flowing hair, rarely revealed by Classic Maya except on captives. On other monuments, traditional Maya imagery appears in odd configurations, as if not understood clearly by the elite at Seibal. The exact ethnic identity of this ninth-century power may be a mystery, but the strong Central Mexican influence certainly suggests that the rulers of Seibal were Mexicanized Mayas, possibly the Olmeca-Xicalanca of the Gulf Coast renowned as traders at the time of the Conquest.

134 Stela 1, Seibal. During the ninth century, new rulers – perhaps the Itzá – came to power at Seibal. Although they adopted the dress of the Classic Maya, they often confused and reinterpreted Classic symbols. The features of the lord portrayed here are hard, and he has a non-Classic nose.

It is perhaps too tidy a solution to attribute contemporary developments further north to the same people who dominated Seibal, but powerful cosmopolitan, particularly Maya, influences undoubtedly made themselves felt at Cacaxtla and Xochicalco in Central Mexico at this time.

In 1975, a local schoolteacher led Mexican archaeologists to well-preserved, beautifully executed paintings in Maya style in two separate buildings at Cacaxtla, Tlaxcala, a hilltop acropolis. One set of paintings had even been packed with fine sand by the ancient inhabitants to help preserve the stucco paint. In Structure A, the doorway is flanked by two stela-like portraits, one showing a standing Maya in bird costume; the other, a Maya in a full jaguar suit. The man *138* in the bird costume and black body paint may be the Terminal Classic prototype of the later Aztec Eagle Knight, but the naturalistic *170* proportions, skilled painting, and attention to both costume details and the human face reveal the Maya origins of the artist, while the shape of forehead and nose indicate the Maya ethnicity of the subject. Other influences are evident as well: borders show Teotihuacan motifs, and the glyphic style is not yet identified.

In the second set of paintings, warriors with Central Mexican profiles in jaguar suits and arrayed with Tlaloc imagery defeat, disembowel, and dismember warriors in bird costume with Maya profiles. This scene was also worked in Maya style. Although not complete, the program is similar in scale and visual power to the war paintings of Room 2, Bonampak (Chapter Seven). If the Cacaxtla battle scene is any indication, Maya forays into the highlands were evidently not always successful. Present at both Bonampak and Cacaxtla is the image of the victory of jaguar warriors over bird figures who also bear Olmec emblems. It is as if the participants were re-cast in symbolic dress, with costumes specific to both victor and victim. In a myth known at the time of the Conquest, the deity with jaguar aspect, Tezcatlipoca, defeats the one with bird aspect, Quetzal-cóatl, to create the contemporary cosmogonic era.

Some eighty miles to the southwest of Cacaxtla lies Xochicalco, a contemporary hilltop acropolis high above the Valley of Cuernavaca. Cosmopolitan influences abound here as well, and are particularly evident on the Temple of the Feathered Serpent. Seated figures of *135*

135 Pyramid of the Feathered Serpent, Xochicalco. Framed by an undulating feathered serpent, as if borne by its bounty, are seated lords. Their profiles recall those of Classic Maya rulers.

Maya proportion, in Maya pose and dress, are carved among the undulations of a great feathered serpent, or literally, Quetzalcóatl, while shell sections define an aquatic environment. The sculptors executed glyphic notations using a Central Mexican system. They also gave the images a double outline, a technique characteristic of Classic *cf. 67* Veracruz art, particularly at El Tajín.

A large, graceful ballcourt similar to that of Copán was situated at the heart of the site, adjacent to what were probably palace chambers.

136 Stela 1, Xochicalco. The very presence of carved stelae at Xochicalco suggests contact with the Late Classic Maya, just as that cultural flowering came to a close. The frontal face of the ruler is set over a skyband, and the composition bears comparison with ill. 118.

Other connections with the Classic Maya are seen on the three stelae excavated at Xochicalco. One shows what is probably a rain deity, but the two others depict a strikingly three-dimensional human face, set within a helmet, framed by a more two-dimensional calendar sign *136* above and skyband below. These stelae show resemblances to the 'niche' stelae of Piedras Negras, where enthroned, three-dimensional rulers are portrayed within two-dimensional skyband borders, in scenes commemorating rulership. The works of art at both Cacaxtla *118* and Xochicalco suggest that elites throughout Mesoamerica may have retreated to isolated sites like these, where they left a new, hybridized material culture.

MITLA

The abandonment of Classic cities in Central Mexico and the Maya area was paralleled in Oaxaca by the end of Monte Albán's long reign as the main city of the region, although the mountain continued to serve as a place of ritual activity and pilgrimage even after permanent occupation ceased. Instead, other Zapotec centers grew in the surrounding valleys, particularly to the south. Large, elegant palace complexes were constructed at both Yagul and Mitla, for instance.

The palaces at Mitla have long been admired for their elegant proportion and ornament. Courtyards with both interlocking and

137 Hall of the Columns, Mitla. This graceful building grants entry to private quadrangles within. Columns inside this building once supported a perishable roof.

open corners are arranged along a general north-south axis. In Colonial times the Spanish built a church into the northernmost quadrangle and established a chapel on the summit of a large mound southwest of the palaces, thus transforming the ancient ruins into modern holy places.

The Group of the Columns, Quadrangles D–E, is the largest of the palace compounds and the most refined in proportion. Quadrangle E consists of four galleried buildings arranged around the sides of a plaza with open corners, while its northern building, the Hall of the *137* Columns, provides the only access to D, a smaller, fully-enclosed quadrangle, maze-like in its plan. The Hall of the Columns is the most beautiful of Mitla structures. Like the House of the Governor at Uxmal (its contemporary), the building has a subtle outward lean, which visually alleviates the weight of its overhanging moldings, similar to those at Monte Albán.

The façades of Mitla buildings shimmer in the clear sunlight of Oaxaca. Geometric mosaics in a variety of designs and composed of individual veneer stones are set in rectangles across the exterior walls. In the private chambers of Quadrangle D the interiors are also cast with intricate patterns, quite conceivably replicating in stone fabrics which had once hung within palace rooms. The designs may refer to various family lineages, perhaps derived from woven textile patterns specific to group or place.

THE HUASTECS

At the very beginning of the Early Postclassic a regional style flourished in north Veracruz, among the Huastecs. This Mesoamerican group is related by language to the Maya, but generations of separate evolution led to a distinct artistic expression. Particular emphasis in the Huasteca (as the region is known) was given to the cult of Quetzalcóatl, and as we shall see this was also true at Tula and Chichen Itzá. Round buildings dedicated to Quetzalcóatl are found at small sites throughout the region.

Characteristic of Huastec sculptures are prismatic yet slab-like *139* three-dimensional works. These have been called 'apotheosis' sculptures because of their dual imagery. A life-sized human figure is worked on the front of the monument, while a smaller image appears on the back – sometimes an infant, borne as if in a backpack, or in the

138 Stucco painting of a man in a bird suit, Structure A, Cacaxtla, AD 700–900. Like a Mesoamerican Daedalus, this handsome young warrior in black body paint wears a full bird suit, from headdress to wings to feet.

case of the example shown here, a skeletal death image. The oversized hands and the rich, incised pattern that covers the stone can be compared with later Aztec workmanship, particularly as seen in ill. 165. The Aztecs conquered the Huastecs in the mid-fifteenth century and may have used Huastec art as a model for their own imperial style. It is also possible that these Huastec sculptures have a prototype in the Maya sculptures of Copán. There, a ruler and his *122*

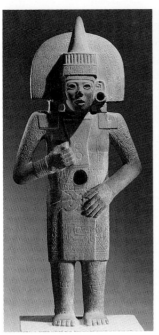
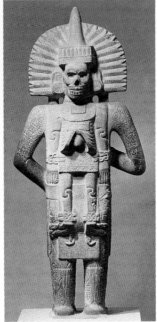

139 A so-called 'apotheosis' sculpture, Huastec culture (Early Postclassic). The strong three-dimensional quality of Huastec stone sculpture may be related to works at El Tajín (ill. 68) and Classic Veracruz ceramic sculptures (ill. 70). The death deity on the back of this monument *(right)* is carried like a burden by the human on the front *(left)*.

predecessor are often recorded in three-dimensional relief on the front and back of a stone shaft. The adult males of Huastec sculpture may be rulers, paired with their infant successors or dead predecessors.

THE TOLTECS

The rise of the Toltecs at Tula, in the state of Hidalgo, and at Chichen Itzá is generally attributed to the tenth century, although both sites were occupied long before. Ironically enough it was the later Aztecs who ensured the Toltecs a prominent place in history. No other people played such an important role in Aztec and Maya chronicles at the time of the Conquest. These historical annals – some of which were transcribed into the roman alphabet – provide information for events going back as far as the tenth century, even if for the period AD 1000 to 1300 the record is not at all complete. For earlier historical records in Mesoamerica, one must turn to Maya inscriptions (scarce as these are from AD 800 to 1000) and use them to compare contemporary archaeological data from other places.

The sixteenth-century documents weave a story of cyclical occur-

rences, where myth and history are one, and – unfortunately for us – geographical locations are often vague. We learn, for instance, of great events at the ancient city of Tula, but Tula, or *Tollan* (literally, 'place of reeds,' but generally understood to mean an urban settlement) is the name ascribed to many important centers from early Postclassic times on. To the Aztecs, both Teotihuacan and Tula, Hidalgo, were the Tula of the past, but their own city, Tenochtitlan, was also a Tula, as was Cholula, and perhaps Chichen Itzá. The sixteenth century reveals a particular view of the Toltecs:

> The Tolteca were wise. Their works were all good, all perfect, all wonderful, all marvelous; their houses beautiful, tiled in mosaics, smoothed, stuccoed, very marvelous.... The Tolteca were very wise; they were thinkers, for they originated the year count, the day count; they established the way in which the night, the day, would work; which day sign was good, favorable.... (Sahagún, Book 10)

The later commentaries seem to have telescoped all past glories into the Toltec era, but they retained the term 'Toltec' to refer to their contemporary skilled craftsmen. As we shall see, the skill of the builders of Tula, Hidalgo, was not exceptional, and in fact, much of the workmanship there can be considered shoddy.

The historical annals reveal three important characters in the drama of the Toltec rise and fall. A great leader named Topíltzin Quetzalcóatl had achieved the rulership of Tula, Hidalgo, by AD 986. He led his people away from human sacrifice, the story goes, until the arrival in Tula of the deceiver Tezcatlipoca, known by a variety of names. Tezcatlipoca took on many disguises, charming and enchanting people, and in private consultation with Topíltzin pressed him to drink such quantities of an intoxicating beverage that the king humiliated himself in front of his people. After several confrontations and subversions, Topíltzin Quetzalcóatl, with a few supporters, fled Tula in shame. He went east to a place known at Tlapallan, or the 'red earth,' and vowed to wreak vengeance on Tula. In 1519, Hernando Cortés would be considered the avenging Quetzalcóatl, an identification on which he capitalized.

Postconquest Maya sources relate the arrival in the Maya region of a great culture hero named Kukulcan in AD 986. Kukulcan is a translation of Quetzalcóatl, or Feathered Serpent, into Yucatec Maya.

171

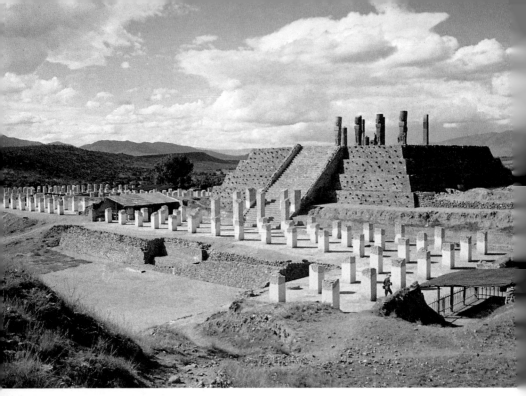

140 Pyramid B, Tula. The French explorer Désiré Charnay first posited a direct connection between Tula and Chichen Itzá, and he recognized the similarity between this pyramid and the Temple of the Warriors at Chichen (ill. 150). Early Postclassic.

He held sway at Chichen Itzá in Yucatán, it is said, until his death. Archaeology demonstrates that a series of structures were indeed begun at Chichen Itzá about this time that bear close links with those of Tula, thus apparently confirming the relationship.

Meanwhile, at Tula, Hidalgo, the Toltecs developed military and mercantile prowess, maintaining commerce and perhaps some social control far to the north and south. In the mid-twelfth century, however, the last king of Tula, Huémac, was forced to flee before growing factionalism and encroaching barbarians, repeating the pattern established by Topíltzin. Huémac settled in Chapultepec, on the western banks of Lake Texcoco in the Valley of Mexico, sources tell us. Tula was ravaged. Toltec power waned, but no later dynasty in Mesoamerica, whether Mixtec, Aztec, or Maya, would fail to invoke their glorious past.

Tula, Hidalgo, lies farther north than any other ancient Mesoamerican city. Located on the Tula River, the site is arid and windy, and although the stark surviving art and architecture suggests a military outpost, it was once a thriving urban center.

Tula was not only ravaged at its abandonment, but it was also looted systematically by the Aztecs. It has taken years of patient archaeological work to reveal the nature of the ancient city. What is now clear is that dense urban housing, laid out along a rough grid, surrounded the ceremonial core. Pyramid C is the largest of the central structures, but it was cleaned of its sculpture in prehispanic times. Pyramid B is just slightly smaller, and stands today as the best-preserved major building at Tula. Its contiguous colonnades, which we can imagine to have had a perishable roof, may once have served as a royal residence. This relationship of massive pyramid to large, interior space formed by piers and courtyards recalls the arrangement at Teotihuacan, where the late Quetzalpapálotl palace adjoins the Pyramid of the Moon, but on a reduced, even spartan scale.

142

140

141 Atlantean columns, Pyramid B, Tula. These giant Toltec sculptures are warriors ready for battle; *atlatl* is held at the side, and the butterfly pectoral and drum headdress are costume elements of those in combat.

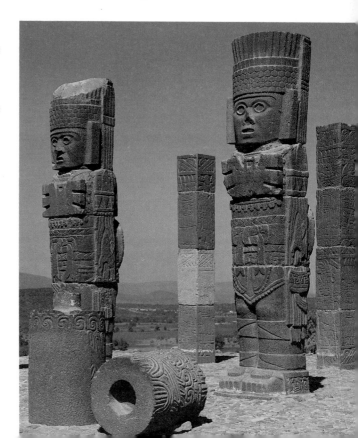

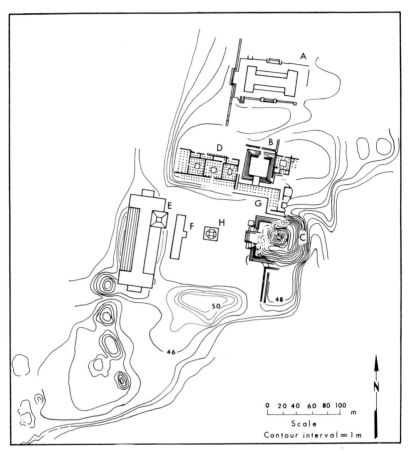

142 Plan of the ceremonial core of Tula. A, Ballcourt I; B, Pyramid B; C,
Pyramid C; D, Palace; E, Ballcourt II; F, Tzompantli; G, Vestibule; H,
Adoratorio.

The colonnade protects the single staircase of Pyramid B, restricting
access to the summit of the pyramid. Against the four distinct levels of
the structure, tenons once supported a façade of carved stone, which
in turn was brightly polychromed – but only a small portion of the
façade survives. Where still *in situ*, friezes of prowling jaguars,
coyotes, and seated eagles with hearts in their beaks are punctuated by
frontal single images of feathered, jaguar-like creatures from whose
mouths emerge the faces of supernaturals with large eyes and

bifurcated tongues, sometimes thought to represent the Morning Star, or Quetzalcóatl. The predatory beasts suggest the later warrior orders of the Aztecs.

Great atlantean columns depicting Toltec warriors and feathered *141* columns surmount the pyramid. The atlanteans functioned like caryatids and held up the roof; the feathered columns framed the doorway. Square pillars with warriors in low relief supported a rear chamber. Within the chamber, the atlantean Toltec warriors must have been an intimidating group. Their huge, blank faces convey the anonymity of the Toltec empire, and the *atlatls* – or Central Mexican spearthrowers – borne in their hands threaten the viewer. Scant traces now remain of the bright polychrome that once colored these sculptures: the warriors' legs, for example, were painted in red-and-white candy stripes, usually indicative of sacrificial victims in Aztec art. Each atlantean consists of four drums held together by dowels, and both their uniformity and method of construction suggest mass production.

An innovation at Tula is the *coatepantli*, or freestanding serpent wall, which forms an L on the north side of the pyramid. With a border of geometric meanders, a single broad entablature supports a repeating relief of great rattlesnakes belching skeletal humans. Cut-out shell motifs of the sort associated in later art with Quetzalcóatl run across the top of the *coatepantli*.

Elevated benches within the palace adjoining Pyramid B may have served as thrones for the elite. Three-dimensional *chacmool* sculptures stood in front of these thrones. The discovery in the nineteenth century of similar *chacmool* figures in both Central Mexico and Yucatán helped spark the notion of Toltec hegemony, but, as we shall see below, the *chacmool* may be a Maya invention. The illustration here *143* shows a fallen warrior, knife still held in place by an armband, and he holds out a flat paten, probably a receptacle for offerings brought to a ruler or deity on the throne behind. As is typical of most Toltec sculptures, the rough basalt retains its blockiness, despite the effort to create a three-dimensional effect.

Although carved stelae are not unknown in Central Mexico, they are not common, and the full-figure, frontal portraits roughly worked on Stelae 1 and 2 at Tula strongly suggest a Maya influence. Like earlier warrior stelae at Piedras Negras, the Tula stelae show the face worked in deep relief and the costume in shallow carving. In the

illustration here the figure is probably a ruler in warrior garb. The headdress of these warriors comprises three 'bowties' surmounted by Tlaloc year-sign insignia and feathers. Among the Classic Maya and at Cacaxtla, Central Mexican motifs are worn both by warriors and by those engaged in sacrifice. These Tula stelae may reflect a strong Maya contact at the end of the Classic, and they may date to the ninth century. At Xochicalco, contemporary stelae called upon Maya forms and motifs in celebrating rulership; at Tula, the precedent is the Maya warrior.

During the Toltec era a distinctive type of pottery known as plumbate ware was widely distributed throughout Mesoamerica. Traditionally thought of as a chronological and geographical marker of the Toltec Early Postclassic horizon, plumbate is nevertheless now generally considered to be of southwest Guatemalan origin, whence it dispersed to the rest of Mesoamerica. The name plumbate suggests a true, lead glaze of the sort used in the Old World, but in fact the glossy, metallic appearance derives from the high iron content of the clay and the reduced oxygen at the completion of firing. Indeed, plumbate perhaps deliberately imitates the sheen of metal, in much the same way as do wares made by the Chimú in the northern Andes. For

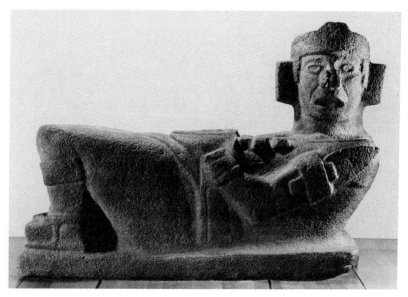

143 A *chacmool* from the Palace, Tula. These reclining sculptures of fallen warriors were set in front of thrones. The receptacle on the chest is for sacrificial offerings. Early Postclassic.

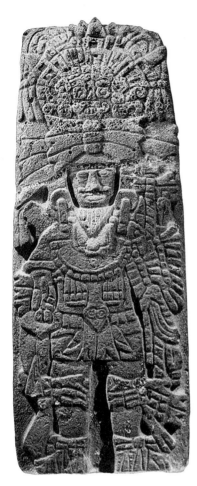

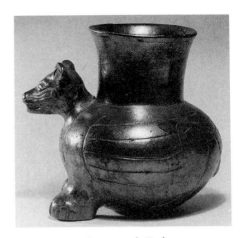

145 The clay of most such Early Postclassic plumbate vessels has been traced to the Guatemala–Chiapas border, and they were widely traded in the Toltec period. Many of the pots take the form of human or animal effigies.

144 Although crudely carved, this Early Postclassic stela from Tula is nevertheless dressed like a Maya warrior. The Tlaloc-and-year sign headdress is similar to that worn by the warrior in ill. 116.

even though metal objects have not been recovered from Tula itself, the Toltec era ushers in metalworking in Mesoamerica as a whole.

The plumbate potters often made human or effigy jars. Some of the human faces suggest portraits, while others seem to be those of deities. One unusual portrait is worked with mother-of-pearl over the terracotta, and the bearded face recalls the Toltec king, Topíltzin Quetzalcóatl, reputedly fair and bearded. *145*

Tula was sacked in the late twelfth century. Its ravagers hurled the atlantean columns from the summit, interred them, and then dug a huge trench through Pyramid B, presumably looting any treasure there. The Aztecs later established a nearby hill as the locus of an

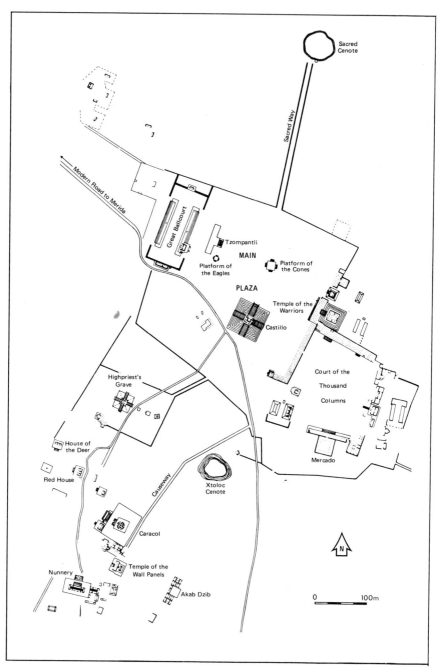

Sacred
Cenote

Sacred Way

Modern Road to Merida

Great Ballcourt

Tzompantli

MAIN

Platform of
the Eagles

Platform of
the Cones

PLAZA

Temple of the
Warriors

Castillo

Court of the

Thousand

Columns

Highpriest's
Grave

House of
the Deer

Red House

Mercado

Causeway

Xtoloc
Cenote

N

Caracol

Nunnery

Temple of the
Wall Panels

Akab Dzib

0 100m

146 Plan of Chichen Itzá

important cosmic myth, so perhaps it was their ancestors, nomadic barbarians, who were among the despoilers of Tula. Whatever the truth of this, the Aztecs actively drew on the conventions and iconography of Tula when they designed their own capital.

Tula was in many ways an experiment: a seeming union of the Maya and Central Mexico, with a center farther to the north than any other in Mesoamerican history. In the end the experiment failed.

CHICHEN ITZÁ

The Toltec florescence at Chichen Itzá is far more exuberant and expansive than at Tula. Similar architectural features and motifs appear at both sites, among them serpent columns, *chacmools*, and Toltec warrior pillars, but the innovation and skill at Chichen suggests Maya stimulus and craftsmanship. To understand the transformation of Toltec Chichen, however, we must turn first to its earlier history as reflected in its architecture.

Chichen was undoubtedly occupied during the Classic, but despite many excavations and much speculation no precise chronology has so far been established for the site. What is most clear is that many buildings relate closely to the Late Classic Puuc developments at Uxmal. This early phase was then probably followed by a period of contact with a Mexicanized Maya group, the Itzá. Subsequently, Chichen began an era of construction when Toltec influences were pronounced. The relationship between the Itzá and the Toltecs remains obscure.

An examination of the site plan itself hints at the different phases of construction. The south half of the mapped portion, as roughly divided by the modern highway, conforms to the more random plan of Classic centers, with a general emphasis on a north-south axis. The north half of the site, on the other hand, has ordered, colonnaded structures – built during the Toltec era – which spread from east to west, defining their own distinct axis. A causeway or *sacbe* runs north-south, unifying the plan. The *sacbe* leads to the Sacred Cenote, a great natural sinkhole, and probably the source of the name of the site, literally, 'the mouth of the well of the Itzá.'

In 'Old' Chichen, buildings such as the Temple of the Three Lintels (a lowlying range-type structure with Chac masks at the corners) recall the galleries of the Puuc. The Red House and the House of the

146

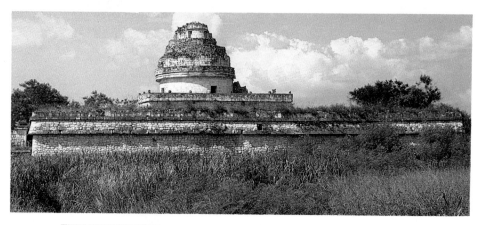

147 *(above)* The Caracol, Chichen Itzá.
Tiny windows in the uppermost story were
oriented for astronomical observations.

148 A cutaway drawing of the Caracol.

Deer are small temples set on raised platforms; their private rear
chambers and orientation to one another suggest the plan and
arrangement of the Cross Group temples at Palenque. Stonework,
however, is limited to heavy blocks, and the finely cut façade masonry
of the Puuc is missing. Nor are the specialized boot-shaped stones
used for vaulting, and the arched doorway – so important visually at
Uxmal – present at Chichen. In fact the visual refinements of negative
batter and uneven spacing of doorways are entirely lacking in Chichen
architecture, which in general cannot match the lyrical quality of
Uxmal.

The first building that shows a dramatic shift away from more
traditional Maya architectural practices is the Caracol, so-called for its
plan, the core of which resembles (perhaps deliberately) the section of
a conch shell. Concentric vaults lead to an upper chamber via a spiral

147
148

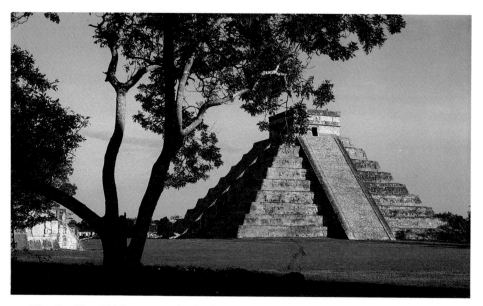

149 The Castillo, Chichen Itzá. Like the funerary pyramids of Palenque or Tikal
(ills. 97 and 101), the Castillo rises in nine distinct levels. The vertical profile and upper
molding of the superstructure are characteristic of Toltec-era buildings at Chichen.
This photograph was taken on the autumnal equinox, when seven serpent segments are
illuminated along the main stairs.

150 Temple of the Warriors, Chichen Itzá. This structure shares the proportions and the
use of a colonnade with Pyramid B of Tula, but the Chichen Itzá building is larger and
far more beautiful. The colonnade in front of the structure supported a perishable roof.
Early Postclassic.

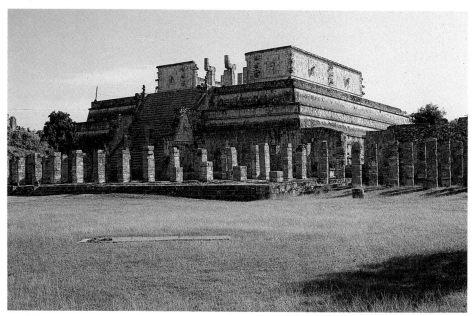

staircase. Stonework and vaulting remain of high quality. The great Mayanist Sir Eric Thompson decried its architectural style, claiming that it resembled 'a two-decker wedding cake on the square carton in which it came.' But one can equally well argue that the circles described within a trapezoid within a rectangle express an interest in geometry similar to that of Vitruvius in the Old World. As recent studies have shown, the unusual plan and placement of openings allow observation of the movements of Venus, whose synodic cycle of 236 days (Morning Star), 90 days (superior conjunction), 250 days (Evening Star), and 8 days (inferior conjunction) was of great importance to all Mesoamerican peoples. For the later Aztecs, round buildings were always dedicated to Quetzalcóatl (astronomically to be identified as Venus), who was seen with a conch shell in his manifestation as Ehécatl, the wind god. The Caracol plan's resemblance to the section of a conch may therefore be more than mere coincidence.

Quetzalcóatl may have been known in earlier times – perhaps even then associated with feathered serpents, which can be seen on many monuments – but it is clear that this god grew greatly in significance during the Early Postclassic, very possibly coincident with the life of the historical individual of the same name (Topíltzin Quetzalcóatl, or Kukulcan to the Maya, literally 'feathered serpent'). At about the same time, supernatural beings such as GI seem to have declined in importance while Chac gained new emphasis, or perhaps even developed out of the older entity. Just what provoked the changes in sacred imagery remains unclear, but ideological shifts often accompany geographic movement and chronological development.

The first Christian bishop of Yucatán, Diego de Landa, visited Chichen in the mid-sixteenth century, and made the earliest surviving European sketch of a Maya building. He drew a plan of the Pyramid of Kukulcan, or Quetzalcóatl, which is now generally known as the Castillo. His plan shows a building of many levels and rounded corners with staircases flowing down all four sides of the building. This structure has remained a beacon for explorers and scholars: in 1882, the French explorer Desiré Charnay lived in its chambers; in 1978, an American archaeologist was tragically struck and killed by lightning on it.

Like the Caracol, the Castillo was oriented to acknowledge movements of the heavens, and on the equinoxes the nine levels of the

pyramid cast a shadow that reveals a segmented serpent along the 149 northern balustrade. The flight of stairs on that side has ninety-two steps, if one counts the serpent heads at the base; each of the other three staircases has ninety-one, for a total of 365. Thus, both in numerology and orientation, the building recognizes the solar year. As we see the Castillo today, it is a radial pyramid of the sort first observed at Uaxactún in Protoclassic times and whose primary role would seem to have been to commemorate the completion of time.

In 1930, Mexican archaeologists exploring the Castillo found within it a complete pyramid-temple, also of nine levels, but with a single stairway to the north. Preserved in the temple chambers were a *chacmool* and jaguar throne, which remain *in situ* today. Given the pattern known at Tikal and Palenque, where earlier pyramids of nine levels held tombs of great kings, it seems likely that this one may also house a royal burial. Although the identity of that individual may never be known, the fact that this structure has always been associated with Kukulcan suggests that the great Toltec king himself may lie within the mass of the pyramid.

A typical feature of the final phase of construction at Chichen during the Early Postclassic are the large number of buildings distinguished by colonnades and serpent columns. The greatest of these is the Temple of the Warriors. Connecting colonnades extend to 150 define a large, semi-enclosed court, the south side of which is flanked by the so-called Mercado and a small ballcourt. As with the Castillo, the outer building was discovered to enclose a smaller but similar structure, now known as the Temple of the Chacmool.

One gains entry to the Temple of the Warriors itself through the maze of square pillars which would once have supported a perishable roof. Each pillar is carved on four sides. Some reliefs feature standing warriors with Toltec 'pillbox' headdress and weaponry; others show skirted figures, probably women, bearing offerings. Similar reliefs are worked on pillars of the rear chamber of Pyramid B at Tula, but the imagery there is limited to warriors. Anyone entering the Temple of the Warriors must have felt both the guidance of the offering bearers and the threat of the warriors.

The doorway at the summit of the temple is flanked by great feathered-serpent columns, whose plumed rattles once supported the door lintel. In the first chamber a *chacmool* was set to receive offerings; in the rear chamber a great platform raised up by miniature atlanteans

once served as the ruler's throne. A building such as the Temple of the Warriors may have been a seat of government, its function largely bureaucratic. The platform supports suggest the literal pillars of government, the warriors and offering bearers the means of its sustenance. The abundance of administrative buildings at Chichen Itzá is perhaps accounted for within a short construction era if we imagine that every regional governor – possibly an individual similar to the *bacab*, or governor, of the Conquest period – built a new establishment.

The Temple of the Warriors undoubtedly bears a striking resem-
140 blance to Mound B at Tula, but it also provides contrasts. Motifs and forms at Chichen reveal foreign influences, but the scale and quality are Maya. Chambers within the Temple of the Warriors, for example, supported corbeled vaulting; stonework was elaborate and finely crafted – and the Temple is only one of several such buildings at Chichen. At Tula, the stonework seems mean and sparse by compari-son, and Mound B stands alone as an impressive edifice. It is almost as if Toltec ideals were first given architectural expression at Chichen, and were then returned to Tula around the year 1000 in a provincial form.

151 The most unusual structure at Chichen is the Great Ballcourt, the largest of all ballcourts in ancient Mesoamerica. Its playing area extends over a length of 146 meters and a width of 36 meters, defining a surface almost identical in size to a modern American football field, and several times the size of the average ballcourt. Unlike most Classic courts, the Great Ballcourt has vertical sides, a feature it shares with the Uxmal design. Rings set into these side walls – presumably hoops through which the solid rubber ball passed or against which it was hit – are placed 8 meters above the playing surface, almost out of range.

Carved reliefs centered under the rings reveal grisly scenes, perhaps
152 documents of the events on the court. On the east side, two opposing teams of seven members each face one another. In the middle of the scene, the first player of the left team has decapitated the first player of the right, who, headless, kneels in front of a large ball marked by a great laughing skull. Six serpents of blood issue from the severed neck. The apparent victors on the left are more uniformly dressed than those on the right, who wear a variety of headdresses. All these ballplayers sport equipment of the sort generally associated with
cf. 71–73 Classic Veracruz: *palmas*, yokes, and handstones; and the padding on arms and knees was designed to take the bruising blows of the heavy

151 Almost too large to be played in by mere mortals, the Great Ballcourt of Chichen Itzá is the largest in Mesoamerica. Entwined serpents are carved on the rings set high in the side walls; carved reliefs adorn the sloping talus.

ball. Beaded scrolls with embedded *kan* crosses of the kind usually intended to represent precious liquid, particularly blood, form the background.

Three large platforms without superstructures guide supplicants toward the Sacred Cenote to the north. One of these platforms, the so-called *tzompantli*, or skull rack, is carved with rows of human skulls. A precedent for depicting human skulls on platforms exists at Uxmal, but the scale and number here indicate an increasing

152 Part of the Great Ballcourt relief, Chichen Itzá. Members of the victorious team have begun to sacrifice their opponents. At the time of the Conquest, the Maya claimed that Mexicans – often specifically the Toltecs – had introduced human sacrifice to their land.

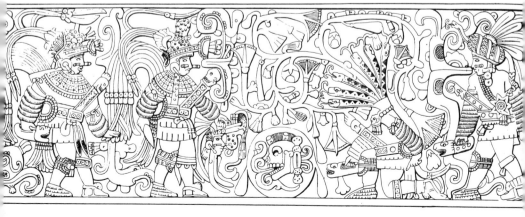

preoccupation with death at the end of Chichen's development, to which this platform and the two associated with it are generally attributed. Alternating jaguars and eagles devour human hearts on the Platform of the Eagles. These motifs also appear at Tula, and at both sites they were probably linked with the rituals of human sacrifice.

Three-dimensional sculpture regained prominence at Chichen during the Early Postclassic. Particular attention was given to thrones, *chacmools*, and mini-atlanteans, but even the design of plumbate pottery reflects the new concern for images in the round.

Thrones and *chacmools* are generally found together – for instance in the inner Castillo structure, Temple of the Chacmool, Mercado, and Temple of the Warriors – and they seem to replace the stela and altar of Classic times. In this we see the office itself commemorated rather than its occupant, whereas in Classic times the individual who held such an office was the focus of the record. Thrones include large platforms supported by mini-atlanteans and built-in benches, but the most splendid one is the red jaguar found in the rear chamber of the inner Castillo structure. Bright red cinnabar covers the jaguar body and jade disks form feline spots. A turquoise mosaic disk of the sort worn by Toltec warriors at the back of the waist was set into the seat.

In front of the majority of thrones stand *chacmools*, the most famous
154 of which was excavated from the Platform of the Eagles in 1875 by Augustus LePlongeon, who gave them the name by which they are known today. The variety and number of Chichen *chacmools* exceeds that of Tula. Perhaps the inspiration for them came from the recumbent captives often carved beneath the feet of figures on Classic Maya stelae, an image which the Toltecs transformed into the three-dimensional idiom of their day. In recent years it has become apparent that Maya materials, forms, and iconography, often with roots in the Classic period, made a more profound impact on Central Mexico than has been previously acknowledged.

Stucco paintings have miraculously survived throughout Chichen
153 Itzá. Scenes of Mayas and Toltecs once covered the interior of the Temple of the Warriors. In the illustration shown here, warriors with candy-striped body paint are defeated by darker figures usually identified as Toltecs, who lead away their bound, naked captives. The houses depicted appear to be Maya, though the stone architecture resembles Central Mexican models. One temple stands within a body of water: is it Lake Petén Itzá, where the Mexicanized Itzá Maya may

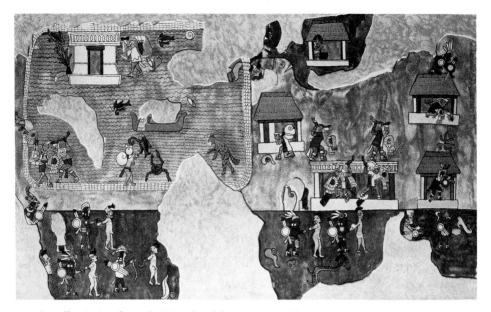

153 A wall painting from the Temple of the Warriors, Chichen Itzá. Copy and reconstruction by Ann Axtell Morris. Such scenes would seem to show a foreign conquest of Chichen in the Early Postclassic era, but there are no lakes near the site that resemble the one depicted.

have lived before coming to Chichen? The naturalistic human proportions of earlier paintings, as at Cacaxtla or Bonampak, give way here to some foreshortening, but non-naturalistic conventions reveal an intricate and lively landscape. Stylistically, the paintings have more in common with early Teotihuacan painting than with the tradition of Maya murals.

Pilgrimages to the Sacred Cenote continued to be made long after the Conquest, and objects dredged from the silt at the turn of this century spanned a millennium. The discovery of human skeletons confirmed the long-held suspicion that human sacrifice had taken place at the well. Among the finds rescued from the Cenote mire were offerings of copal, jade, and finely crafted repoussé gold disks. With their lively scenes of Mayas confronting Toltecs, the gold disks are not only important documents but also among the earliest Mesoamerican works where art is created from metal. The drawing of the human form and the layout of the scene, with basal panel reserved for an earth monster, reflects a development from the Maya tradition. On most of the disks warriors in Toltec dress dominate defeated Mayas.

187

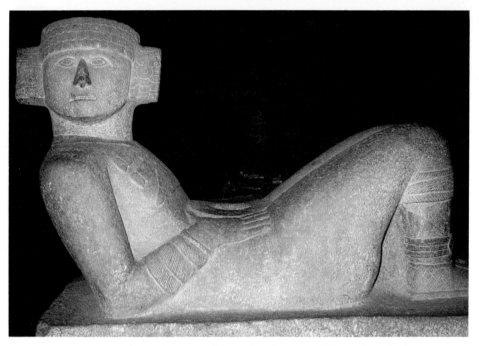

154 The *chacmool* excavated from the Platform of the Eagles, Chichen Itzá, in 1875 by Augustus LePlongeon, who unsuccessfully tried to take the stone sculpture to Philadelphia for the 1876 Centennial celebration.

Toltec, or Toltec-Maya, preeminence in the Early Postclassic may recall patterns of highland political dominance established earlier in Mesoamerica, and it certainly presages the tremendous success of the Aztecs. Such political success, however, does not guarantee priority in the aesthetic arena. Archaeologists may indeed prove one day that Tula truly reigned over the Maya, but the beauty, craft, and abundance of Maya works of the era will not be undermined.

THE DECLINE OF POSTCLASSIC MAYA ART AND ARCHITECTURE

Late Postclassic Maya art and architecture is mostly unimpressive, whether judged against Maya precedents or the splendors of Post-classic Central Mexico. Following the decline and abandonment of Chichen Itzá, Yucatán was loosely governed in the fourteenth and fifteenth centuries by a confederacy based on Mayapán and founded by Hunac Ceel, who had led a treacherous rebellion against Chichen.

188

Mayapán in turn eventually fell prey to treachery and was abandoned in the mid-fifteenth century. Although remembered as a great city at the time of the Conquest, Mayapán was poorly built and highly derivative of Chichen Itzá in terms of its art and architecture.

What did set Mayapán apart, however, was its plan, which was unusual for a Mesoamerican city. It was apparently designed as a walled city, with a population that dwelt mainly within its bounds. Set at its heart is the Castillo, a small and ill-executed copy of the structure of the same name at Chichen Itzá. The Mayapán builders constructed the Castillo in badly cut stone held together only by mud and stucco.

At least ten stone stelae have been discovered at Mayapán. The local limestone from which they are cut is of poor quality, but the stelae nevertheless show interesting imagery. Stela 1, for example, depicts a pair of figures inside a thatched structure, underneath a long glyphic text. Chac, the Postclassic Maya rain god, sits on a throne and gestures at a smaller 'figure,' who may be a stone or clay image, placed on a box, possibly once a *tun* glyph. This stela, and the others like it, may in fact bear scenes connected with the *acantun*, a part of the New Year's ceremonies shown in the Dresden Codex and discussed by Bishop Landa.

155 Large, hollow clay figures such as this one were made by Late Postclassic artists in the form of deities, probably as objects of direct worship. This example was collected at San Antonio, Quintana Roo.

156 Tulum in a reconstruction drawing by Nigel Hughes. Structure 16, often known as the Castillo, commands a splendid view of the Caribbean. The walls of most Tulum structures have a pronounced outward lean.

155 Large ceramic figures of the Late Postclassic have come to light throughout northern Yucatán. Most prevalent among these are images of Chac, who was thought to exist both as a single deity and as a group of four. Typically, these figures hold human hearts in the hand: they must have looked gruesome anointed with blood, as Spanish chroniclers tell us they were. The Postclassic potters used a coarse clay, with various substances added to lower the firing temperature. Most of the figures were once brightly polychromed, some with a stucco paint that obscured imperfections. Only the most tenacious pigments, particularly blue, survive.

Christopher Columbus's son Ferdinand accompanied his father on the Fourth Voyage to the New World, and he described the great seagoing canoes of Maya traders that they saw among the Bay islands off Honduras. Some canoes were piled high with fine cotton mantles, a standard unit of exchange at the time of the Conquest, along with other embroidered garments. Other canoes carried foodstuffs – grains, roots, and fermented corn beverage – and copper bells and hatchets, as well as cacao beans, another unit of exchange. What is clear is that the Caribbean coast sustained considerable commerce, and that commerce in turn provided the basis for the growth of Caribbean

Yucatán centers. Tulum and Tancah were probably the largest of these. On his voyage to Yucatán in 1518, Juan de Grijalva sighted what may have been Tulum, and reported that the city was bustling with activity. The small shrines on the island of Cozumel and at other places along the coast may have been no more than way-stations for travelers – a function they later served for pirates who worked the same coast.

Tulum is beautifully situated overlooking the Caribbean. The sea forms the fourth side of a rectangle with the three walls that surround the main ceremonial structures. Unlike Mayapán, the populace lived outside the walls. The temples of Tulum are small, even diminutive, with some doors too small for easy entry. Most buildings were shabbily constructed and heavily stuccoed. The negative batter, used to subtle effect at Uxmal, was here carried to such an extreme that some buildings look as if ready to pitch over. The cornices of Structure 16 reveal great faces, and the sharp outward slant of the structure makes the eyes bulge and the chin recede.

156

Elaborate paintings cover the walls – both interior and exterior – of many Tulum buildings. The palette of these works is limited to red, blue, and yellow, all outlined in black. Stiff conventional gestures as

157 Many interior wall paintings such as this one (reconstruction) have been preserved at Tulum. The figure here has the facepaint of Tezcatlipoca, an Aztec deity. Exterior stucco was also painted, but little more than traces of those brilliant pigments survive today. Late Postclassic.

well as the proportional system suggest influences from Late Postclassic Mixtec painting. Some of the imagery also hints at contact with Central Mexico: the example here shows a deity covered with turquoise mosaic; his eyes are banded with what appears to be black obsidian. This masking is typical of the Central Mexican deity, Tezcatlipoca. The most famous turquoise mosaic masks to have survived the Conquest were those given to Hernando Cortés by Motecuhzoma, but Grijalva's record shows that he also collected some in Yucatán, and perhaps such costume elements provided the means by which religious iconography was shared. Although the Aztecs were not well informed about their Maya neighbors in Yucatán, the Maya nevertheless knew a great deal about this Central Mexican power by the eve of the Conquest. Foreign elements and even a foreign stylistic impact, however, should not be taken as evidence that Tulum was occupied by foreigners: the glyphs that accompany the paintings of Tulum are purely Maya, indicating that they were designed for a Maya audience. Outside influences do nevertheless show the complicated iconographic interaction at the time of the Conquest. At Santa Rita, in what is now northern Belize, Thomas Gann had copies made of Late Postclassic paintings that were destroyed shortly after he found them in 1896. Their style also bears a resemblance to Mixtec painting, but the unusual iconography is largely Maya, as is the writing.

Probably contemporary with the paintings of Tulum are the four surviving Maya manuscripts. Of these, the finest, most complete and oldest is the Dresden Codex, preserved today in the Dresden Sachsische Landesbibliothek. Cortés was given several Mesoamerican manuscripts in 1519. He sent these to his king, Charles V in Vienna, where the Dresden Codex was discovered in the eighteenth century, so it may have come as part of the Cortés collection. The survival of the Dresden is fortuitous, since the first bishop of Yucatán, Diego de Landa, gathered up and burned every 'idolatrous' manuscript that he could find. Technically a screenfold rather than a bound codex, the Dresden was painted primarily in black and red, but with bright polychrome on some pages, on a stucco surface over native fig-bark paper. Pages are divided into registers, and the glyphs and figural illustrations create a unified text. Most of the book is filled with auguries and predictions most useful in an agricultural context. The rituals of the New Year's ceremonies are described. Calculations deep

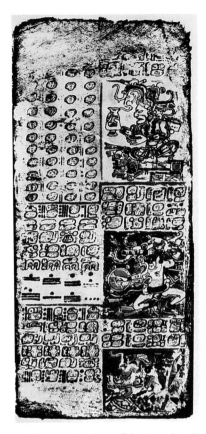
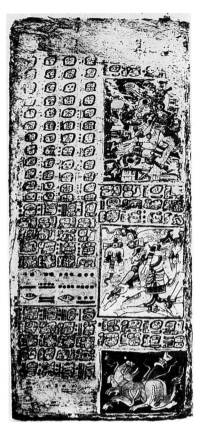

158 Pages 46 and 47 of the Dresden Codex. Perhaps dating to as early as the thirteenth century, this folding-screen book written on bark paper includes elements – such as calculations on the Venus pages shown here – that may have been copied from an older, perhaps Classic-period, manuscript. Here the Venus gods are shown as malevolent forces who cast spears.

into the past and future are also related, as are the movements of the Venus gods and Chac, the rain god. The Venus calculations also provide confirmation of the standard correlation constant used to derive equivalents for Maya and Christian calendars.

Only a few pages survive of the Paris Codex, and the Madrid manuscript – the third of the remaining Maya texts – is less interesting artistically: it appears to have been made with great haste. Its style is very close to the paintings at Tancah. In 1973 a few pages of a fourth text, an ancient Maya Venus table, came to light, and they are now

known as the Grolier Codex after the Grolier Club in New York where they were first exhibited.

At the time of the Conquest various highland Guatemala Maya ethnic groups – Cakchiquel, Quiché, Pokomán, and Tzutuhil – warred over territory and, perhaps more importantly, access to resources. Hilltop acropolises provided strongholds during this era, at Iximché, Utatlán, Mixco Viejo, and Cahyup, among other places. Following the Conquest of Central Mexico, the victorious Spaniards swept down into Guatemala. From Iximché the Cakchiquels took the foreigners' side against their old enemies, the Quiché. By 1527, all groups of Maya had been subjugated, and the Spanish were able to establish a new capital at Ciudad Real, the first in a series of modern capitals that would be wracked by severe earthquake. Iximché, like the other fortified cities, was abandoned. Its plan reveals the nature of political organization there. Iximché was laid out to accommodate, architecturally, two important Cakchiquel lineages. Buildings were largely executed in duplicate: two ballcourts, two palaces, and so forth. The steep profiles of the structures, with emphasis on the *tablero*, recall the profiles of Classic Monte Albán.

159

Sculptural efforts continued in what is now Guatemala after the Conquest. Cortés left his sick horse with the Itzá lords in Tayasal, in the Petén, and after his departure, the horse died. Many years later, when Spaniards passed that way again, they found a stone or wooden image of the horse, enshrined in a temple! Stone cult objects have been

159 Pyramidal platforms, Iximché. Cakchiquel lords reigned from Iximché at the time of Pedro Alvarado's brutal sweep into Guatemala. They helped the Spanish defeat the Quiché.

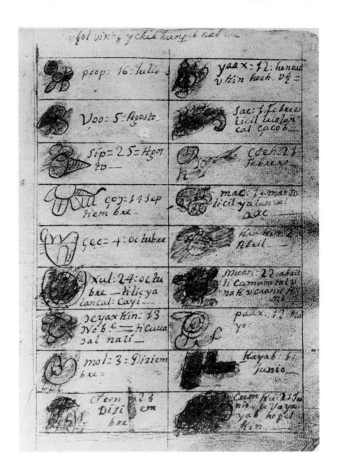

160 Page 23 from the book of Chilam Balam of Chumayel. By the time this manuscript was written during the Colonial period, the glyphs – here showing the Maya months – were little more than vestigial ornaments. The text is in Maya, written in the Roman alphabet.

made in Guatemala even more recently: on a hill near Chichicastenango, a stone image is still venerated by local people.

Both in highland Guatemala and in Yucatán the Maya quickly adopted the Roman alphabet. In some cases, ancient books were transcribed. The *Popol Vuh*, for example, the single most important sixteenth-century document in terms of Maya mythology, was written down by a noble Quiché. Others, such as the many books of Chilam Balam, emphasizing cyclical historical events and prophecies, were written by noblemen in Yucatán. In the margins of the Chumayel manuscript of Chilam Balam, the eighteenth-century scribe added glyphic cartouches, perhaps from the source he was copying. The glyphs he drew were no longer meaningful, but only decorative. It is here we see the end of the tradition of Maya art.

160

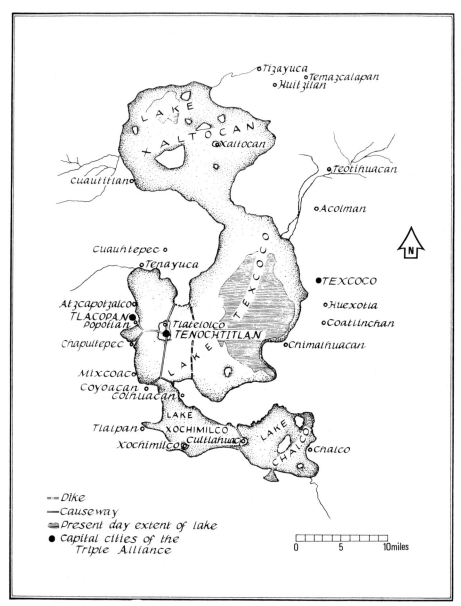

Tizayuca
Temazcalapan
Huitzilan

LAKE XALTOCAN
Xaltocan

Cuautitlan

Teotihuacan

Acolman

Cuauhtepec
Tenayuca

LAKE TEXCOCO

TEXCOCO

Azcapotzalco
TLACOPAN
Popotlan
Chapultepec

Tlatelolco
TENOCHTITLAN

Huexotla
Coatlinchan

Chimalhuacan

Mixcoac
Coyoacan
Colhuacan

LAKE XOCHIMILCO

Tlalpan
Xochimilco
Cuitlahuac

LAKE CHALCO

Chalco

N

=·=Dike
—Causeway
Present day extent of lake
● Capital cities of the
 Triple Alliance

0 5 10miles

161 The Valley of Mexico in Aztec times.

The Aztecs

By 1515, rumors were circulating in Tenochtitlan, the Aztec capital, of strange occurrences. Descriptions came back to Motecuhzoma II from the coast that great floating temples or mountains had been seen on the sea. Evil omens were studied. In 1509, a bright comet had alarmed Motecuhzoma, and during the last ten years of his reign he surrounded himself with soothsayers. According to some sources, a sense of gloom prevailed in Central Mexico, particularly in the mind of the ruler. Was Quetzalcóatl, the deified king of the Toltecs, about to make a return, to wreak his vengeance? Was the fifth sun about to collapse in violent cataclysm, provoking the end of this cycle of life? The melancholic poetry of the king of neighboring Texcoco suggested the transience of life.

> Just as a painting
> We will be dimmed,
> Just as a flower
> We shall become desiccated. . .
> Ponder on this,
> Eagle and Jaguar knights,
> Though you were carved in jade,
> Though you were made of gold,
> You also will go there
> To the land of the fleshless.
> We must all vanish,
> None may remain.

> (After N. Davies, *The Aztecs*,
> after Leon-Portilla, *Trece Poetas*, p. 50)

The Aztecs were the last of the great native Mesoamerican civilizations. Theirs was still a young culture at the time of the Spanish Conquest, and, despite the difficulties that Motecuhzoma II had in suppressing insurrection, they would probably have endured for many centuries had Hernando Cortés and his men not arrived when

they did. For the Spanish, Tenochtitlan was the fulfillment of a fantasy, the sort of place they had heard of in the late medieval romances of Amadís de Gaula. Years later, when Bernal Díaz del Castillo, a soldier with Cortés, wrote a chronicle of the Conquest, he could still recall his excited first impressions of the Aztec capital:

> When we saw so many cities and villages built both on the water and on dry land, and this straight, level causeway, we couldn't resist our admiration. It was like the enchantments in the book of Amadís, because of the high towers, *cues* [pyramids] and other buildings, all of masonry, which rose from the water. Some of our soldiers asked if what we saw was not a dream.
>
> (*The Discovery and Conquest of Mexico*, trans. A. P. Maudslay, New York 1956)

AZTEC HISTORY

According to early chronicles Tenochtitlan was founded in 1345. Before that the Aztecs scraped out a mean living on the old volcanic beds south of Lake Texcoco, near the present site of the National University. (The term Aztec, referring to the dominant people of Central Mexico, became current only in the nineteenth century, but it is convenient and will be used here. They knew themselves as the Mexica.) The Aztecs served as mercenary soldiers for more successful groups. In the early fourteenth century, before they moved to Tenochtitlan, they asked their neighbors and overlords in Culhuacan for a royal bride, in order to establish a ruling lineage. The city offered the ruler's daughter. Having accepted, the Aztecs invited the Culhuacan ruler to visit. When he attended the shrine of what was reputed to be a new deity, he found instead an Aztec priest wearing the flayed skin of his daughter. In response to this obscene offense the Aztecs were driven from their settlement. Some fled into Lake Texcoco and made their way to an island, where they founded Tenochtitlan, which is now Mexico City.

Such acts characterized the early history of the Aztecs, who claimed to be nomadic barbarians, from the mythical place Aztlán, supposedly in northwest Mexico. It is in fact possible that these Náhuatl speakers were already in Central Mexico before they embarked on their search for the new home described to them by Huitzilopochtli, their cult

198

god, a war and hunting deity. By the time of the fall of Tula, in any case, the Aztecs had Central Mexican connections, and were perhaps accomplices in the Toltec downfall. The birth, or possibly rebirth, of Huitzilopochtli took place on a hill near Tula, according to Aztec legend. The god promised to lead them to an island in a lake, where an eagle would sit in a cactus. Tenochtitlan was that home.

During the fourteenth century the Aztecs were vassals to more powerful cities around the lake, such as Azcapotzalco to the west. With the accession of Itzcóatl in 1426, however, the situation changed dramatically. Under his leadership, and with the aid of his second-in-command, a military adviser who bore the title of 'Woman Snake,' the Aztecs crushed their former masters and began to consolidate the lake cities under their direction. Their military might made them greatly feared. They formed the Triple Alliance of Texcoco, Tenochtitlan, and Tlacopan, with control east and west of the lake. Under Motecuhzoma I (1440–1468), the empire grew considerably, particularly to the south. Major waterworks and causeways were built, and *chinampa* agriculture (often called 'floating gardens' but in fact a type of raised-field farming) expanded. Mid-fifteenth century crop failures and other disasters, however (a snowstorm sank *chinampas* and caused thatched roofs to collapse) afflicted Motecuhzoma's reign. Then a successful New Fire ceremony was held in 1455 to commemorate the end of the 52-year cycle (see Chapter Three), and almost miraculously, we are told, the natural disasters ceased. To prevent food shortages from occurring in the future Motecuhzoma began a new campaign of conquest to the east, particularly in the Huastec region, where agricultural bounty was more certain. Under his administration the Aztecs also began what was known as 'flowery war,' or perpetual warfare for the purpose of gaining and offering sacrificial victims, often in gladiatorial combat. The main target of such warfare was Tlaxcala, a state to the east of the Aztecs and by now largely surrounded by them.

Axayácatl and Tízoc, the rulers to succeed Motecuhzoma I, were less successful on the battlefield. Much energy was expended simply in controlling the dominion already established, and forays to the west brought the Aztecs into unsuccessful combat with the Tarascans, who had the benefit of metal weapons. Perhaps because he was jealous of its commercial success, Axayácatl brought the northern part of Tenochtitlan's island, Tlatelolco – known for its wealthy merchants –

firmly under Aztec control. The last ruler of the fifteenth century, Ahuitzotl (1486–1501), was a great soldier who stepped up the pace of both conquest and sacrifice. Parts of Guatemala, Oaxaca, and even El Salvador were incorporated into the Aztec realm. These last three rulers of the fifteenth century were brothers, grandsons of Motecuhzoma I.

Motecuhzoma II, a son of Axayácatl and destined to be the last independent ruler of the Aztecs, was installed as *tlatoani*, literally 'speaker', in 1502. (The Spaniards equated the title with emperor, but the word suggests 'he who speaks for the people.') By this time, the population of the island had grown to about 200,000. Known more for his religious preoccupations than his military skills, Motecuhzoma presided over troubled times in Aztec history, even before the landing of the Spanish. There were ominous portents, and Motecuhzoma could not be reassured. Perhaps a larger problem was the nature of the Aztec 'empire' itself. The Aztecs kept no standing armies. Following an initial subjugation, they depended on local rulers, sometimes puppets, to carry out their administration, particularly in the fulfillment of tribute and the worship of the Aztec cult god, Huitzilopochtli. By the late fifteenth century, the Aztecs were overextended. More and more, distant provinces rebelled and Aztec might had to be wielded to restore control. The 'flowery war' with Tlaxcala became more than a military exercise, and other parts of the realm grew restless. In the end the very fierceness of Aztec retaliation was their undoing, for their enemies eagerly joined forces with the Spanish. Without the Tlaxcala warriors, the Spanish Conquest of Mexico would have been delayed many years.

Even at their first sighting of the Mesoamerican mainland, Spanish explorers knew they had discovered cultures far more sophisticated than any they had encountered in all the twenty-five prior years of their dominion in the Caribbean. At first they reconnoitered the coast of Yucatán, but their progress was impeded by hostile Maya. The Spanish found them living in small cities, with ceremonial centers where 'idols' were kept in temples. The 'idols' offended and disgusted the Conquistadores, who therefore had no scruples about stripping these cult images of the gold and copper that adorned them. The metal wealth of the Postclassic Maya was negligible, however, and under the leadership of Cortés in 1519 attention was turned directly to the Valley of Mexico, to the people that informants of the time called

'Culhua' or 'Culhua-Mexica.' What drew Cortés to Tenochtitlan was not only the lure of gold; Cortés also perceived a great unknown kingdom, from which, if he could conquer it (with only 500 men and less than twenty horses in his original army), he would gain great power and prestige.

In the summer of 1519 Cortés founded Veracruz (the 'true cross') on the Gulf Coast of Mexico. With the aid of his translators – Jerónimo Aguilar, a devout Christian captured by the Maya years before and eager to serve his king, and Doña Marina, a royal native woman later given this name who spoke both a Maya language and Náhuatl, the Aztec tongue – Cortés quickly perceived the fragility of the Aztec hegemony. It may have been with the aid of Doña Marina that he learned of the myth of Quetzalcóatl, the feathered serpent god identified as a Toltec king. It was said that Quetzalcóatl fled Tula in the tenth century, as we have seen, and that he had vowed to return from the east to wreak vengeance. Legend ascribed fair skin and a beard to Quetzalcóatl, and Cortés may have capitalized on this. In mid-August Cortés began his march inland. He convinced local administrators that they no longer needed to fear the Aztecs, and he began to build a reservoir of support. In Tlaxcala, he gained his most important allies. Motecuhzoma tried to dissuade the Spanish from advancing by sending gifts, but this only whetted their appetites. By 8 November 1519, Cortés and his men were able to march into Tenochtitlan. Motecuhzoma did not prevent their entry. Unfortunately for him, however, the Spanish soon made him a hostage to guard their own security, and placed him under house arrest.

Meanwhile, Spanish enemies of Cortés had arrived in Veracruz, and Cortés had to hurry back to the coast. In Tenochtitlan, the Spaniards grew uneasy and restless. In a reckless move, they attacked a religious ceremony where human flesh was being offered at the temple precinct. Insurrection broke out, and in desperation the Spaniards persuaded Motecuhzoma to try to appease the people. As he urged them not to fight he was struck on the head by a stone and killed. When Cortés returned a few days later, he found the remaining Spaniards under siege, and they fled the city on what is now called the 'Noche Triste,' 30 June 1520. Many men, horses, and much gold were lost. Nine months later, bolstered by thousands of Tlaxcalans and reinforcements and supplies from Cuba, Cortés laid siege to Tenochtitlan. Wracked by deprivation and weakened by disease, the Aztecs

under the leadership of Cuauhtémoc at last yielded to the Conquistadores on 13 August 1521.

Cortés wrote a series of letters to Charles V, recounting events and justifying his behavior. By means of these letters Cortés became the first western historian and art historian of Mesoamerica. Other important Renaissance figures also commented with enthusiasm on the splendor of New World treasures. Albrecht Dürer, for example, visited Brussels at the arrival of the first Royal Fifth, that is, one-fifth of the riches collected by Cortés. Many curiosities were sent: perhaps the Dresden Codex and the marvelous costume elements delivered to Cortés by Motecuhzoma's emissaries were among them. Dürer, the son of a fine goldsmith, was particularly impressed by the metalwork:

158, 177

> Also I saw the things which were brought to the King from the New Golden Land: a sun entirely of gold, a whole fathom broad; likewise, a moon, entirely of silver, just as big; likewise, sundry curiosities from their weapons, armor, and missiles; very odd clothing, bedding, and all sorts of strange articles for human use, all of which is fairer to see than marvels. These things were all so precious that they were valued at a hundred thousand guilders. But I have never seen in all my days that which so rejoiced my heart, as these things. For I saw among them amazing artistic objects, and I marveled over the subtle ingenuity of the men in these distant lands. Indeed I cannot say enough about the things which were there before me.

Unfortunately, the same gold that merited Dürer's accolades and dazzled the Old World drove the Spanish to sack and destroy both structures and art in their search for the precious metal. The treasures that Dürer saw were melted down, their value as currency far exceeding their interest as works of art from the New World.

As a result, although the Aztecs made many fine objects of gold and silver, almost none survive. Nor were the buildings that housed these ancient treasures spared either. Tenochtitlan – ransacked and subsequently transformed into the Colonial capital of New Spain – suffered more than any other major Precolumbian city. Nevertheless, thanks to the wealth of documentation of Aztec life, art, and 'idolatrous' customs in sixteenth-century chronicles, we still know more about the art and architecture of Tenochtitlan than we do about any other Mesoamerican city. Recently, major excavations at the heart of the

162 Folio 2, Codex Mendoza. Made in the mid-sixteenth century for the viceroy of New Spain, the Codex Mendoza is a record of history, tribute, and customs of the Aztecs. The central motif of the frontispiece shown here appears on the Mexican flag today.

ceremonial precinct, as well as minor excavations along expanding subway lines, have revealed yet more of the material evidence for Aztec art.

ARCHITECTURE AND CITY PLANNING

Bernal Díaz compared the general plan of Tenochtitlan to Venice, and the city was indeed crisscrossed by a web of intersecting canals, laid out on a grid. Four main residential quadrants radiated from the walled ceremonial precinct. Just outside the walls stood the royal palaces. The frontispiece of the mid-sixteenth-century manuscript, the Codex Mendoza, can be read in many ways, but one is as a map of *162* Tenochtitlan. At the center is the eagle in a cactus, the place symbol for Tenochtitlan and used on the Mexican flag today. As the frontispiece shows, the city was divided by water into four sections.

The page can also be read as a plan of the walled ceremonial precinct. On Mesoamerican maps (and on some European maps as well), east was at the top of the plan. Here we find a house, probably a reference to the great twin pyramid. It is set in opposition to the *tzompantli*, or skull rack, which was also a prominent feature of the ritual precinct. Fifty-one year names run as a border round the page (2 Reed is marked as the year of the Conquest), placing the scene within the cyclical calendar. In the lower margin are two principal conquests of the Aztecs and, as on a Maya stela, captives, the symbols of dominion, lie beneath the heads of state, who are also represented above. For Tenochtitlan, the definition of the city was bound to its position in both space and time.

Another sixteenth-century manuscript, the Primeros Memoriales, *163* also shows the plan of the ceremonial precinct. In this illustration the twin pyramid lies at the top or east; a penitent in white garb stands in front. This is the benevolent Postconquest view of Quetzalcóatl. Beneath him lie the *tzompantli* and I-shaped ballcourt.

In 1978 a chance discovery by workers digging in the vicinity of the ceremonial precinct helped initiate the most important archaeological excavations in Mexico City this century. Among many remarkable finds were a funerary urn recovered in a context that suggests it may have held the ashes of Motecuhzoma I, and unusual sculptures of high *166, 170* quality that fundamentally alter our knowledge of Aztec art. Given the combined information that we now have from sixteenth-century manuscripts and recent archaeology we can at last begin to understand many of the principles underlying the layout of the ceremonial center.

Excavations have shown that some sort of ceremonial architecture preceded Aztec construction in the ceremonial precinct. Over the nearly 200 years of Aztec domination, the Templo Mayor (as the entire complex is often known) was rebuilt several times. Each successive phase of construction was marked by caches and deposits before the new structures completely encased their predecessors. In 1487 the final building program was completed, and it was this version of the precinct that Cortés and his soldiers saw. Father Durán's history of the Aztecs describes the rededication ceremony of 1487. Sacrificial victims were led in long processions from the Huastec region, some individuals tied together with ropes through their pierced noses. Thousands of sacrifices were offered, and blood ran in the streets and canals.

163 In the mid-sixteenth century, this plan of the center of the ancient Aztec capital was drawn up for Father Sahagún in a manuscript known today as the Primeros Memoriales. The Twin Pyramid of Huitzilopochtli and Tlaloc is at the top of the drawing. Beneath Quetzalcóatl, in white, are the skullrack and ballcourt. Only three doorways granted access to the precinct.

This city and temple plan, as might be expected, drew on precedents in the Valley of Mexico, from Tula and Teotihuacan to small cities along the lake. The twin pyramid appears to have been a Late Postclassic invention, known at Tenayuca among other places. It provided an equality between the two deities venerated in the shrines at the summit. The canals laid out along a grid at Tenochtitlan were probably modeled on the rigid grid at Teotihuacan.

Again, as at Teotihuacan, the overall plan of Tenochtitlan took advantage of the natural topography of the Valley of Mexico. The twin pyramid was framed by the volcanoes Ixtaccihuatl and Popocatepetl to the east, recalling the positioning of the Pyramid of the Moon with Cerro Gordo at Teotihuacan. The ceremonial precinct was also laid out to acknowledge the movement of heavenly bodies. During the wetter season, appropriate for agriculture, the sun rose every day behind the blue Temple of Tlaloc, the ancient rain and earth

45

164 At Malinalco, west of Tenochtitlan, a mountainside was carved in Aztec times to set temples into the living rock. The thatched roof is a modern restoration.

god; in the drier months, the sun emerged from the red Temple of Huitzilopochtli, whose associations with warfare, hunting, and fire were appropriate for this season. On the mornings of the two annual equinoxes, however, the sun rose between these two temples and faced the Temple of Quetzalcóatl instead. Quetzalcóatl, of course, was expected to return from the east to wreak vengeance; this temple was thus positioned to keep the vigil.

In the union between Tlaloc and Huitzilopochtli on the Templo Mayor, the old established deity of the Toltecs and perhaps Teotihuacan gave legitimacy to the new cult of the Aztecs. The two seasons of the tropical world, wet and dry, were also thus united. The Temple suggests too the expression *atltlachinolli*, literally 'water-conflagration,' used by the Aztecs to mean warfare, especially sacred war. In the very pairing of Tlaloc and Huitzilopochtli they made this metaphor the center of Aztec religion.

The Aztecs therefore echoed and recreated within the ceremonial precinct the natural topographic features surrounding Tenochtitlan. At other sites around the Valley of Mexico, however, they carved the

mountains themselves, transforming natural forms into manmade ones. At Texcotzingo, a hill east of Lake Texcoco, baths and shrines were worked directly into the cliffside, making it a pleasure garden. Shrines were constructed at the summits of many other mountains in the Valley of Mexico too. At Malinalco, a ceremonial center was built into a mountainside. The most important building there is a round structure carved out of the living rock. To enter the inner chamber *164* one steps through an open pair of monster jaws and onto a giant tongue. A circular bench with jaguars and eagles carved as seats curves round the interior, and a deep hole of narrow diameter at the center of the floor enters the heart of the mountain. The jaguar and eagle pelts suggest that this was a chamber for the military orders of jaguar and eagle knights, who may have conducted penitential rites here, perhaps offering their own blood directly into the earth.

SCULPTURE

The theme of blood sacrifice is important to much Aztec sculpture. The Spaniards were appalled by the accumulation of human blood they found on these 'idols.' One Spanish soldier, Andrés de Tapia, described the experience of seeing a large and terrifying sculpture encrusted with jewels, gold, and human blood. That sculpture may have been the great Coatlicue, or 'she of the serpent skirt,' a depiction *165* so fearsome that it was systematically re-interred at various times after its accidental discovery in 1790 in excavations near the Cathedral, within the old ceremonial precinct. It is probably the greatest of known Aztec sculptures.

The Coatlicue is both a two-dimensional work, intricately patterned, and a great three-dimensional portrait. Like many Aztec sculptures, it is also carved on its underside with an earth monster – indeed some early students therefore erroneously imagined that it was meant to be suspended in the air. The bulky figure is shaped like a mountain, and she leans forward, pressing upon the viewer and enveloping him in shadow. Particularly in profile, she also resembles the great twin pyramid. The head is severed and replaced by two snakes, symbolic of flowing blood. Another snake descends from her groin, suggesting both menses and penis. Her hands and feet have been transformed into claws, and she wears a necklace of severed hands and extruded hearts. It is a nightmare cast within female form.

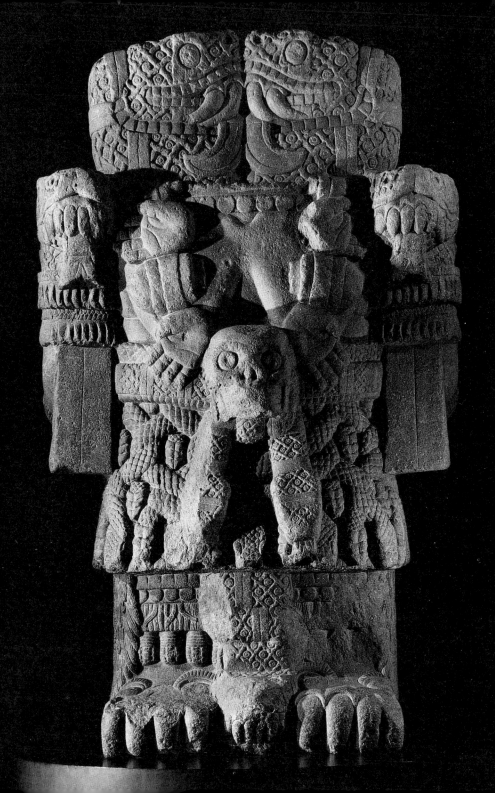

It is also a powerful, imaginative sculpture, representative of the superb work created in Tenochtitlan in the fifty years preceding the Conquest, in what has been termed the 'metropolitan' style by George Kubler.

The Coatlicue may once have resided in the Huitzilopochtli chamber of the twin pyramid, for Coatlicue figured as Huitzilopochtli's mother in Aztec cosmic myth. According to legend, Coatlicue kept a temple shrine on a hill near Tula called Coatepec, or 'hill of snakes.' After tucking a ball of down feathers in her bosom, she became pregnant with Huitzilopochtli. Repelled by her condition, her children, especially her daughter Coyolxauhqui, plotted her death. When Coatlicue's enemies attacked her and sliced off her head, Huitzilopochtli rose from her severed trunk fully grown and armed. He banished the attackers and mutilated his evil sister, severing her extremities, so that she collapsed at the base of the shrine.

The myth was permanently commemorated at the twin pyramid. Serpents lined the base, as if to suggest the placename of Coatepec. Within the Huitzilopochtli shrine was a sculpture of that deity, probably made of wood and now lost, and perhaps the great Coatlicue, preserved in headless form. The recent excavations in the Templo Mayor have revealed a great round stone of Coyolxauhqui *166*

165 *(opposite)* Rediscovered in the late eighteenth century, this sculpture of the goddess Coatlicue was so fearsome that it was reburied for some years. Two serpents form her head, and she wears a necklace of hands and hearts.

166 A huge stone relief of Coyolxauhqui as a dismembered goddess, from the base of the twin pyramid, Tenochtitlan. Discovered by workmen excavating the cellar of a bookstore in 1978, this sculpture sparked renewed interest in the remains of the Aztec sacred center, subsequently the focus of extensive excavation.

at the foot of the pyramid, mutilated and humiliated, a permanent record of conquest and probably the place of much subsequent sacrifice. Coyolxauhqui was also understood to be the moon and Huitzilopochtli the sun, so the myth repeats the dominance of the greater heavenly body over the lesser, even the three-dimensional over the two-dimensional. In their positioning, we should also recall *162* the Codex Mendoza frontispiece and its setting of defeated figures at the bottom of the page.

Such extraordinary Aztec sculptures reveal the energy given over to the new, imperial style. As parvenus in Mesoamerica, however, the Aztecs had many established sources upon which to draw. Enclaves of foreign artists, particularly from Oaxaca, lived in Tenochtitlan, bringing their own styles and techniques to the metropolis. The Aztecs returned to Tula, Hidalgo, to sack the site, and brought back Toltec sculptures – perhaps *chacmools* and warrior figures – to their own capital. They also derived inspiration from the rich three-dimensional tradition of the Huastec region of the Gulf Coast, particularly after conquering much of the area in the mid-fifteenth century. And, almost like archaeologists, the Aztecs were continually uncovering elements of the past. The recent excavations in the Main Temple precinct revealed caches of objects, many of which may have been antiquities even in Aztec times. Olmec, Teotihuacano, and West Mexican stone pieces have been found as offerings. Whether through tribute, looting, or the collection of heirlooms, the Aztecs were the recipients of many works of art that they studied, cherished, buried again, or incorporated into their own visual imagery.

167 The Stone of Tízoc is essentially an historical monument, worked in the conventionalized, stiff-figured manner characteristic of manuscript painting, particularly in Oaxaca, where historical screenfold writings had long been made. Like a Roman emperor depicted as Hercules, the minor Aztec ruler Tízoc is shown in the garb of Tezcatlipoca, a principal Central Mexican Postclassic deity known by his smoking mirror and serpent foot (like God K of the Maya), and in this role he takes a captive. This image appears fifteen times on the Stone, confirming the prowess of Tízoc (in fact he was a failure as a military strategist), but set within a cosmic scheme: a solar disk defines the upper surface of the stone; gnawing schematized earth monsters with reptilian skin lie under the protagonists' feet. From such a depiction, we can probably assume that the *tlatoani* was

perceived to be divine by this time. Motecuhzoma II, we know, was thought of as a god during his lifetime.

No single image of ancient Mesoamerica is better known than the great Calendar Stone: it is reproduced on ashtrays, keychains, liquor labels, and is popular both in and outside Mexico. Like the Stone of Tízoc and the Coatlícue, the stone was saved from the axe by some farsighted priest late in the eighteenth century when it was found near the Cathedral. Despite its name, the Calendar Stone does not function

168

167 *(above)* The Stone of Tízoc commemorates the brief reign of this minor fifteenth-century ruler. Victorious warriors hold captives by the hair, as do the victors in ills. 24 and 180. A solar disk is carved on the upper surface.

168 The great Calendar Stone features a solar diadem with an earth monster within at its center. Although not a functioning calendar by any means, the twenty day signs appear on the disk.

as any sort of useful calendar but works rather as a record of calendrical cataclysm. It represents an expanded cosmic scheme related to the one recorded on the Stone of Tízoc. The basic representation is of a solar diadem, borne by encircling fire serpents and framing the twenty day names. At the center is the outline of the day sign, Ollin, or Movement, within which are described four dates. These commemorate the Four Suns, or previous eras, known by the day names on which destruction took place. On Four Wind, for example (upper left), the world and its inhabitants were destroyed by great winds. According to the Aztecs, the current world would end in cataclysm on 4 Movement, the larger date inscribed. At the very center of the stone is a frontal face bordered by clawed extremities that grasp human hearts. Cecilia Klein has identified this as the Night Sun, but it may instead be the face of the female earth monster, usually found on the hidden underside of other monuments. The image thus created is of the sun fallen on earth, the cataclysm complete, the Aztec world ended. On the Stone of Tízoc, the sun and earth were kept apart

169 The impersonator of Xipe Totec, 'our lord the flayed one,' wears the skin of a flayed human. By the end of a twenty-day ritual in honor of Xipe, the skin would have rotted. Like the shoot of a new plant, the human emerged. An imitation of a plant life cycle, Xipe Totec was a god of springtime. Note the extra set of hands that dangle limply.

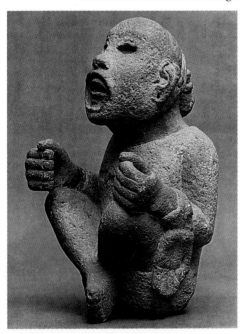
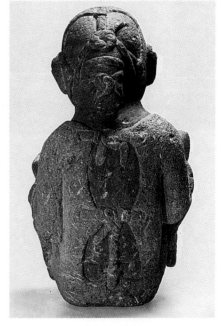

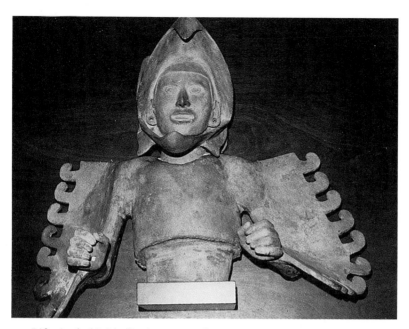

170 Life-sized, this idealized young eagle warrior is posed as if to take flight. Gulf Coast sculptors, skilled in firing such large terracotta works, were probably the makers.

by rulership and captive sacrifice. The Calendar Stone is exhibited and reproduced as a wall panel today, but it was probably set on the ground, with blood offerings anointed on the earth monster to keep the apocalypse at bay.

Many small cult images are known, and it is likely that they were placed in shrines throughout Late Postclassic Central Mexico. Most common among these are female maize deities, generally standing figures with headdresses like temple roofcombs. A good number of such figures are flat and blocky, without the skilled execution of imperial works but also lacking the more horrifying Aztec imagery. The Late Postclassic potters also produced a great many female water deities, on the whole shown kneeling, with their hair tied like drapery pulls at the sides of the head. In provincial works, emphasis thus fell on more beneficent images of fertility.

Another common fertility figure, this time male, was Xipe Totec, *169*

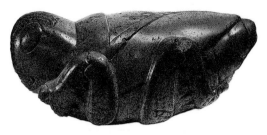

171 This large, 45-cm-long, red carnelite grasshopper, or *chapulín* in Náhuatl, probably refers to Chapultepec, or 'hill of the grasshopper,' just west of Lake Texcoco.

'our lord the flayed one.' Xipe Totec was a god of planting, and his ritual imitated the observed natural life of the maize kernel. A human skin was flayed, and a young man wore it until it rotted off (one dreads to think of the stench), allowing the new, clean youth to emerge, like a sprout from the husk of the old seed. Xipe's cult was at first celebrated most along the Gulf Coast, especially among the Huastecs, but with their conquest the cult spread in Central Mexico. Many ceramic and stone images of Xipe are known, and the flayed skin is often shown with almost loving detail. Unlike the female maize deities, the Xipe figures were also executed in rich three-dimensional forms. Three-dimensional sculpture had a sustained life along the Gulf Coast, from Olmec times to the Spanish Conquest, and the sensual, rounded shapes of Xipe sculptures probably derive from this tradition.

cf. 70 The Gulf Coast also gave rise to a tradition of large, hollow ceramic sculptures. The recent excavations in the ceremonial precinct pro-
170 duced the finest such specimen ever to be found in the Valley of Mexico. Made in four separate pieces, the sculpture represents a life-sized eagle warrior, poised just as if to take flight. Bits of stucco show that he was probably once covered with feathers. One of a pair who flanked a doorway, the warrior is reminiscent of the eagle jamb figure
138 painted at Cacaxtla some centuries before. The beauty and natural proportions of this figure reach out across the centuries, transcending cultural boundaries. It is difficult to believe that the same culture that made the Coatlicue would also create this Eagle Knight. What we find, nevertheless, is a pluralism of aesthetic ideals rarely matched in history, and perhaps best compared with our own era. Naturalism was enshrined at the same time as abstraction; beauty and terror both inspired awe. We know relatively little from the Aztecs of the conceptual ideals of their sculpture, but we do have a description of what a beautiful young male sacrificial victim should be:

[He was] like something smoothed, like a tomato, or like a pebble, as if hewn of wood. [He did] not [have] curly hair, [but] straight, long hair; [he had] no scabs, pustules, or boils ... not with a gross face, nor a downcast one; not flat-nosed nor with wide nostrils, nor with an arched ... nose nor a bulbous nose, nor bent nor twisted nor crooked – but his nose should be well-placed, straight ... [he should be] not emaciated, nor fat, nor big-bellied, nor of prominent, hatchet-shaped navel, nor of wrinkled stomach ... nor of flabby buttocks or thighs ...

(Florentine Codex, Book 4, Sixth Chapter,
trans. Dibble and Anderson)

In the face of the Eagle Knight, we see that perfection.

Naturalism inspired many Aztec works of small scale, among them fine images of squash, cacti, shells, and snakes. The bright red carnelite grasshopper shown here may have functioned as some kind

172 The recumbent figure of this rain god *chacmool* wears a Tlaloc mask and a pendant with an archaistic motif, as if to refer to antiquity in general. The underside of the monument is worked with aquatic motifs.

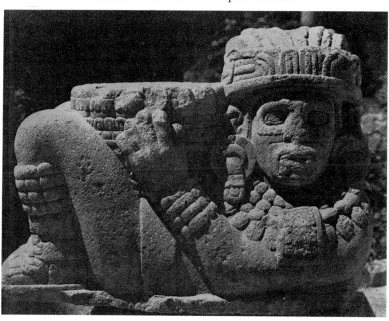

of emblem for the place Chapultepec, the source of fresh spring water for Tenochtitlan, for its name means 'hill of the grasshopper.'

Other Aztec sculptures also served as temple or palace furnishings. *Chacmools* had probably long been used as receptacles for human hearts, and a number of Aztec ones have been found. The earliest known Aztec *chacmool* was recently discovered *in situ* on the Tlaloc side of the twin pyramid, in an early context. It may even have been brought from Tula, with other looted treasures. It is the only *chacmool* to survive with bright polychrome, but most Aztec sculptures were probably painted. In fact, given modern taste, we might be unpleasantly surprised if we were to see them in their original condition.

172 Another very sensuously carved *chacmool* excavated in 1943 outside the ceremonial precinct could have been moved away from the temple compound at the time of the Conquest. The recumbent figure wears a Tlaloc mask and bears a *cuauhxicalli*, a vessel for sacrificed human hearts, on his chest. Tlaloc insignia are inscribed on the vessel's upper surface. The underside of the whole sculpture is worked with a Tlaloc among other aquatic motifs, as if the monument were floating in a liminal state. Like the dead and dying figures at Cacaxtla, this *chacmool* wears a jade plaque from an earlier culture (it would appear to be a Classic Zapotec or Maya piece), as if such objects signified ancient defeated victims. The *chacmool* seems very likely therefore to have come from the Tlaloc side of the twin pyramid, which bore other symbols of antiquity as well.

173 The Temple Stone was found near the palace of Motecuhzoma II in 1831, and probably functioned as his throne. Its imagery is rich and complex. It records the date in 1507 of the last New Fire ceremony, normally celebrated at the completion of a fifty-two-year cycle. On the sides, seated deities draw blood from their loins, and this blood drawn in penance supports the legitimate ruler. Above, Motecuhzoma would be seated on an earth monster, with the solar disk at his back. In this way, he bore the sun; he also prevented it from collapsing onto the earth.

MINOR ARTS

Many musical instruments were worked with designs that indicate their importance in Aztec ritual life. A number of *teponaztlis*, the higher-toned, longitudinal drums, and *huéhuetls*, the deeper, upright

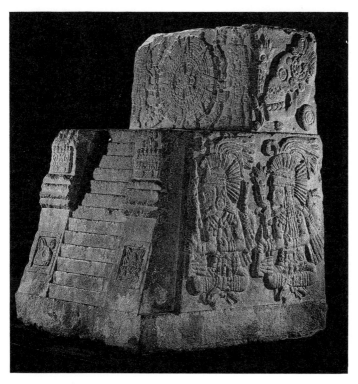

173 The Temple Stone. Also known as the 'Monument of Sacred War,' this miniature temple was probably a throne in Motecuhzoma II's palace. When the lord was seated, he would appear to carry the sun on his back.

drums, have survived from prehispanic times. A fine *huéhuetl*, 174 reputedly from Malinalco, may have been associated with the orders of jaguar and eagle knights there and might even have been used to accompany rites in the Malinalco chambers. The drum carries the date 164 of the destruction of the Fifth Sun, 4 Movement. Jaguars and eagles dance ecstatically around the instrument, and all emit speech scrolls of the twined *atltlachinolli*, 'water-conflagration,' or warfare symbols. They also carry banners to indicate that they are sacrificial victims, as if perhaps to pronounce their willingness to be sacrificed to the Fifth Sun, and such sacrificial events were probably accompanied by music.

Other fine Aztec works were made of feathers or covered with

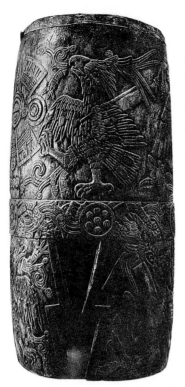

174 A *huéhuetl*, or large upright drum, reportedly from Malinalco (ill. 164). Deerhide would have been stretched across the top of the cylinder, and the drum was played with the hand. The *teponaztli*, a longitudinal drum, was played with drumsticks.

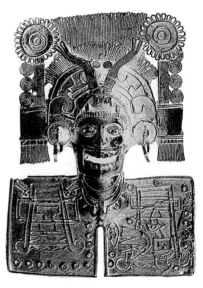

175 A large gold pectoral from Tomb 7, Monte Albán, Late Postclassic. Below the skeletal deity's head are signs in the Mixtec calendrical system. Both filigree and lost-wax techniques were mastered by these Oaxacan craftsmen.

feather mosaic, turquoise mosaic, and gold. Little of the goldwork survives, thanks to the destructive lust of the Conquistadores. Virtually the only pieces for us to study and admire are of Mixtec manufacture, discovered in Oaxaca during this century. In Tenochtitlan, the Mixtecs were recognized as the greatest metalworkers of the era, and an enclave lived there to practice their craft. Oaxaca, the region of the Zapotecs and Mixtecs, was spared much of the violent destruction of the Conquest, and in the immediate aftermath the area was not identified as a great source of raw metals. Cortés received much of Oaxaca as a grant from Charles V, but luckily did not know

176 *(above)* Perhaps sent to
Charles V by Cortés, this exotic
Aztec feather headdress has been
preserved in Vienna since the
Conquest. Some scholars have
speculated that Motecuhzoma II
himself might have worn it.

177 Probably part of a whole
costume of the deity Tezcatlipoca,
this mask is made of turquoise
mosaic, obsidian, and gold pyrites
over a human skull.

the location of all Mixtec gold treasure. In 1932 Alfonso Caso excavated a royal tomb on Monte Albán that had been re-used by the Mixtecs in Late Postclassic times. He discovered a superb cache there of over a hundred gold objects, along with fine artifacts of silver, pearl, jade, rock crystal, obsidian, and bone. At last the skills that earned Dürer's accolades became evident to the twentieth century. The most spectacular object is the large pectoral of a skeletal deity, worked in a lost-wax method.

The malleability, color, and inert nature of gold have always made it an appealing raw material, although the Aztecs valued jade more highly. They referred to gold as *teocuícatl*, or 'excrement of the gods.' Given the destruction of the Conquest, we will probably never know the nature of Aztec goldwork to any greater extent.

High-quality Aztec feather painting (a mosaic technique, really, of finely cut exotic bird feathers) has also not survived, although detailed feather paintings are known with Postconquest, Christian imagery. Aztec headdresses and shields on the other hand have endured. At an 1890 conference in Paris, Zelia Nuttall first suggested that the fine featherwork preserved in Vienna might be Motecuhzoma's headdress. To prove its wearability, she made and wore a reconstruction. With its extraordinary green quetzal and blue cotinga feathers, gold, and beads, the original headdress certainly may have been a royal garment, but there is no evidence that it was the property of Motecuhzoma II in particular. Illustrations in the chapter on featherworking in the Florentine Codex, the sixteenth-century encyclopaedia (see below), show the making of a similar headdress.

Motecuhzoma II sent Cortés a chest containing turquoise mosaic masks and feather costumes of various deities in 1519. Guided by his interpreters to put on the Quetzalcóatl costume, Cortés strengthened the perception that he was that deity. Such costumes and masks may have been offered to the earlier explorer Grijalva as well. These curiosities were sent to Europe, but it is no longer certain which ones were in Motecuhzoma's gift. One of the masks in the British Museum is of the deity Tezcatlipoca, with black obsidian bands set against a bright blue face. Gold pyrites form the eyes. Unlike many of the other masks, this mosaic is built over a human skull, and its wearer would have been unable to see.

Bernal Díaz described the sumptuous meals prepared for Motecuhzoma II. Tens of dishes would be served up for the king's

178 Ceramic cup from Cholula, with decoration of three jaguars. Bright polychrome slip was used by Cholula potters to draw intricate patterns and figural scenes. The pottery was in demand throughout the Valley of Mexico at the time of the Conquest.

179 Hundreds of Tlaloc effigies were unearthed from the Tlaloc side of the Templo Mayor. This unusual ceramic effigy vessel was painted bright blue after firing.

pleasure, including turkey, boar, venison, rabbit, quail, duck, pigeon and human flesh. Motecuhzoma would sit and eat behind a screen, alone. Díaz informs us that Motecuhzoma ate only from Cholula pottery (so named although it was made at various places in the Valley of Puebla). With their rich polychrome slip design over fine, thin pottery, Cholula wares were far superior to the Aztec product. Many *178* designs and color patterns can be related to the Borgia group of manuscripts (see below).

Some unusual ceramics have been recovered from the Templo Mayor excavations. Two fine vessels were found on the Huitzilopochtli side that were made in an archaizing fashion, imitating Toltec work, and the cremated bones they contained could be royal remains, perhaps even of Motecuhzoma I. Remarkable bright blue pigment was preserved on a Tlaloc effigy vessel, found on the Tlaloc *179* side of the temple. Like many fifteenth- and sixteenth-century Aztec Tlaloc images, the deity has the braided 'cruller' over his nose that characterizes the Classic Maya Jaguar God of the Underworld.

180 Page 6, Codex Selden. Although additions were made after the Conquest to this Mixtec manuscript on deerskin, most of the pages were completed in prehispanic times. A young woman named 6 Monkey is the heroine of this portion of the genealogy. The story reads from bottom to top, following the footprints. In the second register from the top, as the footprints show, 6 Monkey goes into hiding – and only her lower body is visible.

181 *(opposite, above)* Folio 1, Codex Féjerváry-Mayer. The cover page of this prehispanic manuscript presents concepts of the world order: the four cardinal points are associated with particular colors, birds, and trees with a maltese-cross frame of 260 dots, referring to the calendar round and its completion.

182 *(opposite, below)* Page 56, Codex Borgia. Framing one end of a divination cycle are these paired deities, Mictlantecuhtli and Quetzalcóatl in the guise of Ehecatl, the wind god. They stand over an open-mouthed earth monster, and the twenty day names run along the sides of the page.

Shortly after his accession to power in 1426, Itzcóatl decided to have history rewritten. Manuscripts were collected and destroyed, making way for a new record of official Aztec history and religion. Nevertheless, it is obvious from the variety of historical and mythic information later written down in the Roman alphabet that a great diversity of religious and historical ideas continued long after Itzcóatl's edict. The supremacy of Huitzilopochtli as a cult god was fought throughout the region, and in fact Tezcatlipoca seems to have remained the supreme deity among those claiming Toltec descent.

Sadly the Spanish Conquest was more effective than Itzcóatl's purge, and, even though books were common among the Aztecs, no manuscript survives that can be attributed to Preconquest Tenochtitlan. Examples from other regions remained intact, however, and various schools of manuscript painting thrived for fifty years after the Conquest. Books served many purposes for the Aztecs: genealogies were kept, 260-day ritual calendars were consulted, and religious esoterica were guarded in screenfold manuscripts. For generations after the Conquest, Mixtec screenfolds were brought to Colonial courts to document testimony in land disputes. Painted in thin stucco on deer hide, these manuscripts were sometimes scraped and re-used; for sixteenth- and seventeenth-century purposes, 'idolatrous' lore might be purged in order to allow legal use of the genealogical records. The Codex Selden relates the genealogy of one prominent Mixtec family. Red guidelines indicate the boustrophedon, or back-and-forth, reading order of the manuscript, and we can observe the *180* highly conventionalized nature of representation. In the section illustrated here, the Postclassic heroine 6 Monkey is seen avenging the murder of her father and brothers. Footprints indicate travel or movement: at the center of the page, 6 Monkey (her name tied to her like a cartoon balloon) hides in a hill, as she has been counseled to do. She later leads a successful military campaign, and is depicted holding *cf. 24, 167* her subjugated captive in the posture characteristic of male victors.

There are many surviving Mixtec genealogies, and although they are embedded within a context of mythic origins (some families derive from trees, others from stones), they are essentially historical. Another collection of Postclassic manuscripts to survive is known as the Borgia Group, so named after the largest and most complex of

these screenfolds, now in Rome. Of these, the Borgia, Cospi, and Vaticanus B manuscripts may share a common origin in Puebla or Tlaxcala. Most of the Borgia manuscripts incorporate divining almanacs of the 260-day calendar with other religious material. No histories are known. Calendrical and cosmic concerns are expressed together on the front page of the Féjerváry-Mayer, and the page has the character of a medieval carpet page. Two-hundred-and-sixty dots are laid out in the form of a maltese cross, recalling the Maya completion sign. Radiating in four directions from the central image are four world trees surmounted by four directional birds. Such a picture conveys notions of world creation and world order within the frame of the calendar. *181*

cf. 22

The Borgia manuscript is the single most complex surviving Mesoamerican book. The Venus pages in the center of the manuscript contain the travels of Quetzalcóatl in the underworld. The divination pages of the 260-day calendar have a border of paired deities. The opposition of Mictlantecuhtli, the chief death god, with Ehécatl, an aspect of Quetzalcóatl, emphasizes the principle of duality in Mesoamerican thought, for Quetzalcóatl was also perceived to be a creator god. *182*

THE EARLY POSTCONQUEST ERA

After the Conquest, the production of indigenous art and architecture mostly ceased. Temples were dismantled and their stones used to build the churches, civic buildings, and houses of the conquerors. Disease, strife, and despair all took their toll, as did forced labor in mines. In the sixteenth-century history of New Spain, the only light for the native population was the arrival of mendicant preaching friars. Charles V charged three religious orders, the Franciscans, Dominicans, and Augustinians, with the conversion of the new land. They came in groups of twelve, emulating the Apostles, and among their number were educated, enlightened individuals, instilled with ideas of the Renaissance. Just as Europe was in the throes of the Reformation, the new souls for conversion presented the Catholic church with another and different sort of challenge. Millions were converted and they needed schools and churches. This gave rise to one of the most energetic building programs in the history of the world. Hundreds of monastic complexes were constructed with native labor

183 Battle of eagle knights and centaurs, Postconquest wall painting, Ixmiquilpan, Hidalgo. Under the guidance of Augustinian friars, native artists incorporated European and Precolumbian motifs in several sixteenth-century programs of decoration.

under the direction of friars who rarely had any knowledge of architectural principles. The Franciscans arrived first and built establishments throughout the Valley of Mexico; Dominicans came next and entered Oaxaca. The Augustinians, who arrived last, led the conversion to the north.

The predominant type of church constructed was the open-air chapel, a medieval form revived to meet the needs of the Mesoamerican population, who were unused to large interior spaces. The architecture was Christian, but Precolumbian imagery nevertheless crept in. In some cases, Mesoamerican ideas were used to convey the new teachings of Christianity. At the Augustinian establishment at *183* Ixmiquilpan, the paintings that line the nave show eagle and jaguar knights doing battle with centaurs, who are portrayed as villains. On

one level, we can understand this to show a converted indigenous population in native armor fighting the pagan Chichimecs of the north. The Spaniards, however, were interpreted at first by native Mesoamericans to be combinations of man-horse, like centaurs, and so we must also see an indigenous spirit in these paintings.

Much of the architectural sculpture associated with the monastic establishments was worked in very low relief, a technique typical of Aztec ornament but one which also came about when woodcut images were transferred to three-dimensional forms, as was generally the case. Many of the large atrio crosses, however, had obsidian embedded in them, recalling an Aztec practice of incorporating an obsidian heart into many sculptures. *cf. 165*

The two Precolumbian art forms that succeeded above all others in the early Colonial era were manuscript making and feather painting. Native scribes recorded histories, divinatory almanacs, and religious tracts, generally under the guidance of Franciscan priests. The earliest manuscript of the early Colonial period, the Codex Borbonicus, was long thought to pre-date the Conquest, but it has now been shown that throughout this screenfold on native paper spaces were left for romanized glosses. The first part of the manuscript is a divinatory guide of the 260 days, with auguries and patrons. The two center pages relate complex notions of calendar and time, and the last pages chart the 365-day cycle and the feasts of the months. The European influence is most obvious in this last section. In the drawing of a New Fire ceremony, for instance, fire priests hold bound fagots, while the depiction of the knots shows a knowledge of perspective. *184*

European paper soon replaced native fig paper entirely; the screenfold gave way to the bound book. But indigenous painting traditions and conventions survived for some time, perhaps inspired by prehispanic books still available for consultation. The frontispiece of the Codex Mendoza may have its roots in a carpet page such as page 1 of the Féjerváry-Mayer. The luxurious tribute list of the Mendoza must have been copied directly from a similar record kept by Motecuhzoma, but – as Donald Robertson has pointed out – transferred from screenfold to codex form. *162*
181

Ostensibly, the aim of the friars was to understand indigenous religion in order to extirpate it, but in the *Florentine Codex, The General History of the Things of New Spain* (*c.* 1566–77; 1585) – a thirteen-book encyclopaedia organized along the lines of a medieval

184 Folio 34, Codex Borbonicus. Calendar priests feed the flames during a New Fire ceremony. Aztec deities are drawn along the left-hand side of the page: at the right, a pregnant woman is shown sequestered within doors, as prescribed by the ceremony.

185 *(opposite)* Folio 47, Codex Mendoza. Organized by province, the center section of the Codex Mendoza is a copy of Motecuhzoma II's tribute roll. Here, luxurious goods from the far southern reaches of Aztec dominion in Guatemala – jaguar pelts and bird feathers – are illustrated as the required payment. Province names run down the left-hand side of the page.

compendium such as that of Bartholamaeus Anglicus – one senses that Father Bernardino de Sahagún's goals exceeded mere religious needs. His interest in the New World was truly catholic. His record, written in Náhuatl and illustrated by native artists, is the single most important document of Aztec life. Father Sahagún's manuscript went through several drafts, and illustrations for an early version show stronger Precolumbian traditions, perhaps copied, and less concern for shading and landscape, both of which interest the illustrators of the later Florentine Codex. In one volume of the later work, information on metalwork and feather painting is lavishly illustrated, and a headdress like the one in Vienna today is shown. Background landscapes include European castles, surely drawn after some European book.

163

This surviving manuscript tradition was the final stage of Mesoamerican art and architecture. By the end of the sixteenth century the intellectual friars had been supplanted by parish priests who took less interest in their native flocks. The ravaged indigenous population had shrunk by now from twenty million on the eve of the Conquest to a mere million. Perhaps not quite the cosmic cataclysm predicted by the Aztecs, it was nevertheless one of the worst catastrophes in history. There were even too many churches for the population by 1580. The great art and architecture of Mesoamerica vanished under modern buildings or encroaching wild growth, or in other instances was simply destroyed. Not until the end of the eighteenth century would modern man begin the serious investigation of Mesoamerican antiquities.

Abbreviations

BAEB Bureau of American Ethnology, Bulletin
CIW Carnegie Institution of Washington
HMAI Handbook of Middle American Indians
INAH Instituto Nacional de Antropologia e Historia
MARI Middle American Research Institute, Tulane University
PMM Peabody Museum, Harvard University, Memoirs
PMP Peabody Museum, Harvard University, Papers

1 Introduction

The most important survey in English of Precolumbian art is that of George Kubler, *Art and Architecture of Ancient America*, 2nd and 3rd editions, Harmondsworth and Baltimore (Pelican), 1975 and 1984 (it also includes the art and architecture of Central and South America). The 16 volumes and 2 supplements of the *Handbook of Middle American Indians*, ed. Robert Wauchope, Austin (Univ. Texas), 1965–84 are the most comprehensive examination of all aspects of Mesoamerica, and they form the best single source for the field. The most valuable archaeological surveys are Muriel Porter Weaver, *The Aztecs, Maya, and Their Predecessors*, 2nd edition, New York (Academic Press), 1981; Michael D. Coe, *Mexico*, 3rd edition, London and New York (Thames and Hudson), 1984; and the same author's *The Maya*, 3rd edition, London and New York (Thames and Hudson), 1984. Also to be considered among the art historical and architectural surveys are Pál Kelemen, *Medieval American Art*, New York (Macmillan), 1943; Elizabeth Easby and John Scott, *Before Cortés: Sculpture of Middle America*, New York (Metropolitan Museum of Art), 1970; Miguel Covarrubias, *Indian Art of Mexico and Central America*, New York (Knopf), 1957; José Pijoán, *Historia del arte precolombino (Summa Artis X)*, Barcelona, 1952; Ignacio Marquina, *Arquitectura Prehispánica*, Mexico 1951; Doris Heyden and Paul Gendrop, *Pre-Columbian Architecture of Mesoamerica*, New York (Abrams), 1975.

The term 'Mesoamerica' has been in use since mid-century (Paul Kirchoff, 'Mesoamerica,' *Acta Americana* 1 (1943): 92–107). Nigel Davies has recently re-examined and evaluated diffusionist thought in a highly readable book (*Voyagers to the New World*, New York (W. Morrow), 1979). Bernal Díaz wrote the most comprehensive and lucid eye-witness report of the Conquest (*The Discovery and Conquest of Mexico*, trans. A.P. Maudslay, New York, 1956). Of all early travelers who looked at ancient ruins, John Lloyd Stephens' accounts are the most interesting today (*Incidents of Travel in Central America, Chiapas, and Yucatan*, 2 vols., New York (Harper), 1841). Bernardino de Sahagún's *Florentine Codex, A General History of the Things of New Spain*, trans. A.J.O. Anderson and C. Dibble, in 13 books, Santa Fe (School of American Research and University of Utah), 1950–1982, is an encyclopaedia of prehispanic life in Central Mexico.

Gordon Willey and Jeremy Sabloff have written a history of archaeological exploration (*A History of American Archaeology*, London and San Francisco, 1974), but like R.E.W. Adams' 'Maya Archaeology 1958–1968, A Review,' *Latin American Research Review* 4:2 (1969), 3–45, there is limited consideration of ancient art. One of the most interesting historical views was written by an historian: Benjamin Keen, *The Aztec Image in Western Thought*, New Brunswick (Rutgers), 1971.

2 The Olmecs

General books and collections of essays to consult on Olmec subjects include: Elizabeth P. Benson, ed., *The Olmec and their Neighbors*, Washington, D.C. (Dumbarton Oaks), 1982; Ignacio Bernal, *The Olmec World*, Berkeley (Univ. California), 1969; Michael D. Coe, *America's First Civilization: Discovering the Olmec*, New York (American Heritage), 1968; and Susan Milbrath, 'A Study of Olmec Sculptural Chronology,' *Dumbarton Oaks Studies in Pre-Columbian Art and Archaeology* no. 23, 1979. Coe has written on San Lorenzo (with Richard Diehl): *In the Land of the Olmec*, 2 vols. (Austin (Univ. Texas), 1980; for La Venta, see P. Drucker, Robert Heizer, and R.J. Squier, *Excavations at La Venta, Tabasco, 1955*, BAEB 170. On early ceramic art: Michael D. Coe, *The Jaguar's Children: Preclassic Central Mexico*, New York (Metropolitan Museum of Art), 1965; Carlo Gay, *Xochipala: The Beginnings of Olmec Art*, Princeton (Art Museum), 1972. Colossal heads have been seriated by C.W. Clewlow, 'A Stylistic and Chronological Study of Olmec Monumental Sculpture,' *Univ. Cal. Arch. Research Facility*, no. 19, 1974. Painting and petroglyphs are discussed by David C. Grove, 'The Olmec Paintings of Oxtotitlan Cave,' *Dumbarton Oaks Studies in Pre-Columbian Art and Archaeology* no. 6, 1970; and Grove, *Chalcatzingo: Excavations on the Olmec Frontier*, London and New York (Thames and Hudson) 1984. P. David Joralemon has written on the iconography: 'A Study of Olmec Iconography,' *Dumbarton Oaks Studies in Pre-Columbian Art and Archaeology* no. 7, 1971; also, 'The Olmec Dragon: A Study in Pre-Columbian Iconography,' in H.B. Nicholson, *Origins of Religious Art and Iconography in Preclassic Mesoamerica*, Los Angeles (UCLA), 1976, 27–72.

3 The Late Formative

For the evolution of writing and its early forms, as well as important decipherments, see Michael D. Coe, 'Early Steps in the Evolution of Maya Writing,' in H.B. Nicholson, *Origins of Religious Art and Iconography in Preclassic Mesoamerica*, Los Angeles (UCLA), 109–22; Matthew Stirling, 'An Initial Series from Tres Zapotes, Vera Cruz, Mexico,' *National Geographic Society, Contributed Technical Papers*, 1:1 (1940); J. Eric S. Thompson, *Maya Hieroglyphic Writing*, 2nd edition, Norman, Oklahoma (Univ. Oklahoma), 1960; Alfonso Caso, *Los calendarios prehispánicos*, Mexico City (UNAM), 1967; Heinrich Berlin, 'El glifo 'emblema' en las inscripciones mayas,' *Journal de la Société des Americanistes*, NS 47 (1958), 111–19; Tatiana Proskouriakoff, 'Historical Implications of a Pattern of Dates at Piedras Negras,' *American Antiquity* 25 (1960), 454–75; and 'The Lords of the Maya Realm,' *Expedition* 4:1 (1961), 14–21; Yuri Knorosov, *The Writing of the Maya Indians*, trans. and ed. Tatiana Proskouriakoff and Sophie Coe, *Harvard University Russian Translation Series* 4, 1967; Joyce Marcus, 'Zapotec Writing,' *Scientific American* 242:2 (1980), 46–60; *Emblem and State in the Classic Maya Lowlands*, Washington (Dumbarton Oaks), 1976.

The Late Formative in Oaxaca is discussed by John Scott, 'The Danzantes of Monte Alban,' 2 vols., *Dumbarton Oaks Studies in Pre-Columbian Art and Archaeology* no. 22, 1980, and Ignacio Bernal, 'The Ball Players of Dainzu,' *Archaeology*, 21 (1968). See also the book by Richard Blanton listed here under Chapter 5 bibliography. Archaeoastronomical principles in ancient American art and architecture are discussed in Anthony F. Aveni, *Skywatchers of Ancient Mexico*, Austin (Univ. Texas), 1981.D. M. Earle and D. R. Snow, 'The Origin of the 260-day Calendar: the Gestation Hypothesis Reconsidered in Light of its Use among the Quiche-Maya,' in Fifth Palenque Round Table, 1985, pp. 241–44.

Various interpretations of West Mexican clay sculptures have been put forth by Furst, Kubler, and Von Winning (Peter Furst, 'West Mexican Tomb Sculpture as Evidence for Shamanism in Prehispanic Mesoamerica,' *Antropológica*, 15 (1965); George Kubler, 'Science and Humanism Among Americanists,' *Iconography of Middle American Sculpture*, New York (Metropolitan Museum of Art), 1973, 163–67; Hasso von Winning and O. Hammer, *Anecdotal Sculpture of West Mexico*, Los Angeles, 1972). For archaeological background, consult Betty Bell, ed. *The Archaeology of West Mexico*, Ajijic, Jalisco, Mexico, 1974.

The rise of the early Maya civilization is studied by John Graham, Robert Heizer, and Edwin Shook, 'Abaj Takalik 1976: Exploratory Investigations,' *Univ. Cal. Arch. Res. Facility* no. 36, 85–114; David Freidel, 'Civilization as a State of Mind: The Cultural Evolution of the Lowland Maya,' in G. Jones and R. Kautz, eds., *The Transition to Statehood in the New World*, Cambridge, 1981, pp. 188–227; Ray T. Matheny, 'El Mirador, Peten, Guatemala,' *Papers of the New World Archaeological Foundation* no. 45, 1980; on iconography, see David S. Stuart, 'The Iconography of Blood Among the Classic Maya,' paper read at the Princeton University Symposium on the Origins of Maya Iconography, November 1982. See also,

Garth Norman, 'Izapa Sculpture, Part 1, Album,' *Papers of the New World Archaeological Foundation* no. 30, 1973.

4 Teotihuacan

René Millon, *Urbanization at Teotihuacan, Mexico*, 2 vols., Austin (Univ. Texas), 1974, is the most comprehensive study of the ancient city of Teotihuacan. Updated information is included in Millon, 'Teotihuacan: City, State, and Civilization,' in *HMAI Supplement*, 1982, 198–243. See also Laurette Sejourne, *Un palacio en la ciudad de los dioses*, Mexico City, 1959.

Possible motives for placement of pyramids are presented by Doris Heyden, 'An Interpretation of the Cave Underneath the Pyramid of the Sun in Teotihuacan, Mexico,' *American Antiquity* 40:1 (1975), 131–47, and Stephen Tobriner, 'The Fertile Mountain: an Investigation of Cerro Gordo's Importance to the Town Plan and Iconography of Teotihuacan,' in *Teotihuacan, Mesa Redonda de la Sociedad Mexicana de Antropologia*, XI, vol 2. See also Aveni (as above, Chapter 3).

Painting is considered by Clara Millon, 'The History of Mural Art at Teotihuacan,' *Mesa Redonda de la Sociedad Mexicana de Antropologia*, XI, vol. 2; Esther Pasztory, *The Murals of Tepantitla, Teotihuacan*, New York (Garland), 1974; and Arthur G. Miller, *The Mural Painting of Teotihuacan*, Washington, D.C. (Dumbarton Oaks), 1973. Iconography is investigated by Pasztory, 'The Iconography of the Teotihuacan Tlaloc,' *Dumbarton Oaks Studies in Pre-Columbian Art and Archaeology* no. 15, 1974, and George Kubler, 'The Iconography of the Art of Teotihuacan,' *Dumbarton Oaks Studies in Pre-Columbian Art and Archaeology* no. 4, 1967.

5 Classic Monte Albán, Veracruz and Cotzumalhuapa

On Monte Albán, see Richard E. Blanton, *Monte Albán: Settlement Patterns at the Ancient Zapotec Capital*, New York and London (Academic Press), 1978; also John Paddock, ed., *Ancient Oaxaca*, Stanford, 1966; Caso and Bernal studied the urns of Oaxaca, *Urnas de Oaxaca*, INAH Memorias 2, 1952. See also Marcus, as above (Chapter 3). Also to be considered are studies of the Middle Classic: Esther Pasztory, ed., *Middle Classic Mesoamerica, AD 400–700*, New York (Columbia), 1978.

For El Tajín, see J. Garcia Payón, *El Tajín, Guía Oficial*, INAH (Mexico City), 1957; Michael E. Kampen, *The Sculptures of El Tajín*, Gainesville (Univ. Florida), 1972; and S. Jeffrey K. Wilkerson, 'Man's Eighty Centuries in Veracruz,' *National Geographic Magazine* 158:2 (August 1980), 203–31.

The Mesoamerican ballgame is discussed by T. Stern, in *The Rubber-ballgame of the Americas*, American Ethnological Society Monograph 17, 1948; Stephen D. Borhegyi, 'The Pre-Columbian Ball Game: A Pan-Mesoamerican Tradition,' *38th International Congress of Americanists*, I, 1969, 499–515. Matthew Stirling explored Cerro de las Mesas, *Stone Monuments of Southern Mexico*, BAEB 138, 1943.

For Cotzumalhuapa, see Barbara Braun, 'Sources of the Cotzumalhuapa Style,' *Baessler-Archiv* 51

(1978), 159–232, and Lee A. Parsons, *Bilbao, Guatemala: An Archaeological Study of the Pacific Coast Cotzumalhuapa Region*, 2 vols. Milwaukee Public Museum, 1967–69.

6 The Early Classic Maya

The best surveys of the Maya are: Coe, as in Chapter 1; Elizabeth P. Benson, *The Maya World*, New York (Thomas Crowell), 1977; Norman Hammond, *Ancient Maya Civilization*, New Brunswick (Rutgers), 1982; John Henderson, *The World of the Maya*, Ithaca (Cornell) 1981; and the 4th edition of Sylvanus G. Morley and George W. Brainerd, *The Ancient Maya*, rev. Robert Sharer, Stanford, 1983. These, along with many of the books below, are equally useful as references for Chapter 7, and should be consulted for the Postclassic Maya of Chapter 8 as well. For an earlier point of view on the nature of the Classic Maya, see Sylvanus G. Morley, *The Ancient Maya*, 1st edition, Stanford, 1947; J. Eric S. Thompson, *Rise and Fall of the Maya Empire*, Norman, Oklahoma (Univ. Oklahoma), 1956.

Some examples of the extensive work in the Maya area carried out by the Carnegie Institution of Washington are: Oliver G. Ricketson and Edith B. Ricketson, *Uaxactún, Guatemala, Group E, 1926–1931*, CIW Pub. 477, 1937; A.V. Kidder, Jesse D. Jennings, and Edwin M. Shook, *Excavations of Kaminaljuyú, Guatemala*, CIW Pub. 561, 1946; A.L. Smith, *Uaxactún, Guatemala, Excavations of 1931–37*, CIW Pub. 588, 1950. Tatiana Proskouriakoff based her careful reconstructions on such archaeological reports (*An Album of Maya Architecture*, CIW Pub. 558, 1946). For technical observations on Maya architecture, see Lawrence Roys, 'The Engineering Knowledge of the Maya,' CIW *Contributions*, II (1934).

Both Early and Late Classic sculptures are discussed and illustrated in Sylvanus G. Morley, *Inscriptions of Petén*, 5 vols., CIW Pub. 437, 1937–38; Alfred Percival Maudslay, *Biologia Centrali-Americana: Archaeology*, 5 vols., London 1899–1902; *Corpus of Maya Hieroglyphic Inscriptions*, vols. 1–5, Peabody Museum, Harvard University, 1977-. See also Teobert Maler, *Researches in the Central Portion of the Usumatsintla Valley*, PMM 2, 1901–03. Proskouriakoff has written the single most comprehensive study of Maya sculpture to date, *Classic Maya Sculpture*, CIW Pub. 593, 1950.

On Tikal, see William R. Coe, *Tikal, a Handbook of the Ancient Maya Ruins*, Philadelphia (University Museum), 1967; 'Tikal: Ten Years of Study of a Maya Ruin in the Lowlands of Guatemala,' *Expedition* 5:2 (1963), 5–56; Clemency Chase Coggins, 'Painting and Drawing Styles at Tikal: An Historical and Iconographic Reconstruction,' Ph.D. diss. Harvard, 1975; Sylvanus G. Morley and Frances Morley, 'The Age and Provenance of the Leyden Plate,' CIW *Contributions*, V (1939).

7 The Late Classic Maya

(See also Chapter 6.)

On Palenque: Merle Greene Robertson, *The Sculpture of Palenque*, vol. 1, *The Temple of Inscriptions*, Princeton, 1983; Peter Mathews and Linda Schele, 'Lords of Palenque: The Glyphic Evidence,' *Primera Mesa Redonda de Palenque, Part 1*, ed. M.G. Robertson, Pebble Beach, California (R.L. Stevenson School), 1974, 63–76; Alberto Ruz Lhuiller, *El Templo de las Inscripciones, Palenque*, INAH, 1973.

On Tikal, see Mary Ellen Miller, 'A Rationale for the Placement of the Funerary Pyramids of Tikal,' paper read at the Association for American Anthropology, November 1983; Aubrey S. Trik, 'The Splendid Tomb of Temple I at Tikal, Guatemala,' *Expedition* 6:1 (1963), 2–18; Christopher Jones and Linton Satterthwaite, Jr., *The Monuments and Inscriptions of Tikal: The Carved Monuments*, Tikal Report 33a, Philadephia (University Museum), 1982.

For Copán: Sylvanus G. Morley, *Inscriptions at Copán*, CIW Pub. 219, 1920; *Introducción a la Arqueología de Copán, Honduras*, 3 vols., Proyecto Arqueológico de Copán, Tegucigalpa, Honduras, 1983; Mary Ellen Miller, 'Meaning and Function of the Main Acropolis, Copan,' paper read at the Dumbarton Oaks Conference on the Southeast Classic Maya Zone, October 1984; William L. Fash, 'Maya State Formation: A Case Study and Its Implications', Ph.D. Diss., Harvard University, 1983.

On Puuc architecture, including Uxmal: John Lloyd Stephens, *Incidents of Travel in Yucatan*, 2 vols., New York, 1843; Jeff Karl Kowalski, 'The House of the Governor at Uxmal,' Ph.D. diss., Yale University, 1981.

On Belize: David M. Pendergast, *Altun Ha, British Honduras (Belize): The Sun God's Tomb*, Royal Ontario Museum of Art and Archaeology, Occasional Paper 19, Toronto, 1969.

The two most important early iconographic studies are those of Paul Schellhas, *Representations of Deities in the Maya Manuscripts*, PMP 4:1, 1904, and Herbert J. Spinden, *A Study of Maya Art*, PMM 6, 1913. Recent studies include George Kubler, *Studies in Classic Maya Iconography*, Memoirs of the Connecticut Academy of Arts and Sciences, vol. 18, 1969. Many important studies of Maya art, epigraphy, and iconography have been published in the *Mesa Redonda* volumes, ed. Merle Greene Robertson (Robert Louis Stevenson School and Univ. Texas Press, 1974–1985).

On Maya jades, A.L. Smith and A.V. Kidder, *Excavations at Nebaj, Guatemala*, CIW Pub. 594, 1951; Tatiana Proskouriakoff, *Jades from the Cenote of Sacrifice, Chichen Itzá, Yucatán*, PMM 10: 1, 1974. For figurines, see Mary Ellen Miller, *Jaina Figurines*, Princeton (Art Museum) 1975; Roman Piña Chan, *Jaina, la casa en el agua*, Mexico City (INAH), 1968.

The chronology and terminology for Maya ceramics drives from the Uaxactún excavations (Robert E. Smith, *Ceramic Sequence at Uaxactún, Guatemala*, 2 vols., MARI Pub. 20, 1955). Recent studies have focussed on iconography: Michael D. Coe, *The Maya Scribe and His World*, New York (Grolier Club), 1973; *Lords of the Underworld*, Princeton (Art Museum), 1978; R.E.W. Adams, *The Ceramics of Altar de Sacrificios*, PMM 63:1, 1971; and the identification of individual masters: Justin and Barbara Kerr, 'The Painters of the Pink Glyphs,' paper read at the Fine Arts Museum of Long Island, Hempstead, New York, October 1981.

Bonampak has recently been re-evaluated (Mary Ellen Miller, *The Murals of Bonampak*, Princeton, 1985).

The Classic Maya Collapse, ed. T. Patrick Culbert (Albuquerque, Univ. New Mexico Press, 1973), considers the end of Classic Maya civilization from several points of view.

8 Mesoamerica after the fall of Classic cities

On Xochicalco: J. Litvak-King, 'Xochicalco en la caída del clásico', INAH Anales de Antropología, VII (1970), 131–44.

A flurry of publications accompanied the discovery of the Cacaxtla paintings. Best of these is Donald McVicker, 'The Mayanized' Mexicans,' American Antiquity 50:1 (1985), 82–101. See also Marta Foncerrada de Molina, 'La pintura mural de Cacaxtla, Tlaxcala,' Anales del IIE, UNAM 46 (1976) 5–20; Diana Lopez de Molina, 'Los murales prehispanicos de Cacaxtla, Boletín INAH (1977), 2–8. The presence of foreigners in the Maya area is discussed by J. Eric S. Thompson, Maya History and Religion, Norman, Oklahoma (Univ. of Oklahoma), 1970, and John Graham, 'Aspects of non-Classic Presences in the inscriptions and Sculptural Art of Seibal,' in Culbert, Collapse, pp. 207–19 (above, Chapter 7).

Articles in Kent V. Flannery and Joyce Marcus, eds., The Cloud People: Divergent Evolution of the Zapotec and Mixtec Civilizations, New York (Academic Press), 1983, consider the Early Postclassic in Oaxaca. The volume is also valuable for earlier eras in Oaxaca.

On the Toltecs, see Richard Diehl, Tula: the Toltec Capital of Ancient Mexico, London and New York (Thames and Hudson), 1983; Nigel Davies, The Toltecs Until the Fall of Tula, Norman, Oklahoma (Univ. Oklahoma), 1977; also, The Toltec Heritage from the fall of Tula to the Rise of Tenochtitlan, Norman, Oklahoma (Univ. Oklahoma), 1980; Jorge Acosta, 'Resumen de las exploraciones arqueológicas en Tula, Hidalgo, durante los VI, VII y VIII temporadas 1946–1950,' INAH Anales 8 (1956), 37–116. Désiré Charnay first noted the resemblances between Tula and Chichen Itzá (Ancient Cities of the New World, New York, 1888).

Various reports summarize the many years of excavations by the Carnegie Institution of Washington at Chichen Itzá. The most important studies: Karl Ruppert, Chichen Itzá, CIW Pub. 595, 1952; A.M. Tozzer, Chichen Itzá and Its Cenote of Sacrifice, PMM 12, 1957; Earl H. Morris, Jean Charlot, and Ann Axtell Morris, The Temple of the Warriors at Chichen Itzá, Yucatan, 2 vols., CIW Pub. 406, 1931. On Toltec art forms at Chichen Itzá, see George Kubler, 'Serpent and Atlantean Columns: Symbols of Maya-Toltec Polity,' Journal of the Society of Architectural Historians, 41 (1982); Mary Ellen Miller, 'A Re-examination of the Mesoamerican Chacmool,' Art Bulletin, 67:1 (1985), 7–17.

The final Carnegie project was carried out at Mayapán: H.E.D. Pollock, Tatiana Proskouriakoff, and Edwin Shook, Mayapán, CIW Pub. 619, 1962. For Tulum, see Samuel K. Lothrop, Tulum: An Archaeological Study of the East Coast of Yucatán, CIW, Pub. 335, 1924; also, particularly for the copies of the murals there, Arthur Miller, On the Edge of the Sea: Mural Painting at Tancah-Tulum, Quintana Roo, Mexico, Washington D.C. (Dumbarton Oaks), 1982.

Thomas Gann visited Santa Rita and published the murals there, Arthur Miller, On the Edge of the Sea: Mural Painting at Tancah-Tulum, Quintana Roo, Mexico, Washington D.C. (Dumbarton Oaks), 1982. Thomas Gann visited Santa Rita and published the murals there: 'Mounds in Northern Honduras,' BAE, 19th Annual Report, 1900.

A.L. Smith, Archaeological Reconnaissance in Central Guatemala, CIW Pub. 608, 1955, presents Postclassic architecture of the Guatemalan highlands.

F. Columbus wrote his father's biography, and reported the great canoes of the Maya (The Life of the Admiral Christopher Columbus by his Son Ferdinand, trans. and ed. Benjamin Keen, Rutgers, 1959). Juan de Grijalva, as recorded in The Discovery of New Spain in 1518, trans. and ed. Henry R. Wagner, Pasadena (Cortes Society), 1942, collected exotic objects from the Maya.

On Maya pre- and post-Conquest books: J. Eric S. Thompson, The Dresden Codex, Philadelphia (American Philosophical Society), 1972; J.A. Villacorta and C.A. Villacorta, Codices Maya, Guatemala City, 1930; the Grolier Codex is illustrated in Coe, The Maya Scribe (see Chapter 7 above). The Popol Vuh has been translated many times. Cited here is Munro S. Edmonson, The Book of Counsel: The Popol Vuh of the Quiché Maya of Guatemala, MARI Pub. 35, 1971; Dennis Tedlock's translation has now been published, New York, 1985. A.M. Tozzer published a heavily annotated version of Bishop Landa's account of Yucatán (Landa's Relación de las cosas de Yucatán, PMP 18, 1941); also useful is the William Gates translation (Yucatán Before and After the Conquest, Baltimore, 1937, reprinted by Dover, 1978).

9 The Aztecs

The best book on any single area of Precolumbian art is Esther Pasztory's Aztec Art, New York (Abrams), 1983. Richard F. Townsend's, 'State and Cosmos in the Art of Tenochtitlan,' Dumbarton Oaks Studies in Pre-Columbian Art and Archaeology no. 20, 1979, is a fine examination of a few major sculptures. H.B. Nicholson and Eloise Quinones Keber, Art of Aztec Mexico: Treasures of Tenochtitlan, Washington, D.C. (National Gallery), 1983, provides valuable commentary on the many Aztec objects exhibited at the National Gallery in 1983. Eduardo Matos Moctezuma presents the recent excavations he directed in Mexico City at the Aztec capital ('The Great Temple of Tenochtitlan,' Scientific American 251:2 (1984), 80–89).

On specific monuments, see Cecilia F. Klein, 'The Identity of the Central Deity on the Aztec Calendar Stone,' Art Bulletin 58:1 (1976), 1–12; Justino Fernandez, Coatlicue, estética del arte indígena antigua, Mexico City, 1954.

The most readable history of the Aztecs is Nigel Davies' The Aztecs, London (Macmillan), 1973, and Norman (Univ. Oklahoma) 1980; he follows fairly closely the information from Father Diego Duran's Historia de las Indias de Nueva España. For the Conquest of Mexico, see Bernal Díaz del Castillo (see Chapter 1) and Hernando Cortés, Letters from Mexico, trans./ed. A.R. Pagden, New York (Grossman), 1971.

Many aspects of Aztec life are documented in Bernardino de Sahagún, Florentine Codex (see Chapter

1); on Aztec ideology, see H.B. Nicholson, 'Religion in Pre-Hispanic Central Mexico,' *HMAI*, 10:1 395–446; also, Miguel Leon-Portilla, *Aztec Thought and Culture*, Norman (Univ. Oklahoma), 1963. For music, see Robert Stevenson, *Music in Aztec and Inca Territory*, Berkeley (Univ. California), 1968. Mixtec goldwork is discussed by Alfonso Caso, *El Tesoro de Monte Alban*, INAH, 1969. All New World gold and silver are considered by Andre Emmerich: *Sweat of the Sun and Tears of the moon: gold and silver in Pre-Columbian Art*, Seattle, Univ. Washington, 1965. The manuscripts mentioned in this chapter are all available in facsimile edition. *Codex Selden*, commentary by Alfonso Caso, glosses by M.E. Smith, Sociedad Mexicana de Antropologia, 1966; *Codex Féjerváry-Mayer*, Graz (Akademische Druck u. Verlagsanstalt), 1971; *Codex Borgia*, Commentary by Eduard Seler, Mexico City (Fondo de Cultura Económica), 1963; *Codex Mendoza*, ed. and commentary by James Cooper Clark, London, 1938; *Codex Borbonicus*, Graz (Akademische Druck u. Verlagsanstalt), 1974. The Postconquest manuscripts are described by Donald Robertson, *Mexican Manuscript Painting of the Early Colonial Period: The Metropolitan Schools*, New Haven (Yale), 1959.

Early Postconquest life and art are best examined in Robert Ricard, the *Spiritual Conquest of Mexico*, Berkeley (Univ. Cal.), 1966; Constantino Reyes, *Arte Indocristiano*, Mexico City (INAH), 1981; Manuel Toussaint, *Colonial Art of Mexico*, rev. and trans. Elizabeth Wilder Weismann, Austin (Univ. Texas), 1967; George Kubler, *Sixteenth Century Architecture of Mexico*, New Haven (Yale), 1948; John McAndrew, *The Open-Air Churches of Sixteenth-Century Mexico: Atrios, Posas, Open Chapels, and Other Studies*, Cambridge (Harvard), 1965.

List of illustrations

Unless otherwise indicated, photographs are by the author and site plans by Martin Lubikowski. Measurements are given in centimeters (and inches).

Abbreviations

AMNH American Museum of Natural History, New York
INAH Instituto Nacional de Antropologia e Historia
MNA Museo Nacional de Antropologia, Mexico
NGS National Geographic Society
UM University Museum, University of Pennsylvania.

113 Plan, House of the Governor, after Marquina.

114 Great Arch, Kabah.

115 Palace Tablet, Palenque, photo M. G. Robertson.

116 Lintel 25 Yaxchilán, H 127 (50), Trustees of the British Museum.

117 Stela 11, Yaxchilán, H 358 (140⅞), photo T. Maler, courtesy the Peabody Museum, Harvard University.

118 Stela 14, Piedras Negras, H 281.9 (111), UM.

119 Stela 12, Piedras Negras, H 313 (123), Museo Nacional de Arqueologia, Guatemala City.

120 Lintel 3, Tikal, H 205.7 (81), Museum für Völkerkunde, Basel.

121 Stela 16, Tikal, H 352 (138½), drawing W. R. Coe.

122 Stela N, Copán, Trustees of the British Museum.

123 Stela F. Quiriguá, H 731.5 (288), drawing A. P. Maudslay.

124 Zoomorph P, Quiriguá, H 220.9 (87), photo A. P. Maudslay, courtesy Trustees of the British Museum.

125 Jade mosaic vessel, Tikal, H 24.5 (9½), UM.

126 Gann jade, H 14 (5½), Trustees of the British Museum.

127 Bone, Burial 116, Tikal, after A. Trik.

128 Eccentric flint, H 24.8 (9¾), Dallas Museum of Art, The Eugene and Margaret McDermott Fund in honor of Mrs Alex Spence.

129 Jaina carved shell, H 8 (3⅛), Dumbarton Oaks Research Library and Collection, Washington D.C.

130 Male/female Jaina pair, H 24.8 (9¾), Detroit Institute of Arts, Founders Society purchase, Katherine Margaret Kay Bequest Fund and New Endowment Fund.

131 Codex-style pot, Metropolitan Museum of Art, rollout photo © Justin Kerr 1975.

132 Altar de Sacrificios vase, H 25.4 (10), Museo Nacional de Arqueologia, Guatemala City, photo I. Graham.

133 North wall paintings, Bonampak, Peabody Museum, Harvard University.

134 Stela 1, Seibal, H 237 (93¼).

135 Pyramid of the Feathered Serpent, Xochicalco, photo M. D. Coe.

136 Stela 1, Xochicalco, H 178 (70), MNA.

137 Hall of the Columns, Mitla.

138 Cacaxtla painting.

139 'Apotheosis' sculpture, H 158 (62½), The Brooklyn Museum, Henry L. Batterman and Frank S. Benson Funds.

140 Pyramid B, Tula, photo W. Bray.

141 Atlantean columns, Tula, photo Irmgard Groth-Kimball.

142 Plan, Tula, from Diehl 1984.

143 Chacmool, Tula, H 66 (25 ⅞), photo M. D. Coe.

144 Tula stela, H 122 (48), MNA, photo author.

145 Plumbate vessel, H 16 (6¼), MNA.

146 Plan, Chichen Itzá, after Morley and Brainerd.

147 Caracol, Chichen Itzá.

148 Section, Caracol, AMNH.

149 Castillo, Chichen Itzá.

150 Temple of the Warriors, Chichen Itzá.

151 Great Ballcourt, Chichen Itzá.

152 Great Ballcourt relief, from Marquina.

153 Wall painting, Temple of the Warriors, Ann Axtell Morris, Carnegie Institution of Washington.

154 Chacmool, Chichen Itzá, H 148.6 (58½), MNA.

155 Mayapán incensario, H 54.6 (21½), photo courtesy of the Museum of the American Indian, Heye Foundation.

156 Tulum.

157 Painting, Tulum, after copy by M. A. Fernandez 1939–40.

158 Dresden Codex, Sächsische Landesbibliothek, Dresden.

159 Pyramidal platforms, Iximché.

160 Book of Chilam Balam, Firestone Library, Princeton University.

161 The valley of Mexico, after Coe 1984, drawing P. Gallagher.

162 Codex Mendoza, Bodleian Library, Oxford MS Arch. Selden Al.

163 Primeros Memoriales from Codex matritense.

164 Malinalco.

165 Coatlicue, H 257 (99), MNA.

166 Coyolxauhqui stone, H 340 (133⅞), photo Smithsonian Institution.

167 Stone of Tizoc, D 275 (104½), MNA, photo INAH.

168 Calendar Stone, D 360 (141¾), MNA.

169 Xipe Totec, H 40 (15¾), Museum für Völkerkunde, Basel.

170 Eagle warrior, H 168 (66), INAH, photo author.

171 Carnelite grasshopper, L 45.7 (18), MNA.

172 Rain god chacmool, H 73.6 (29), MNA.

173 Temple Stone, H 123 (48⅜), MNA.

174 Huéhuetl, H 115 (45¼), photo INAH.

175 Gold pectoral, H 12.2 (4⅞), MNA.

176 Feather headdress, H over 124 (48), Museum für Völkerkunde, Vienna.

177 Skull mask, Trustees of the British Museum.

178 Cholula pottery cup, H 12 (4¾), Metropolitan Museum of Art.

179 Tlaloc effigy vessel, H 35 (13¾), Templo Mayor collection.

180 Codex Selden, Bodleian Library, Oxford Ms Arch Selden A2.

181 Codex Féjerváry-Mayer, Merseyside County Museums.

182 Codex Borgia, Vatican Library.

183 Wall painting, Ixmiquilpan.

184 Codex Borbonicus, Bibliothèque de l' Assemblée Nationale, Paris.

185 Codex Mendoza, Bodleian Library Ms Arch Selden Al.

Index